BUILDING TA

ATE MODERN

HERZOG & DE MEURON TRANSFORMING GILES GILBERT SCOTT

ROWAN MOORE AND RAYMUND RYAN
WITH CONTRIBUTIONS BY ADRIAN HARDWICKE AND GAVIN STAMP

TATE GALLERY PUBLISHING

Tate Modern
was built with
the support of

A MILLENNIUM PROJECT
SUPPORTED BY FUNDS
FROM THE NATIONAL LOTTERY

The Arts Council
of England with
National Lottery
funds

 english
PARTNERSHIPS
LONDON

 Southwark
Council

Cover: north façade of Tate Modern at twilight
Photo by Marcus Leith, Tate Photography

Published by order of the Trustees of the Tate Gallery 2000

A catalogue record for this publication is available from the British Library

Published by Tate Gallery Publishing Limited
Millbank, London SW1P 4RG

© The Trustees of the Tate Gallery 2000. All rights reserved
Designed by Peter B. Willberg
Printed and bound in Great Britain by Alderson Brothers

CONTENTS

Tate Modern from Southwark
Bridge

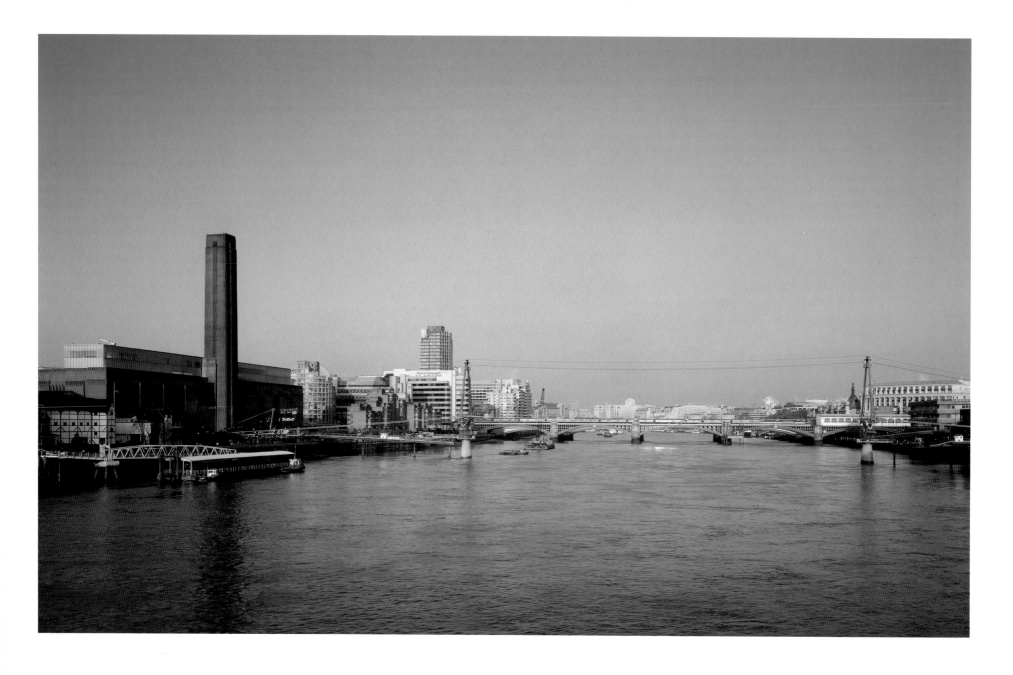

INTRODUCTION
ROWAN MOORE

The choice of Bankside as the site for the new Tate has baffled many. It is one of Britain's leading monuments to the new millennium, a temple to the contemporary in art, a treasure house of creativity. It is the latest in a line of grand art galleries that include such architectural marvels as the Pompidou Centre in Paris, the Staatsgalerie in Stuttgart, the Getty Center in Los Angeles and the titanium vortex of Frank Gehry's Guggenheim in Bilbao. It is the creation of the Tate Gallery, an institution famous for provoking both enthusiasm and hostility towards avant-garde art. Yet it wraps itself in a 1950s overcoat of brown brick, in the shape of a fairly well-designed ex-power station by the conservative architect Giles Gilbert Scott. It looks, at first sight, like an extreme case of the notorious British obsession with heritage.

Other millennial projects in London, whether the Dome, the Wheel, or the Bridge on Tate Modern's doorstep, are different. They are architectural monosyllables, comprehensible at a glance. They dramatise their own structures with dazzling displays of spikes and wires. They are made of materials considered modern like steel and glass, and bear the pronounced architectural signatures of their creators. They are shiny, glossy, glow-in-the-dark objects which, when finished, have the same smooth sheen as the computer-generated visualisations with which they were first presented to the public.

Other art galleries, at least since Frank Lloyd Wright's New York Guggenheim of 1957–60, have taken the form of objects as visibly signed and as collectible as the works they contain. The museum has become the defining monument of late modernist architecture, which is curious when you consider that museums look to the past, and modernism to the future. The highest possible precedents are invoked – the Acropolis by Hans Hollein's Städtisches Museum in Mönchengladbach, the Pyramids by I.M. Pei at the Louvre. They aspire, like Mies van der Rohe's National Gallery in Berlin, or Louis Kahn's Kimbell in Fort Worth, to a universal timelessness, beyond the time and place in which they stand.

By contrast Tate Modern is matt, not gloss, and, if the form of the original power station could not be more definite, the architectural contribution

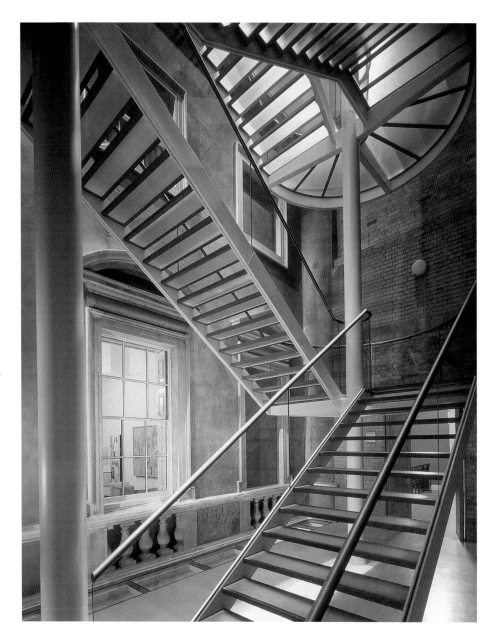

of Herzog & de Meuron is protean. While the 'light beam' on the roof may glow in the dark, its detail is simple. Nor does it follow the modern pattern of converting old buildings, set by projects like the Royal Academy's Sackler Galleries, which is to make the clearest possible distinction between crisp new work and crumbling antiquity. At Tate Modern it is not always possible to know where Gilbert Scott ends and Herzog & de Meuron begin. It takes time to unravel and understand the latter's contribution: unlike the millennium monosyllables, it is a building that reveals more with second and third acquaintance.

And, on further acquaintance, it begins to dawn that Tate Modern's apparent self-effacement may be its cleverest and most radical move, the thing that sets it apart from every other large new art gallery in the world. Sheer spectacle, after all, is becoming commonplace: the splendours of Bilbao are probably unsurpassable for the forseeable future and, while the Wheel, the Bridge and the Dome inject a welcome energy into London, there are more qualities to architecture than energy.

Tate Modern: exhibition gallery.
View by Herzog & de Meuron
with notes identifying fittings
and other details

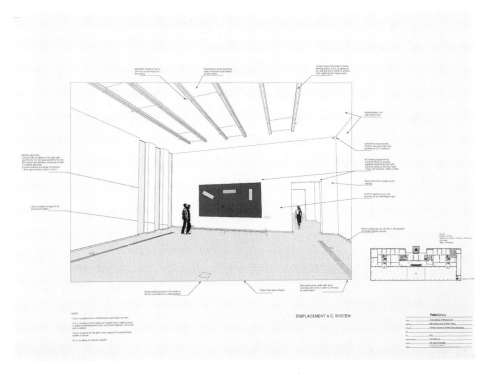

By re-using the imposing power station, the Tate and their architects bypass the need to create the memorable, signature form that is deemed essential in every other modern art gallery. They simply borrow it from the old building, with adaptations. The tactic also allows them the luxury of the power station's former turbine hall, a colossal and, indeed, spectacular space which could never be achievable in a brand new building. In Tate Modern there will not be the nagging, ever-present voice of the celebrated architect, nor the uneasy, synthetic feeling that comes from inhabiting the work of a single imagination. The architects, freed from the obligation to make grand gestures, can address more subtle and complex matters, and create a more nuanced, intricate relationship between the fabric of the building and the life that goes on in and around it.

They can concentrate on the qualities of individual spaces. With these they battle to achieve a deceptive simplicity and apparent ordinariness, the better to reveal latent strangeness, both within their own design and within the idea of putting art in a power station. Thus the exhibition galleries are designed to feel solid and room-like, rather than provisional arrangements of partitions splattered with the paraphernalia of smoke detectors and lighting equipment. The architects have carefully considered different proportions in different galleries, and different arrangements of artificial and natural light. In a way, they are the most normal possible rooms, but they are made extraordinary by a few telling moves like the single gallery twice as high as the others, or long bay windows that connect the calm galleries with the vertiginous space of the turbine hall, or the unsealed oak floors and cast-iron ventilation grilles which keep the galleries from being over-refined. Details like this shape the experience of a space, yet are too often dealt with in a routine and unreflective way by even the most celebrated architects.

Herzog & de Meuron's approach to Tate Modern embodies an understanding of human experience that is contradictory, uncertain, strange and many-shaded. It includes the knowledge that things are not always what they seem, the possibility or rather certainty of imperfection, the co-existence of shadows and light, the intertwined relationship of hope and pessimism. For human life, outside certain dubious religious cults, does not consist of the ever-fixed grin. In the twentieth century this knowledge was manifest in every art form, from Picasso to Beckett to Hitchcock to Jazz, except architecture. Modernist architecture always proclaimed itself to be unconditionally progressive, light-filled, transparent and optimistic. The paradoxical price that was paid for this sunniness was more actual misery, in the shape of constructed, failed utopias and plain dreary buildings, than was ever caused by ostensibly less up-beat art forms.

Thus Tate Modern, after presenting itself as something ordinary, reveals itself to be strange and beautiful. If it looks at first like a massive pile of bricks, the two-storey glass light beam on its roof and cutaways in its elevation make it fragile. It looks relentlessly symmetrical, but isn't. Outside the building you can be reasonably confident you are standing at ground level, but the mighty ramp that takes you down into the turbine hall casts this into doubt. Scale is subject to surprising shifts, and the monolithic exterior gives you little preparation for the multiform interior.

Inside, bands of artificial and natural light echo each other, sometimes blurring, sometimes revealing the distinction between the solar and the electric. The turbine hall feels higher for the compression of the spaces leading to it, and the exhibition galleries more dazzlingly white for the dark grey walls of the turbine hall.

The building's games with appearances – making the artificial seem natural or the solid evanesce – heighten experience through contrast in a time honoured way. More than this, they open up perceptions narrowed by electronic media. Television and computers separate images from their material presence and make them weightless, one-dimensional and manipulable, which hands architecture the role of reasserting the physical,

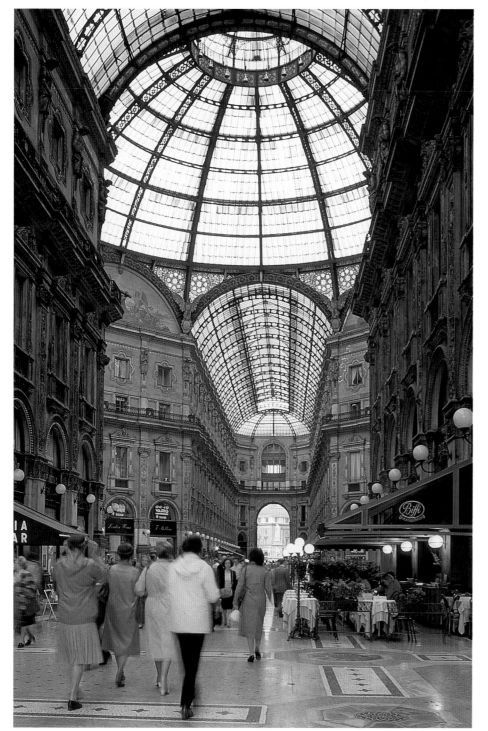

The Galleria, Milan

the material and the sensual. What the architecture of Tate Modern achieves is to reconnect image and substance in an inevitably paradoxical relationship, which engages us with our surroundings in far less simplistic ways than those to which we are accustomed.

Thanks to Tate Modern's reuse of the power station, and the refusal to impose an overwhelming architectural gesture on the site, the things that are extraordinary and mysterious about the completed building grow out of the time, place and culture in which it is situated. For better or worse, the decision to build a power station directly opposite St Paul's Cathedral was typical of the casual urbanism you would find in few European countries except Britain. The transformation of urban districts from industry to culture is to be found in every Western country. These strange facts are allowed to be inherent to the gallery's fabric making it, without affectation, into a space like none other, which yet enables it to ring true as a part of the city in which it stands. It appeals not to the eternity of the Acropolis or the Pyramids but to the continually shifting present.

A setting is created in which the works of art on show resonate within a wider context and more powerfully than they would among the generic interiors of the everyday works of architectural genius that now house art in a large number of European and American cities. Despite the forbidding, cliff-like walls of the old power station, there is continuity with the city beyond, while also a strong sense of entering somewhere extraordinary, a place where the senses and the mind will be exhilarated and stretched.

Tate Modern seems well prepared to play the role of the modern art gallery, which is to be a small city of many different types of exhibition and activity, rather than a simple machine for viewing art, and the turbine hall has the potential to be a great public space made special by the presence of art, a more provocative version of the Galleria in Milan.

Thanks to the complexity of its architecture it promises to avert the greatest danger of the all-encompassing art institution, which is that of being a cultural shopping mall.

Tate Modern is a building with many frequencies, embracing emotions ranging from joy to unease. It engages both the mind and the senses; a work of intense conceptual effort, but also of the visceral impact of the turbine hall and the pure pleasure of the light-filled galleries. All that takes getting used to is the idea that a monument of the new millennium might have been hanging about on the south side of the river Thames since the 1950s, but nobody noticed.

TRANSFORMATION
RAYMUND RYAN

Here it is, an old behemoth of Heavy Industry re-presented for the twenty-first century, a redundant power station poised as a Palace of Art and Experimentation. Bankside's static mass of dull brick and structural steel has been opened up to the life and eclectic nature of London. Viewed from across the Thames, or momentarily glimpsed down a Southwark side street, Tate Modern beckons with intent. Its looming profile is infiltrated with light.

Bankside's switch from private to public is literally signalled by its penthouse, an asymmetric 'light beam' glowing against the sky. Down on the ground, a broad ramp pierces the 1950s edifice to access gently a vast public hall. The Tate's reorganisation of Bankside enables visitors to ascend swiftly from hall to rooftop or pause to meander calmly through distinct suites of exhibition space. Everyone is invited in to explore the curious nature of contemporary art.

1 Michael Craig-Martin, 'The Art of Context', *Minimalism*, Tate Gallery Liverpool 1989; reprinted in *Michael Craig-Martin*, Whitechapel, London 1989

FROM REDUNDANCY TO URBAN STARDOM

'Radical art never creates anything entirely new:
it simply shifts the emphasis'
MICHAEL CRAIG-MARTIN [1]

Southwark was peripheral in the development of London after the Second World War. As the metropolis expanded outwards, the extraordinary growth of Heathrow to the west has in certain respects been mirrored by Canary Wharf and other substantial projects in the East End. Today, financial institutions still cluster in the famous Square Mile, the City being constantly added to by such landmark buildings as the NatWest tower (R. Seifert & Partners, 1981) and the gleaming Lloyd's (Richard Rogers Partnership, 1986). Directly across the river from St Paul's Cathedral, Southwark remained remote.

Southwark has been bypassed by this intense urban activity along

London's east/west axis. For Londoners and for many visitors to London, whether working in a City office or enjoying a Thames cruise, the one visible monument between the National Theatre and Tower Bridge was the ageing power station at Bankside. For some, the grandeur of St Paul's to the north seemed offset by the dour dignity of Giles Gilbert Scott's brick pile to the south. A provider of limited local employment, Bankside presented itself emphatically as a hermetic object and inaccessible precinct.

Today many planners and politicians are interested in exactly such locations. Now, after periods of neglect or lack of cohesion, post-industrial Southwark is becoming a role model for a new British urbanism. As regards infrastructure, the Underground extension from Green Park to Greenwich and Stratford will undoubtedly improve links with the rest of Greater London. Under the stewardship of the London Borough of Southwark, and its Director of Regeneration and Planning Fred Manson, more intimate, tactile projects are under way, including signage and street furniture designed by young London practices such as muf architecture/art, Caruso St John and East. These latter initiatives complement the bigger developments, *petits projets* to the *grands projets* in the lingo of Mitterrand's Paris.

As peripheral urban areas seek to find new vigour and purpose, ambitious museums throughout the capitalist world are simultaneously engaged in expansion. The 1990s have been marked by the erection of very many 'signature' buildings for cultural institutions old and new. Of these typically eye-catching works by star architects, the most celebrated are the Getty Center in Los Angeles (Richard Meier & Partners, 1997) and the Guggenheim Museum Bilbao (Frank O. Gehry & Associates, also 1997). When spectacular projects appear, the financial benefits can be

substantial – it is estimated that Tate Modern will generate 2,500 jobs. But what meaning or value do these media sensations have for the existing host communities?

Tate Modern is the first institution of international stature to adapt an existing industrial structure (it contains 133,500 square feet – 12,402 square metres – of exhibition space alone). In architectural terms, it magnifies strategies of re-use instigated by some smaller art galleries in the 1980s, most notably the Saatchi Collection in St John's Wood and the Temporary Contemporary (a former police vehicle service depot) in Downtown Los Angeles.[2] Tate Modern is, however, also concerned with the civic realm beyond its four opaque walls. Working with the urban fabric of Southwark, as opposed to parachuting in some exotic designer bauble, the Tate hopes to integrate in a holistic way the cityscape and the everyday life of Southwark and South London.

2 The Saatchi was designed by the late Max Gordon and the Temporary Contemporary, now known as the Geffen, by Frank Gehry

THE TWO TATES

Tate Modern is the realisation of a long-held intention to resolve the schizophrenic nature of the old Tate Gallery. Founded as a gallery of British art in 1897, when the sugar magnate Sir Henry Tate donated his collection and £80,000, it also functioned as Britain's main gallery of modern art from 1916. The logic of this arrangement was never strong, with George Stubbs's horses in one half of the gallery and the work of Marcel Duchamp in the other. As the Tate was also short of space, and never able to show more than 20 per cent of its collections at any one time, the case to build a new, separate Tate gallery of modern art became compelling. The main obstacle was financial. This was made more difficult by the reaction during Margaret Thatcher's administration against spending public money on new, grand cultural buildings. Between the completion of the National Theatre in 1975 and the opening of the British Library in 1997, not a single project of this sort was embarked upon in London.

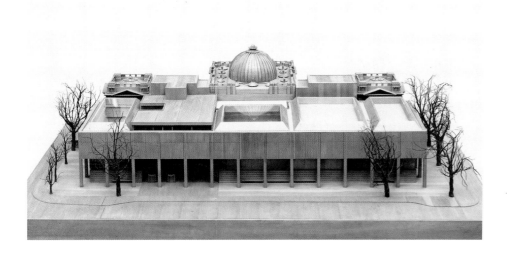

One previous attempt to address the shortage of space was Richard Llewellyn-Davies's extraordinary 1968 proposal for building a large new block in front of the Tate's existing portico, completely blocking it from view. In 1979 the developer of the 'Green Giant', an office tower planned for the southern end of Vauxhall Bridge, proposed an annex to the Tate at the tower's foot, to be financed from the tower's profits. This site is now occupied by the MI6 headquarters.

Under the directorship of Nicholas Serota, who was appointed in 1988, the Tate's role as a centre of modern and contemporary art gained in prominence. The Tate's Turner Prize, awarded annually to a British artist under fifty, became a focus of public controversy and debate about the rising and provocative generation collectively known as Young British Artists.

The idea of a separate gallery of modern art was resumed and in December 1992 the Tate announced its intention to split into two collections. Two days later the National Lottery Bill was published, which created the first realistic prospect of funding a new Tate, as the lottery's proceeds were to go to capital projects deemed to be 'good causes'. One of the bodies charged with distributing the money was the Millennium Commission, whose task was to make awards to projects suitable to mark the new millennium. In 1995 the Millennium Commission eventually awarded the proposed new Tate their maximum grant of £50m. A further grant of £6.2m was later made by another lottery distributor, the Arts Council. The government regeneration agency, English Partnerships, contributed £12m to the purchase of the site and the removal of the power station's machinery, and the rest of the eventual total cost of £134.5m, which included everything from site acquisition and tree planting to the staff costs incurred by the project, came from private donations.

Under the terms of the lottery, money could not be awarded to projects initiated by central government, but to bodies like the Tate who, before receiving any grant, had to develop their plans and demonstrate their feasibility. Nor could lottery money ever fund the total cost of a project. These

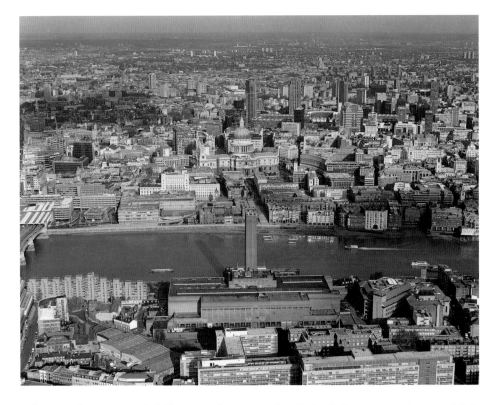

rules made a crucial difference between the British lottery projects, which are a series of individual initiatives by non-governmental bodies, and the *grand projets* of President Mitterrand, which were directed and funded from above.

In 1993 the Tate started to canvass the views of artists and curators. Conferences were held to discuss the nature and needs of major art galleries in the twenty-first century. Meanwhile a search was launched for suitable sites, which ended with the selection of Giles Gilbert Scott's Bankside Power Station. Despite its size and prominent position, and in contrast with the same architect's Battersea Power Station, many Londoners were unaware of its existence. While enthusiasts for this period of architecture argued that it was a superior design to Battersea, attempts to have it listed as a building of historical interest had been unsuccessful.

The Tate's choice caused dismay in some quarters. It was seen as an example of the excessive conservatism and respect for heritage that had limited British architecture in the 1980s. The lottery, it was felt, should be the chance for assertive new landmarks in central London, and criticisms were to resurface when it became clear that alterations to the old building would be subtle rather than dramatic. In an exhibition of their work, the architects Future Systems showed a speculative design for a wholly new building on the site. At the opening of that exhibition a message was read out from Norman Foster, calling for spectacular new architecture in London, to an applauding audience.

These critics, however, misread the Tate's intentions. The choice of an existing building undoubtedly had political advantages, as it bypassed the destructive rows that affect large new buildings in London, but the choice of the power station was never an exercise in industrial archaeology. It was

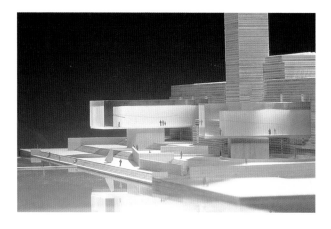
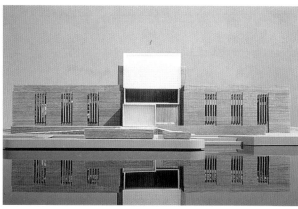
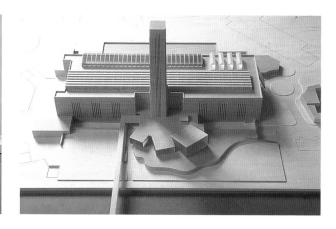

driven more by the view, ascertained by the Tate through its discussions with artists and curators, that adapted industrial spaces made more sympathetic and inspiring spaces for exhibiting art than purpose-built new ones.

Once the site had been chosen the Tate held an international architectural competition, which attracted approximately 150 requests from architects wishing to compete. Thirteen firms were asked to propose initial design strategies, with six proceeding to a more detailed second round. It is an indication of the global ambition of the Tate Modern project that each of these six participants practice at the highest professional levels, building or in the process of building galleries and museums on several continents.[3] For the most part, however, they were from a generation younger than the one that had hitherto dominated the field of grand cultural projects. A squall also blew up in the London press over the fact that only one of the final six was British. In fact the international choice of competitors only followed a practice that had been standard in other European countries for years.

The architects who presented more detailed schemes for Bankside were:

Tadao Ando Architect and Associates (Japan), with two robust glass boxes skewering the building to protrude out towards the Thames

David Chipperfield Architects (the sole British representative), who proposed to remove Bankside's landmark chimney and situate a city-like plan of streets and courtyards beneath a glazed roof

Rafael Moneo (Spain), with a complex roof of elegantly modelled light scoops and a low expressionistic café breaking out towards the river

Rem Koolhaas/Office for Metropolitan Architecture (Netherlands) with Richard Gluckman (US), layering a vertical promenade or circuit of identifiably new volumes within Gilbert Scott's brick wrapper

3 Three of the architects (Ando, Moneo and Piano) have already been awarded the Pritzker Prize, the world's most prestigious architectural award: the other three cannot be far behind

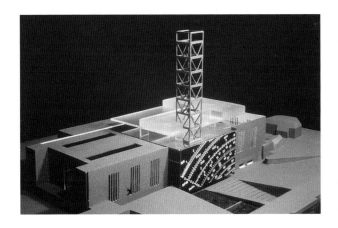

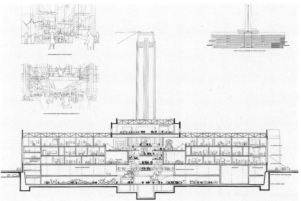

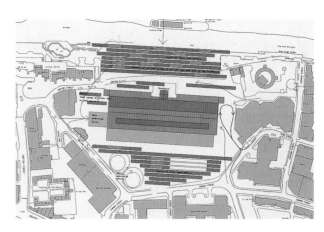

Renzo Piano Building Workshop (Italy), with a new contiguous high-tech roof for the universal control of light, plus a covered plaza and axial pavilion at north and south entrance points respectively

Herzog & de Meuron, the eventual winners, from Basel in Switzerland

Why did the Swiss team win? Paradoxically because they proposed the least drastic changes to the fabric of Bankside itself. Rather than obliterate the qualities of the industrial building that initially attracted the Tate, they would heighten them. The Herzog & de Meuron scheme has never been about making strange complicated shapes or obliterating the past. Londoners will still be able to recognise Gilbert Scott's power station; people from Southwark can now 'trespass' almost anywhere about its 3.4 hectare site. While the elongated penthouse is unmistakably new, a brilliant horizontal line crossing the dark vertical marker of the chimney, there are few other external clues to the transformations within.

Jacques Herzog and Pierre de Meuron, both born in 1950, have known each other since childhood. Both trained at the ETH, Zurich's rigorous architecture school, and they have been practising together since 1978. Harry Gugger and Christine Binswanger joined them as partners in the practice in 1991 and 1994 respectively, and they work collaboratively. In the early stages of the new Tate all four contributed, and Binswanger ran the preparation of the competition proposals. It was Gugger who steered the project through the many changes and refinements, and the budgetary and technical challenges it underwent between the competition win and the completion of the building. Herzog has been closely involved throughout.

At the time of the Bankside competition Herzog & de Meuron's reputation was rapidly rising in the architectural world, on the basis of a series of beautifully executed but relatively small projects in and around Basel. Since then their rise has accelerated. They are leading figures of a generation that, following on from modernism and post-modernism, could not be

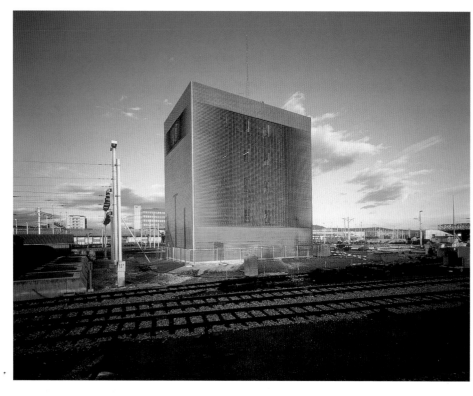

seminal Goetz Gallery, a flush box clad in birch ply and matte glass set in a suburban Munich garden.

At Goetz, the stacking or layering of simple elements of structure is reminiscent of certain Minimalist or Conceptual art works. That tactic and Goetz's splendid manipulation of clerestorey light reappear at Bankside. For Herzog & de Meuron have also been deeply inspired by contemporary art practice, having collaborated with Joseph Beuys in the past, and continuing to work closely with artists and curators. The work is never about abstract theory alone. It is concerned with that which Walter Benjamin famously described as 'aura'.[5] As long ago as the 1930s, the German cultural commentator warned of the lack of specificity or presence in the artefacts and environments created through mass-production. Today, Herzog & de Meuron achieve architectural aura through placement – the positioning of things, through texture, and through skillful physical construction. They test the sensual qualities of buildings with full-scale mockups, and continuously invent new ways of working and finishing materials.

categorised as either. Indeed, their work is characterised by a refusal to adhere to a single style or range of materials and details, while retaining an underlying consistency.

From the smallest pavilions and interiors to large-scale planning or infrastructural investigations, their work is predicated upon connections between urbanism and form and land-use. To their collective analytical mind, typological relationships exist between the apartment and the street and the structure of the city. The Tate jury members,[4] who visited buildings by all six finalists, were undoubtedly impressed by the logic and the beauty of such realised Herzog & de Meuron projects as the Basel railway signal box, a small industrial monument wound in bands of copper, and the

4 The jury consisted of, amongst others, Nicholas Serota, Michael Craig-Martin and the collector Janet de Botton.

5 Walter Benjamin, 'The Work of Art in the Age of Mechanical Reproduction', *Illuminations*, Fontana Press, London 1970

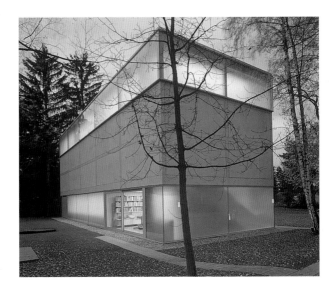
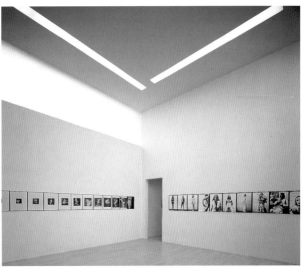

The transformation of Bankside from power station to art gallery has produced its own distinct aura through a fusion of old and new. The abandoned monument has found an exciting role. It aims to shift an entire metropolitan emphasis.

A NEW PUBLIC REALM

Three years after Herzog & de Meuron's competition success and two years before the actual opening of Tate Modern, the penthouse was already in place and clearly visible from many locations around London. Viewed from Blackfriars Bridge, crossing from north to south banks, the orthogonal glass and metal box reflects the ambient light above the city, occasionally appearing sharp and pristine, at other moments merging with the grey sky. As one circumnavigates through the City or Southwark, the simple box changes expression. Above Bankside's heavy brick walls, the architects' 'light beam' adjusts to weather conditions during the day, and is then illuminated from within at dusk. It has a vitreous ghostly character, with inner shadows hinting at structure and mass.

Whereas the penthouse is obviously an addition, the architects have also made judicious subtractions. Minor excrescences on the north façade have been removed and rectilinear cavities inserted to both sides of the chimney. By projecting the glass wall of the café from the north-west corner, the building above appears to balance precariously. This hollow pile of the original building is itself made up from a variety of brick details (in places, it has simply been patched); tall, thin windows with an industrial-ecclesiastical look have been retained with their original metal frames. The geometric massing of Bankside has always had an Art Deco flavour, its flat rectangular surfaces advancing or receding, serrated towards the top or ending in jazzy finials. After Herzog & de Meuron's intervention, the variegated nature of Gilbert Scott's composition is even more evident.

Conceived with Kienast Vogt Partner, the Zurich-based landscape practice, the ground around the building has been resurfaced with gravel in

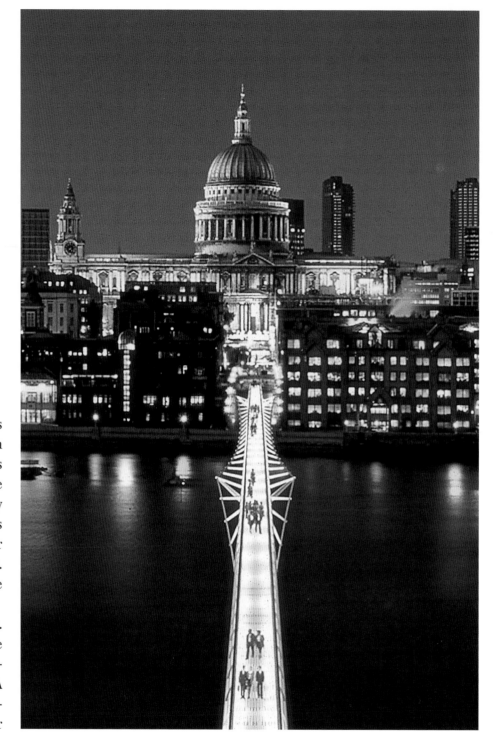

various states of aggregate. The tough urban character of Southwark's
streets sweeps in and up to the bulk of Gilbert Scott's building. The idea
is to integrate all horizontal and vertical surfaces of the building and its
landscaping into one comprehensible precinct. Then, augmenting the
fundamental north/south and east/west axes, distinct areas are created by
overlays: perimeter hedges enclosing gridded displays of daffodils towards
Sumner Street; a taxi rank and bike shed toward Hopton Street; and linear
swatches of birch trees and rubber-topped benches towards the Thames.
Fringed by a public path, the more constricted eastern yard is for service
and deliveries only.

The Thameside gardens are the most impressive external venue.
Warmed by the afternoon sun, this robust riverside shelf connects Tate
Modern with pedestrian paths along the South Bank and is further anim-
ated by the sleek new Millennium Bridge darting across to the City. A
separate design competition open to teams of architects, artists and engin-
eers, was won by architect Norman Foster in collaboration with sculptor

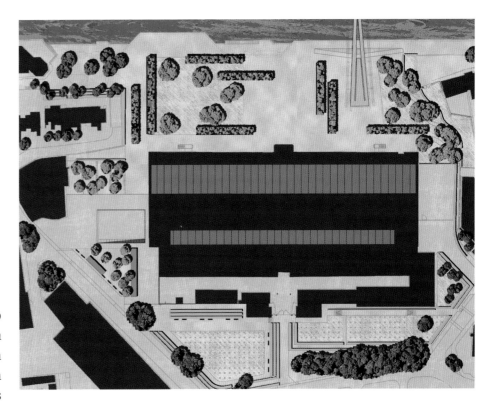

Anthony Caro and engineers Ove Arup & Partners. The bridge is a superb example of high-tech urban equipment, described by its creators as a 'blade of light'. It is for pedestrians only, and is the first new river bridge in Central London since 1894. After considerable design evolution, attention to disabled access and the heights of rivercraft, the bridge's inauguration is timed to coincide closely with that of Tate Modern.

From the river side the public can enter Tate Modern through the north block formerly housing the boiler house and proceed into the turbine hall, without being interrupted by barriers marking out the territory of the art gallery. The boiler house is stacked with exhibition space, the turbine hall to the south has been left as an enormous void. A final sliver of space along Gilbert Scott's south façade continues to operate as a London Electricity supply station, its humming still audible to the outside world. It is planned that this layer, known as the switch house, may eventually become a further block of accommodation, pierced by the Thameside/Southwark axis. The normal north-south route for pedestrians between Southwark and the City will thus take them through the very heart of the museum, whether or not they have any intention of viewing art.

On the western side, bounded by Hopton Street and an extant paper merchant (a real urban relic), the ground surface erupts in places to form street furniture. Then it dips downwards to become the enormous ramp leading gently but ceremoniously into the turbine hall. The ramp extends the entire breadth of the hall, supplying views up towards the café and auditorium, and down on to the Tate shop and other public amenities. Off to the right are the power station's circular, subterranean oil tanks, which are to be made in a later phase into exhibition spaces of an unprecedented kind.

If the ramp is reminiscent of earthwork devices in classical French

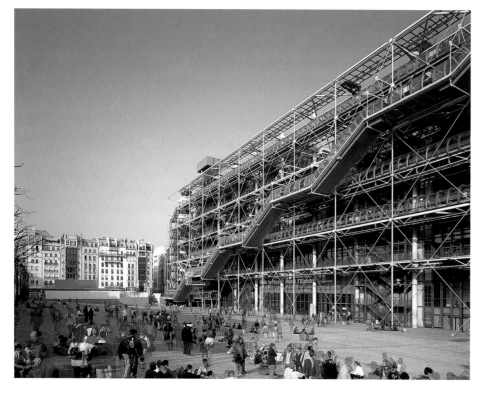

gardens, it is also at home with Gilbert Scott's industrial vocabulary. It descends to deposit visitors beneath a bridge platform, a key dramatic moment where the upper north/south and lower east/west axes cross in a latter-day version of the *cardo* and *decumanus*, the roads that crossed at the centre of a Roman city. A stairway drops from the bridge above to allow visitors to approach the reception counter together.

In the twentieth century, architectural evangelists often spoke of Cathedrals of Industry. At Tate Modern the immensity of the turbine hall, and its diffuse contained light, is truly cathedral-like. Measuring 152 × 24 × 30 metres, it is as close to a spiritual experience as one might find in today's secular world. Enormous steel columns, tattooed with rivets and bolts,

march down both flanks to support exposed roof trusses high overhead. Natural light filters down from a broad zip of skylight. Glazed boxes project from the former boiler house, siblings of the exterior penthouse. Potentially open night and day, the turbine hall should have the excitement of Leicester Square, or of the Pompidou Centre in Paris, especially in the evening.

This new public space in London is quite literally awesome. Some of the foyers and galleries stacked within the boiler house extend out into the vitrines. When the visitor steps forward into a glazed box, there is an exhilarating, almost vertiginous sense of hovering above it all. Two gantry cranes, capable of being manoeuvred along the entire length of the hall, remain up towards the trusses as functioning souvenirs of past reality. Otherwise the space is empty. It is waiting for activities and objects as yet unspecified to arrive. For the original competition entry, Herzog & de Meuron montaged an image of Rachel Whiteread's *House* onto their interior views, a bulky sculpture easily accommodated in the vast hall.

A concrete piece that used a condemned terraced house as its mould, and bore the imprints of fireplaces and windows, *House* was an example of contemporary art's re-presentation of the materiality and symbols of daily life. Surely the architects, who are themselves making an everyday building extraordinary, saw it as a talisman for the public nature of the place they have now helped create.

TOTAL CIRCULATION

The success of all large public buildings depends upon the smooth flow of visitors and personnel. Museums need to funnel crowds efficiently but also allow the visitor intimacy or moments of direct experience before individual works of artistic or historical interest. At Pompidou (Renzo Piano and Richard Rogers, 1977), escalators were sheathed in transparent tubes and clipped – as a moving logo – to the exterior of the building. For Tate Modern, the architects have placed vertical circulation deep inside the building mass, threading escalators, perpendicular banks of lifts, service ducts and a boldly sculptural staircase through the former boiler house. Although internal, there is a visual connection between these active components and the turbine hall, helping to energise the hall as a special civic room.

Starting at the lower ground level, these arteries of vertical circulation bypass the public concourse at street level (Level 2) and access the galleries (Levels 3, 4 and 5) before emerging into the penthouse with its restaurant, Members' Room, and screened mechanical equipment. The lifts provide the quickest means of transportation, the escalators the most spectacular; the open stairway is important for more leisurely and engaging circulation. At each level, the gallery sequence is reached through large foyers that look back into the turbine hall through bay windows. These are furthermore intended by the architects as sites for informal events and art installations.

The visitor then enters the exhibition galleries, the spaces on which the success of Tate Modern depends. Their design raises essential questions of

what the optimal conditions are for viewing the art of today, questions which are close to the collective heart of Herzog & de Meuron, given their interest in visual culture.

For many years, the Herzog & de Meuron practice has collaborated directly with artists. With the French-Swiss artist Rémy Zaugg they have worked on projects ranging from the built Antipodes student residence in Dijon to a hypothetical planning exercise for the tri-national conurbation of Basel.[6] In 1995, Zaugg designed an exhibition of Herzog & de Meuron's work at the Pompidou Centre with skeletal display tables and a suspended grid of lighting tubes. While the designs for the new Tate were being developed, the architects in turn built the artist a studio in a rundown suburb

of Mulhouse, in France, north/north-west of Basel. Tate Modern is informed both by contemporary art theories and by this free-standing pavilion, which served as a full-scale test for the exhibition galleries.

Zaugg's work is primarily concerned with perception and with the transmissibility of meaning, whether from a canvas or three-dimensional installation. Very attuned to borders, edges and margins, he might be said to believe in the right to existence of things and the importance of the quality of space between them. Herzog has explained how 'Zaugg's rigorously phenomenological approach is very close to what we try to pursue in architecture. It's a matter of questioning knowledge that is handed down to us, questioning foregone conclusions, things assumed to be true.'[7] For those influenced by phenomenology, the essential qualities of objects, their 'thingness', is revealed through experience. Tate Modern can thus be considered as a set of finite rooms linked by spatial or haptic experience.

At his property, bounded by roadways and an ageing textile factory, Zaugg will point out new swatches of hedge used to demarcate particular

6 Other artists who have collaborated with Herzog & de Meuron include Joseph Beuys, Helmut Federle, Pipilotti Rist, Thomas Ruff, Adrian Schiess, Rosemarie Trockl, Hannah Villiger, and Jeff Wall

7 *Herzog & de Meuron*, TNProbe Volume 4, Tokyo 1997

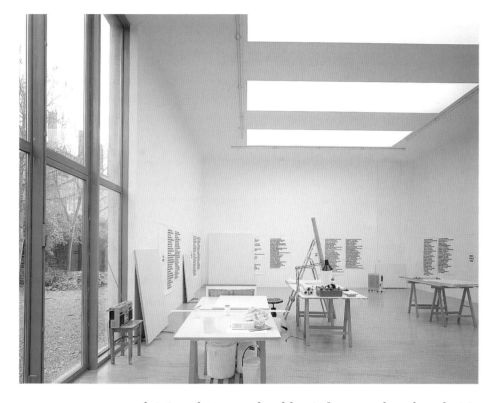

areas or zones, explaining that one should reinforce a place by what is already there.[8] Referring specifically to the studio, he has said 'we used the same method as in other projects, the goal being to forget everything we've ever known, to eliminate a prioris, to be child-like again and not to be afraid of not being able to find the right solution but simply to let things happen'.[7] The Zaugg studio by Herzog & de Meuron is almost naive. It is a parallelepiped made of raw concrete with contiguous canopies along opposite sides. Its flanks are deliberately allowed to stain with rainwater and are cut into with single floor-to-ceiling openings. Inside the plain rectangular plan, however, are several quite distinct chambers each 5 metres high.

At Tate Modern, the galleries at Level 3 and 4 are not dissimilar: 5.2 and 5.0 metres high respectively and, like Zaugg's studio, with uniform white walls and ceilings, floors of more substantial textures, natural light from the side, and electrical illumination from rectangles flush with the ceiling. These environments embody the statement by Michael Craig-Martin (a juror for the Tate Modern competition) that 'the apparent simplicity of Minimalist works focuses attention without distraction on the straightforward reality of the object, the relation of the object to the space in which it is seen, the relation of the viewer to this experience'.[9] In both the artist's studio and the Tate Modern galleries, all intrusive fixtures for light, heat, air, security and fire protection are banished. Space and light are paramount, and the galleries are conceived as distinct, solid-walled rooms rather than as enclosures formed by temporary partitions within open and theoretically flexible spaces favoured by art galleries of recent decades. In Craig-Martin's terms, there are no distractions.

Zaugg believes in allowing exhibition visitors to wander quite freely between rooms, as if released from temporary intense experiences of art.

8 Conversation with author, Mulhouse-Pfastatt, 24 September 1999

9 Michael Craig-Martin, 'Reflections on the 1960s and early 1970s', *Art Monthly*, March 1989; reprinted in *Michael Craig-Martin*, Whitechapel, London 1989

He favours an almost organic arrangement of rectilinear cells, rooms housing art separated from each other by art-free spaces and offering views back to the outside world. At Tate Modern, in a move that is both Zaugg-like and prompted by the Tate's brief, long foyers flow out into the linear bay windows before leading on into the gallery circuit.

The layouts of Levels 3 and 4 are almost identical, except for one splendid double-height space facing west through a high Gilbert Scott window. All galleries on these levels are horizontally oriented, with limited views of the City or the vast void of the turbine hall. It is at Level 5 that the extraordinary moment occurs. Perimeter strips of normative gallery space, parallel to the Thames and turbine hall, have zenithal illumination (through skylights that align with the ceiling light boxes below). Then, in the central interstitial zone, the ceilings of four galleries move up into the undercroft of the penthouse to gain wonderful clerestorey light. Here the patterns of movement through the old boiler house have come to a climax. The visitor is aware of a new soffit hanging high above the original

Bankside envelope. The penthouse floats above with light suffusing the gap between the apparently old and the unmistakably new.

WORKING WITH OLD AND NEW

> 'La modernité, c'est le transitoire, le fugitif, le contingent, la moitié de l'art dont l'autre moitié est l'éternel et l'immuable'
> CHARLES BAUDELAIRE [10]

The designs of Herzog & de Meuron are attentive to gaps and to skin, a priority which could result in forced dermatological differentiation. The policy of accretion and even fusion which the practice has adopted towards the Gilbert Scott building has, however, produced an architecture in which one cannot always distinguish between old and new. The penthouse and the turbine hall bay windows are blatantly of today but the exterior ramp, the thin vertical windows, and the concrete floors in the upper galleries are more ambiguous. This absence of shock between the inherited fabric

(tradition) and new construction (progress) indicates a concern for normality and for the unimpeded appreciation of art. The interiors created by Herzog & de Meuron are essentially calm. In reality, most of Tate Modern's interior is new.

In recent decades, after the sweeping excesses of High Modernism, architects and critics have reconsidered the importance of history and of details in design. These ostensibly distinct concerns come together in the work of the Italian Carlo Scarpa. In such meticulous projects as the Palazzo Querini Stampalia (Venice) and the Museo di Castelvecchio (Verona), Scarpa stitched together the fabric of the past with fragments of jewel-like new construction. Herzog & de Meuron's attitude to the past is radically different to Scarpa's intuitive tastefulness. Rather than inducing a piece-meal beauty from a group of highly specific interventions, Herzog & de Meuron use primary ideas globally. That is to say, the same concept is tested in every part and at every scale of a single project.

From the outset, the architects decided to remove the street-level deck

10 Charles Baudelaire, from Frisby,
Fragments of Modernity in the Work of Simmel, Kracauer and Benjamin,
MIT Press, Cambridge MA 1986

and to strip machinery from the turbine hall. Only a small slip of deck was retained to become the bridge platform at the interstices of Bankside's north/south and east/west axes. The roof above the turbines, a flat slab with a long central roof-light, was found to be defective and had to be entirely replaced, an unintended item for the project's schedule and budget. The guts of the boiler house were also removed and a new steel structure built up storey-by-storey, a frame capable both of holding the concrete floor slabs of the exhibition galleries and supporting the added weight of the immense penthouse above. At a certain stage in the construction process, in 1997, all that remained of the power station were its encircling masonry walls, the bones of its steel frame, and the chimney. These same walls now appear to miraculously support the flush 'light beam'.

The volumes that in-fill the former boiler house do not distract the eye or foot from the essential purpose of experiencing art. On Levels 3 and 4 at Tate Modern, the concrete floor is overlaid with untreated European oak making for a sensuous enfilade from one space to the next. On Level 5,

where light filters in from the lower section of the penthouse, the concrete slab is exposed and smooth-finished. These upper spaces might be said to relate to the skies (atmospheric changes outside certainly affect the mood within) whereas the lower levels depend for natural illumination on side lighting through the original attenuated windows (now overlaid, on the galleries' inner surface, with complementary steel-framed and double-glazed glass panels). The hall and chimney are special but the galleries themselves exhibit little dichotomy between old and new.

The galleries are sided in white-painted MDF (Medium Density Fibreboard) mounted on internal light metal frames – the walls the visitor sees do not hold up the building. These partitions separating the galleries are exceptionally thick. They enclose the majority of technical services. The portals, wrapped or lined in oak, are sufficiently deep to hide open door leaves out of view, an elegant aid to the uninterrupted flow of space. Inlaid into the floors are occasional air vents made of cast iron, like grilles in a public street. The lower galleries unashamedly rely on artificial

illumination (today many believe that contemporary art is better served by dependable electricity than by fickle sunlight). All this contributes to Tate Modern's complex industrial aesthetic.

Throughout the building, the architects had originally wished to use more differentiated colours and textures (in fact, Herzog & de Meuron seem increasingly interested in the benefits of hue). Down at Level 2, close to the entry ramp, the bright red of the auditorium, both outside and in, is the strongest remnant of a more heteroclitic approach. Its pillar-box shade jumps out when seen from the turbine hall, as if in a brilliant sectional collage. Below it, the large Tate bookshop has an English oak floor while that of the education resource centre, to the east, is covered in orange marmoleum. This insertion of vivid contemporary volumes and materials into the carcass of the old indicates an attitude which does not kow-tow before the past but works with it.

Many of Herzog & de Meuron's recent projects, including the colourful Ricola Marketing Building at Laufen (1999) and the recent competition-

winning design for the M.H. De Young Museum in San Francisco (estimated completion: 2006), explore further the possibilities for colour, for reflection and refraction in carefully calibrated planes of fabric and glass. These experiments loosen the rationalist right-angled box into more folded or polygonal forms, encouraging physical and visual movement, allowing in San Francisco for the interweaving of external and internal circulation, of the natural and the artificial. At Tate Modern, there are fragments of this soft geometric approach in sculpted soffits and in a canted glass screen running past the longer auditorium wall into the plaza-level café.

'Those who know Jacques Herzog,' Rem Koolhaas has written, 'confront an explosive temperament rigidly controlled; in the work, the control is always evident, the explosive energies repressed, displaced . . . to where?'[11] Herzog's energies are surely latent in the many trials and experiments he, de Meuron and their colleagues undertake with every project. By definition, as with all experiments, their findings may not prove to be useful or ever be used. They may also not be clearly visible. As Zaugg has said,

Herzog & de Meuron do not abide by a prioris. In the case of Tate Modern, several ideas were examined for the new screen wall inserted between the boiler house and turbine room, the key interface and skin of the interior, before the eventual concept was selected.

The architects explored the consequences of laying glass over the entire vertical threshold (like some unprecedented scientific specimen), of spreading mesh over the same expanse, and of arranging dark bricks in particular patterns with many small interstitial gaps. Investigations included the dense stacking of lumber to turn the bookstore into an environmental timber sculpture, combining ramps with built-in furniture for the Members' Room (a collaboration with the designer Jasper Morrison), and draping richly-coloured cloth inside the penthouse restaurant. Such moments would add a diverse sensuousity to the entire project, a multilateral relationship with Gilbert Scott's Bankside which is not strictly archaeological but capable of warmth, surprise and change. One realised product of these experiments are the all-black terrazzo washrooms.

11 Rem Koolhaas, 'New Discipline',
Rem Koolhaas, *Architecture of Herzog
& de Meuron*, Peter Blum Edition,
New York 1995

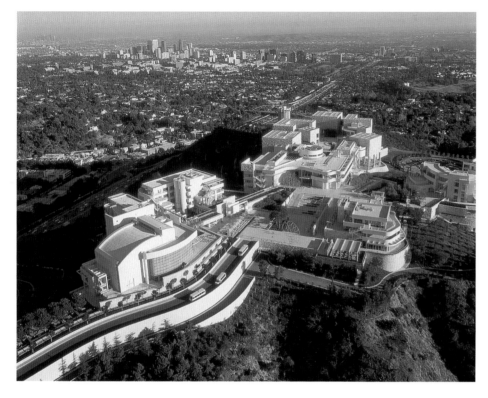

As early as the 1950s, similar freedoms were seized upon by artists including Robert Rauschenberg and Ellsworth Kelly with their lofts and warehouses in Lower Manhattan. The now paramount model for art museums is akin, therefore, not only to factories and other blue collar facilities left abandoned in various urban zones but also to the spaces in which much contemporary art is itself produced. As Warhol predicted, labelling his studio The Factory in the 1960s, there is a symbiosis between artworks produced in machine-serving spaces and the attitudes of artists to museums and galleries. These factors have forged a new hybrid, transient sensibility. The place of art and the place of the artist fluctuate but are increasingly alike.

12 Brian O'Doherty, *Inside the White Cube, The Ideology of the Gallery Space*, Lapis Press, Santa Monica/San Francisco 1986

A PLACE FOR ART

'A cliché of the age is to ejaculate over the space on entering a gallery.'

In a series of lectures from the mid-1970s, later published as *Inside the White Cube*[12], the critic and artist Brian O'Doherty dissected the unwritten codes dictating the architecture of modern exhibition space and the artificial relationships between it and both artists and the viewing public. In an 'Emperor's New Clothes'-type manoeuvre, O'Doherty disrobed the conventions of gallery design then the rage in both the US and Europe. 'Some of the sanctity of the church,' he wrote, 'the formality of the courtroom, the mystique of the experimental laboratory joins with chic design to produce a unique chamber of aesthetics'.

Twenty years later, that 'chamber of aesthetics' (close in O'Doherty's mind to a Chamber of Horrors?) reached its apotheosis with the Getty Center on its hilltop above West Los Angeles. Immaculate and aloof, the Getty is disengaged from the fluid city far below. Designed by Richard Meier, it relies on a contorted *promenade architecturale*, never letting you forget that you are (lucky to be) inside an exquisite composition. Designed by

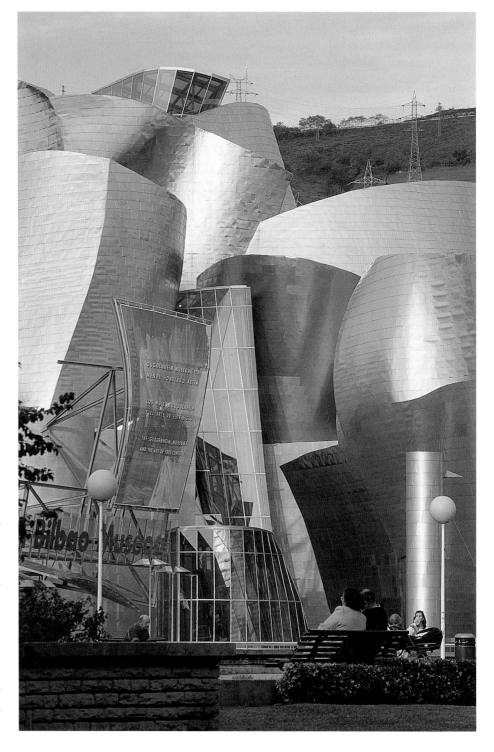

Frank O. Gehry & Associates, the Bilbao Guggenheim is more user-friendly. It allows you to become advantageously lost, removed from the vortex-like core and able to relate directly to works of art before returning quickly to the obvious architectural action. Some spaces are dynamic, others serene.

As the Guggenheim has expanded internationally, from New York's Upper East Side to Venice, Bilbao and Berlin, the Tate has also grown by establishing satellite branches within Britain, in Liverpool (1988) and St Ives (1993). Both institutions have decided to distribute their energies with only limited intensification on their original sites. Such a strategy seems particularly suitable for contemporary art which is so often portable and, as with video work, literally immaterial. Much smaller than Tate Modern, the Tate of the North inhabits an old industrial building, a stone and iron warehouse in Liverpool's Albert Docks, whereas that in St Ives is a specific free-standing structure in a highly visible location (architects for the galleries were James Stirling, Michael Wilford and Associates, and Evans and Shalev Architects respectively).

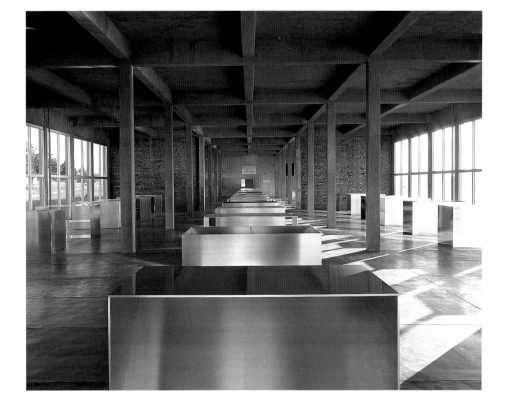

By deciding to refurbish a former power station, the Director of the Tate Nicholas Serota chose not to attempt a prima donna structure, a chamber of aesthetics, but to mould the new contingent with the old. In his 1996 Walter Neurath Memorial Lecture Serota pointed out that in the nineteenth century National Galleries became illustrated history books, tying the world of art together in didactic chronological sequences. After the Second World War, personal experience in the presence of art became paradigmatic. 'The best museums of the future,' Serota told his audience, soon after the Herzog & de Meuron design was first unveiled, 'will … seek to promote different modes and levels of "interpretation" by subtle juxtapositions of "experience". Some rooms and works will be fixed, the pole star around which others will turn.'[13]

The galleries executed by Herzog & de Meuron embody this weave of permanent and temporary, of major and minor, allowing visitors to choose between individual works and grand curatorial themes. Perhaps it is a peccadillo or modest eccentricity but the Tate's self-description as a Gallery

rather than a Museum suggests that its primary raison d'être is to exhibit art, rather than cataloguing, restoring and then locking it up. (At Tate Modern, storage is in fact in a separate depot elsewhere in Southwark.) Serota's lecture praised the placement of art in non-traditional places, the invitation, for instance, to artists to install work in secondary spaces within existing institutions or to colonise spaces not traditionally associated with fine art, spaces like the demobbed army sheds re-used by the sculptor Donald Judd in Marfa, Texas.

Hours from the nearest city or airport, Marfa is now a place of pilgrimage for artists, curators and architects from all over the world, a paradigm of Minimalism and site as lauded by Craig-Martin. Serota emphasises the elegance of Judd's presentation and the importance of time or duration for meaningful visits: 'from this example, lessons have been learned with regard for the need in museums for places of prolonged concentration and contemplation'. The new interior architecture of Tate Modern needs therefore to be both flexible and tranquil so that art and very many visitors

13 Nicholas Serota, *Experience or Interpretation, The Dilemma of Museums of Modern Art*, Thames and Hudson, London 1996

can calmly co-exist. To judge from visits before work had actually been installed, the firm spaciousness of the galleries augurs well for multiple art uses while the turbine hall provides a unique challenge and stimulus to artists working at an urban scale.

Tate Modern now has its own Director to run things. He is Lars Nittve, former head of the Louisiana Museum north of Copenhagen. At a MoMA symposium in late 1996, Nittve outlined his personal views of the contemporary museum. Dwelling upon the need for engagement between artists and the public, he argued for architectural conversion where one could 'spend less energy on façade and shape of the building and put much more energy into the interior'. 'The museum is there,' Nittve explained, 'in order to create a kind of ideal meeting point between an audience and an artist's work.'[14] Among the public attractions that Tate Modern plans to cultivate are the terraces and gardens, offering many possibilities for sculpture, and the three oil tanks hidden beneath the south terraces, a mysterious industrial monument that may shock received notions of public space.

14 Lars Nittve, 'Pocantico Conference: Building the Future', *Imagining the Future of the Museum of Modern Art*, Museum of Modern Art, New York 1998

'I also think,' Nittve told his New York audience, 'that the museum [isn't] only … about physical space.' A museum for the twenty-first century must have capacity for the electronic and the virtual which one can only imagine as the new century begins. In the future, it seems, Tate Modern might function as much like a TV Channel or franchise operation as any traditional museum. This is the way many artists are thinking. The great value of Tate Modern is that it possesses certain built-in tolerances allowing for artistic unpredictability. With its engineering and support services secreted behind walls and ceilings, what is truly essential at Tate Modern is not architectural display but the functions and events that that architecture serves or inspires. Like a city, it is much more than a static architectural structure.

If Herzog & de Meuron's 'light beam' is the signifier of Tate Modern, the architects have not forgotten that what is signified is the energy of ideas and emotions within. These things are not quantifiable. By its very nature, Tate Modern is a site of constant experimentation.

CONVERSATION
JACQUES HERZOG, NICHOLAS SEROTA AND ROWAN MOORE
AUGUST 1999

ROWAN MOORE I want to talk about what the gallery is as a public phenomenon. In conceiving of the project do you see it as playing a symbolic role and being a public space for London or does it start with the art?

NICHOLAS SEROTA The choice of the site was motivated by two considerations. One was what we thought Bankside would yield as a space to show art. But the choice of location was undoubtedly engendered in part by the recognition that creating a great museum of modern art in the centre of a city does create a public space and a public attraction. Britain is not organised in the way France is organised. It is not a great public project, an initiative by government. It is an initiative taken by a small group of people whose powers are limited, but one of the powers that we did have was to try and put it on a site where it would have a public presence and in a part of the city where its arrival would make a difference.

JACQUES HERZOG The very ingenious thing in terms of urbanism that Nick and only he saw was that Bankside was an incredible chance, which for some unbelievable reason was not discovered before. Now that everything is happening everybody understands. The choice of Bankside was almost an act of urbanism to which we as architects didn't contribute anything. The only thing we could then contribute was trying to understand what the location is and to try to develop it very logically according to connecting paths and lines, the river, the bridge, the situation with St Paul's.

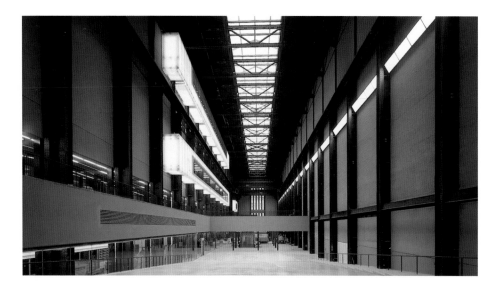

We conceived the building as something permeable, something you walk through, and as something that literally attracts people, a public plaza. And the turbine hall was the obvious place to make that connection between the outside and the inside, the galleries, the people, the art – and everything comes from that idea.

NICHOLAS SEROTA Herzog & de Meuron realised that the turbine hall was essentially a street that ran through the building and that it had both a north façade and a south façade, formed not just by the building we are developing at present but also the building that will be developed over the next five years using the switch house and the oil tanks.

ROWAN MOORE So are the most important decisions to do with leaving it alone and putting the doors in the right place?

JACQUES HERZOG I think the ramp was very important. We still don't know if it will work; we'll have the answer soon. The success of that space has to do with how art, people, the shop and so on go together, and this has a lot to do with proportions and how you go down the ramp and under the bridge and how the stairway goes up. In the end everyone will think that it's all self-evident and that it can only be like this but in fact it's difficult to achieve.

NICHOLAS SEROTA But the bold move on the turbine hall was to take out the decking that formed a floor at ground level. It was bold because it meant that we were losing the possibility of creating a basement space below that floor, that is to say giving up a huge

 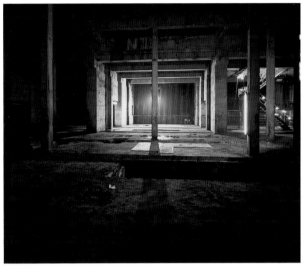

volume where conventionally people might have put an auditorium or a black box space or whatever. The benefit of giving it up was that as the visitor comes down to that lowest level they see to the north of them the whole of the façade of the museum and they can immediately apprehend the configuration of the building: shops, restaurant, education, galleries 1, 2, 3 – they can see where it all is. The other benefit which will only become apparent when we build the second half of the building is that when you come down the ramp you will look to the right and see to the south a space below the ground level which is nevertheless lit by natural light

ROWAN MOORE the oil tanks

NICHOLAS SEROTA the oil tanks and the space that leads to the oil tanks. There is a space there that will create a connecting art gallery that is the size of the South Duveen gallery at Millbank and of very similar proportions. It will be a very, very dramatic experience to come down this ramp and have these two possibilities on either side of you.

JACQUES HERZOG It also has to do with our idea that when you come into the museum nothing should be lower and nothing should be higher in status. We wanted people to be in front of the north and south façade and to give different

areas equal importance. We have three gallery floors that are all of equal height. We also have an opportunity for the curators to have all kinds of art on every floor and to have equal access to the centre.

NICHOLAS SEROTA That flows from a belief on our part that we shouldn't be establishing hierarchies in the media that are shown in the gallery. What we have tried to do is to create a series of rooms that can be used for any medium. When I take people to the building they sometimes express surprise that they'll be looking at drawings in a five metre high room. I find myself saying you can never really have too much space above your head. Also it's no longer true that drawings are always in standard imperial sizes and hung in a line. Artists are working in drawing in all kinds of ways at present.

ROWAN MOORE 'You can never have too much space above your head': that could be the motto for the building.

NICHOLAS SEROTA Unfortunately we don't own the Steve McQueen video that is called *The space above my head*!

One of the things that was attractive about Herzog & de Meuron's competition design was that it had a very simple logic to it. What we have been trying to do through this whole process is to ask the big questions and then work towards the smaller questions so that the parts fit within the whole. So the big moves are to do with how the museum fits within

the larger urban configuration, how you move through the building, how you move from gallery to gallery and then you fit all the smaller parts within that.

JACQUES HERZOG You also have to give a clear orientation because it's going to be such a big museum that you would feel lost if somewhere at your back or somewhere up there there's something you don't know about. I think that when you come in almost everyone immediately understands how the building is structured. You can almost physically show that, like in a landscape.

NICHOLAS SEROTA But then the spatial organisation within the building is also given by certain characteristics of the building as designed by Scott. So for instance the great windows of the north face, because we wanted to have as much natural light as possible in the galleries, start to generate decisions about where the galleries should be and at what level.

JACQUES HERZOG The symmetry of Scott's building is something we had to deal with which I think we all felt sometimes was a bit too heavy. But because the building is so big the symmetry helps. And there are many areas where the symmetry is broken, like the bay windows and the ramp. This balances without destroying the symmetry.

NICHOLAS SEROTA The gallery plans are not symmetrical. And even though there is a constant ceiling height, rooms will have a very different atmosphere according to their shape and size, so that even within a relatively fixed number of possibilities you end up with a wide variety of spaces.

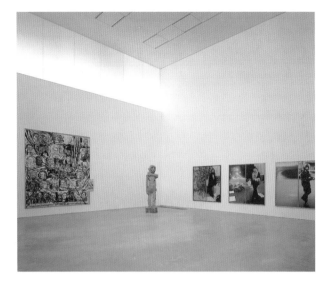

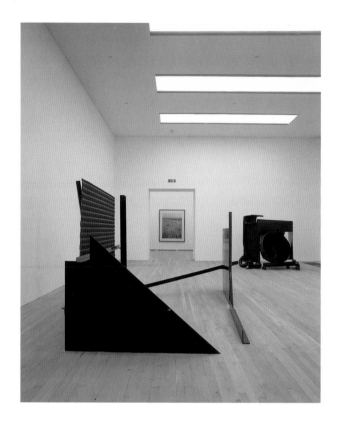

ROWAN MOORE You're describing it almost as a giant rack in a warehouse where you pull out the different kinds of space for different kinds of art. This sounds non-specific but it's clearly not a non-specific building.

JACQUES HERZOG I wouldn't say it's like a rack. In gallery design there are always two different poles: there's the highly specific gallery which usually tends to be too spectacular, too sculptural, too individualistic, and on the other hand there is the supermarket. The supermarket has been developed to give a good orientation to put everything in the same light. We have tried to take the best things from the supermarket and also the best things from something very specific. So Tate Modern has both aspects. It should give you a very attractive feeling where space is changing, where we go from one work of art to another. The works of art also change the space again.

NICHOLAS SEROTA There was a wish to create a series of rooms in which each would have a definite character but once hung with art it would be the art that came to the fore. Although there will be rooms that are breathtakingly beautiful.

ROWAN MOORE At issue here are the egos or the aspirations of artists and architects, which is always one of the biggest issues with museums. When you talk to artists their idea of a really good gallery is often one in which the architect's work is almost invisible, which wouldn't be an architect's view of a good building.

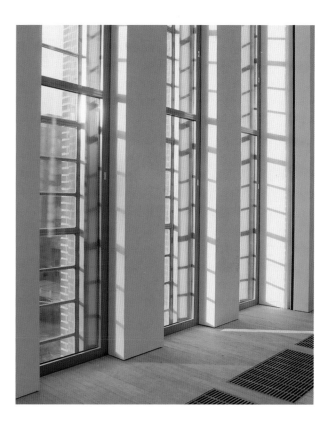

NICHOLAS SEROTA There are different forms of intrusion, aren't there? It's not just a question of making a room as neutral or as minimal as possible because that can create a tyranny of perfection. There were moments at which we've been trying to recognise that even though we were creating entirely new galleries they lay within Giles Gilbert Scott's building, which had a certain rigour and also an industrial character. For example we had a long debate about what sort of air conditioning we should be using and came to the conclusion that we would use a low-velocity system that involved creating holes in the floor through which the air would rise, and then Jacques and Harry [Gugger] designed a cast iron grille that was a response to the fact that this was originally an industrial building. Or for instance where we were having wooden floors we decided not to have the conventional perfectly smooth or polished gallery floor but have something rougher than that. So the building is not so perfect that as soon as you put a handmade work of art in it it looks too crafted. Works of art that are made by hand don't fit comfortably in buildings that feel as though they are machines.

JACQUES HERZOG I truly think that these are among the most beautiful galleries in the world. It was the most difficult thing to make the galleries very sober, very neutral, very simple, very clear and at the same time to avoid the

boring minimalism which is all too perfect. It helps that we don't have the money to make it all too refined.

NICHOLAS SEROTA One of the reasons we chose Herzog & de Meuron was that they respond to the particular circumstances of an individual commission, as you find on the grilles, or the handrails or the way the treads work on the stairs. When you first look at those solutions you could almost believe that they were part of the original power station except that they are too refined for Giles Gilbert Scott. You have this sense that the architects have looked at the building and tried to interpret in a contemporary manner a solution that might have been conceived fifty years ago. Not in a retro sense, but in some way they create a bridge between the old and the new.

ROWAN MOORE What is the virtue in doing that rather than a sharp contrast of, say, the Sackler Galleries at the Royal Academy, where you have the crumbly old building and the absolutely perfect new building?

NICHOLAS SEROTA The virtue is that you don't glamorise heritage. The turbine hall is still a quasi-industrial space but you don't walk in there and think of it as a heritage object, whereas when you climb up the space between Burlington House and the Sackler Galleries you are very conscious of an appeal to history.

JACQUES HERZOG Our job is not to say clearly 'this is our intervention' but to create a museum for the twenty-first century where everything works. In some areas it's better not to expose any new materials rather than the old ones because who would be interested in that?

We discovered that in many areas using existing materials was just giving better results, whereas in other areas you can clearly see that, for example, the glass light beam is obviously a crisp new element of our time.

ROWAN MOORE Is that partly because the Scott building is not an object of veneration in the way some historic buildings are? It has a kind of ordinariness about it.

NICHOLAS SEROTA It's certainly a very workmanlike building but it also had only one distinctive architectural space, namely the turbine hall.

JACQUES HERZOG We found out step by step where we should hold back and where we should be more pushy, more aggressive. That had nothing to do with more or less respect for the existing building but only what will be the final result. We treated the Scott building like part of our own structure, not something which is worse or different.

ROWAN MOORE You talked about this invisible site which is being made visible by putting the Tate there. The obvious architectural manoeuvre would be to put in a large new architectural object with a curious shape to draw attention to this invisible place, yet of all the architects in the competition you proposed the least external intervention.

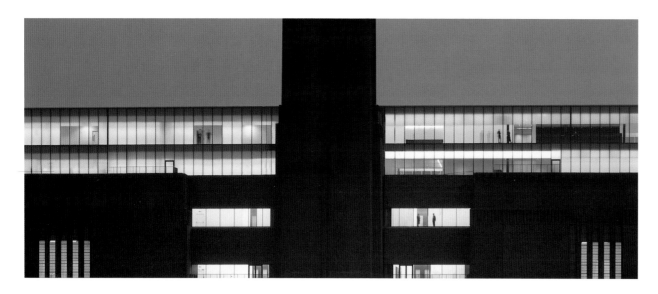

JACQUES HERZOG We looked at the gallery from the inside and thought what could be better than the existing windows. The strong symmetry was more of a concern than adding a feature, so we did several things with the tower and the light beam. If you look at the building you could see that the symmetry is a fake symmetry and the light beam disbalances it because it doesn't go the full length on one side. And we knew that when we built it the light beam would be such a strong feature, because when you build something in reality it is always more powerful than the drawings. So many architects tend to do more than is needed to be visible in reality. Once the light beam is lit it will be very, very powerful in combination with the tower.

NICHOLAS SEROTA An ambition for the Tate was literally to open to a large public a building that had previously been closed. With a very simple gesture Herzog & de Meuron somehow released some of the potential of Scott's box and opened it to the public, whereas some of the other competition entries set out to mask the box or deal with perceived inadequacies of the box. Herzog & de Meuron saw that one simply had to twist it in a way that realised that potential.

ROWAN MOORE I can't imagine a new gallery of that size with those sizes of spaces by any living architect being anything other than oppressive. You would have the mind of that architect present in every part of the building. So was it helpful that there were decisions made for you by the existing building, for example that the windows were there?

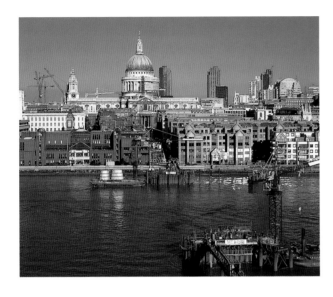

JACQUES HERZOG That suggests that we are happy if someone does something for us.

ROWAN MOORE The fact that they are there closes down some options and gives you some kind of framework.

JACQUES HERZOG Those cathedral windows are the best kinds of windows to have. You get light from the side which goes from the floor to the ceiling which opens in this case onto wonderful views of the City of London. Any other opening to the façade would have been stupid.

NICHOLAS SEROTA It's certainly true that, had it been a product of a single architectural practice – even Jacques and Harry and Pierre – if it had been a single language throughout as you have in the Pompidou or in the Getty, that single note could become too dominant in terms of then being a receptacle for many different kinds of art. To that extent the incorporation of parts of the old building has been helpful in creating a certain tension.

ROWAN MOORE In using the power station is there any conscious attempt to make a connection with the past, with history?

NICHOLAS SEROTA The fact that the building was designed mid-century and the new purpose was to show the art of that century and the next was certainly a nice play for us.

JACQUES HERZOG I always looked at the building as being older than mid-century. For me, being from outside the country, the fact that it's a brick building and that it's a very English building makes it very interesting. It couldn't be in

Paris or New York. And when you talk about the political role of museums it's very good that the Tate has such an English building even if it's for a very international audience, even if it's transformed by Swiss architects and it contains international art. In the same way the Pompidou Centre is a very French building.

ROWAN MOORE Some people have made a connection between the power station and various twentieth-century works of art that are inspired by industrial things – either Caro's or Serra's use of industrial materials or Duchamp and the readymade. Is it too simplistic to say the building is a vast version of that kind of art? Is that a meaningful connection?

JACQUES HERZOG I think for Nick that was an important aspect. For me it's very interesting to deal with an existing structure because in the future we will have to deal with existing structures in Europe. You cannot always start from scratch. So unlike many people who criticise us because they think the twenty-first century should be expressed in something glamorous and very unique I think it's interesting to show that the world is not just one idea and there are many things which need to come together to make a very complex thing. I think this museum is a very contemporary concept because it uses old structure.

NICHOLAS SEROTA It includes the past not in the sense of venerating heritage. It's not a Victorian warehouse where we have simply painted all the iron columns red. It's about using the fabric and giving it new purpose and new life. Also, we are building this museum for something like two-thirds of the cost of a new building. We set ourselves

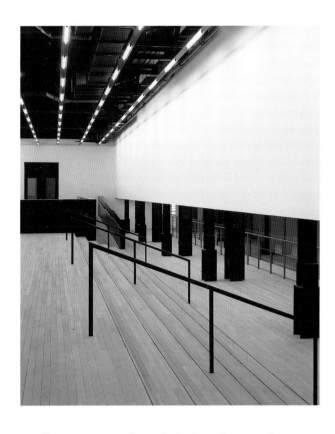

the very challenging task of creating these galleries at significantly below the cost for a conventional gallery and that has put a very considerable squeeze on the amount of, as it were, architecture.

ROWAN MOORE Was the budget a constructive pressure?

NICHOLAS SEROTA Broadly speaking it has been constructive but there have been some painful moments. If we had had more money there would have been greater complexity of the volumes. There would have been some intervening mezzanines so there would have been connections between the floors that would have been more sophisticated and more complex, so the visitor coming back again and again would have had a richer experience. You still see some hint of that in the balconies that overlook the turbine hall.

ROWAN MOORE Was the limit on the budget set by the Millennium Commission's maximum grant of £50m?

NICHOLAS SEROTA The limit was to conceive of a scheme which, once we knew that the maximum sum from the lottery would be £50m, would still be realised. Which meant we had to raise another £80m from other sources to make a total of £130m. We could have set the target of raising another £100m but that might have stretched the bounds of credibility.

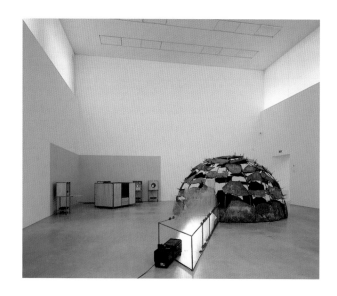

ROWAN MOORE At first sight the gallery spaces look quite like other art spaces. Would you say they are made special by their finishes, or what?

NICHOLAS SEROTA Some people, but not artists and not those who can see the subtleties, will regard them as rather conservative spaces. They don't have some of the visual pyrotechnics you get for example in Bilbao, but I challenge anyone to go into some of the double-height spaces and not have their breath taken away. And I hope that they will also be able to look at the art in that context whereas when you have pyrotechnics the art looks all too insignificant.

ROWAN MOORE In developing the galleries, did you consider every contemporary artform you could conceive of, from giant steel sculptures to video installation?

NICHOLAS SEROTA There was a presumption that we were going to build huge galleries for very large works of art and that artists would have to pump up their work to fill the galleries. I fear that if the building is criticised now it will be because the galleries are not large enough, but it was a very conscious wish on our part that when people were confronted with the art of the twentieth and twenty-first centuries they saw it from close to, in spaces that were of a human dimension, rather than entering vast halls where at the

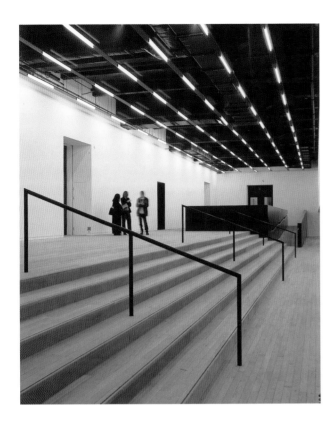

far end there was Frank Stella or an Andy Warhol reduced to the size of a postage stamp. Probably there will also be other spaces within the building that will be naturally larger, like the oil tanks.

JACQUES HERZOG Also the exhibition area on Level 4 could be used as one big space. You can do amazing things with the building. You can do anything and you can experience all these different spaces. And if in one show the curator feels that he or she wants to use other kinds of spaces they could always use the concourses or other areas for special installations. The whole entrance area on the north façade behind the tower could be a very interesting space to show art in some special moment.

ROWAN MOORE In your work you talk about the play of ordinariness and strangeness. Tate Modern is an ordinary building but there's also something weird about it, both in the original building and the way you're dealing with it. What for you are the moves that bring out these qualities of ordinariness and strangeness?

JACQUES HERZOG It's very difficult for me to judge. I can only say that this building has something very ordinary, very typically London, and yet you only have to enter the building to see there is something absolutely extraordinary about it. We certainly like that double aspect.

ROWAN MOORE You sometimes talk about Alfred Hitchcock in relation to your work. There are in Hitchcock, and some contemporary art, things like fear and danger and the

sinister, which are things which architects usually try to exclude, as if they don't exist. Would you say that there is anything of that in your work?

JACQUES HERZOG I hope so because what I like in Hitchcock's work is that he describes normal people and shows that whatever is special or scary or beautiful comes out of these very normal situations. You only switch it or shift it a little and other things become visible beyond that first aspect of normality.

ROWAN MOORE Do you want people to be taken aback when they enter the building?

JACQUES HERZOG I always like things that don't bother me when I don't want them to. I like things which work, which are well done, which have shadow at the right moment, which are well lit, but where there is much more for those who want to discover it. Tate Modern has the ramp; it has the bridge, it has the height of the turbine hall, it has the vastness. It has the possibility just to walk through but also to see art. It has the wooden floor and the metal grille with which, if you look at them properly, you feel the proximity between them and the Scott building. It has the light beam which balances the tower but, if you don't want to see that, it's just a normal brick building which is just a little bigger than another one. It has all those things for those who want to discover it.

A Cézanne can look a little bit badly painted but if you want to look at it there is an enormous complexity and you just don't believe what is there. I believe that neither art nor architecture are here to entertain us but if you are interested it can be like a mountain. You know, a mountain is boring but if you look at it in a special way it can be amazing for you.

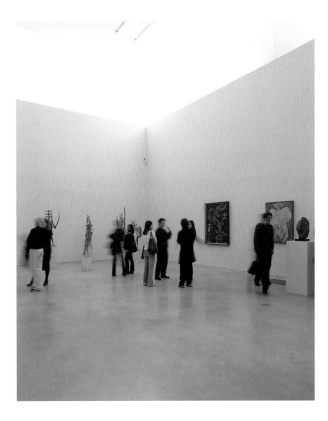
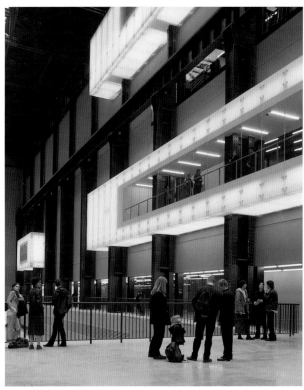

You can walk on it, you can discover the plants, the different shades, the different light. Everything is here for us to take or to leave and architecture or art which tries to capture your attention by having blue paint on its steel structure designed by I don't know who – all these things catching your attention are just boring. They are the most conventional thing you can imagine.

ROWAN MOORE But it's not a building that the visitor will feel is completely normal or will make you feel completely comfortable either.

NICHOLAS SEROTA It undoubtedly has a very profound physical and psychological impact as you approach it and enter it.

ROWAN MOORE It's not something you would drift into as you would into a shopping mall. It makes you change the way you walk.

NICHOLAS SEROTA There have been incidents introduced by the architect that undoubtedly heighten or reinforce that feeling: the constriction when you come in through the west entrance or in a different way from the north. There will be a feeling of compression and then release as you come into the turbine hall.

JACQUES HERZOG But it was never our intention to dwarf people. We are not longing for monumentalism. We hate monumentalism. Monumentalism doesn't mean something that is big but having a one and only goal, which is to impress and to manipulate people.

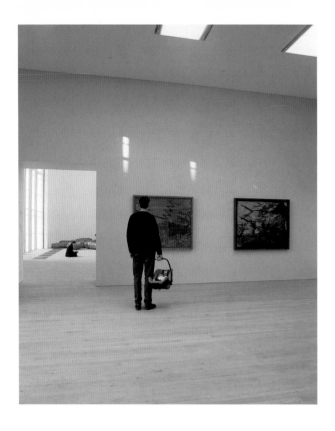

NICHOLAS SEROTA One of the things about a museum is that it is a public space but it is also a place in which people create their own personal space. One of the interesting experiences for a visitor to Tate Modern is going to be the combination of that sense of sharing experience as you move through the building, but also having your own intimate and individual relationship with a work of art or with a part of the building. I think you need that absence in certain parts of the building in order to give room for the mind to move. It's like a late Cézanne where not every part of the canvas is covered. Someone came in yesterday, looked at the turbine hall and said, 'You should fill those walls with all the reserve collection.' Well, it's not a warehouse, it's a museum. It's not a place of commerce but is different from the rest of the world. One of the dangers of the way in which museums have moved in the last twenty years is they have become more like the rest of the world, with the banners and the shops and the malls and so on.

JACQUES HERZOG The interesting thing is that the concept is almost that of the Galleria in Milan It is a grand space where people in the city can just walk in and walk through and have a coffee. But at the same time you should feel an atmosphere of art. It should not be like a station or a shopping mall.

ROWAN MOORE This brings back the issue of populism and being accessible which

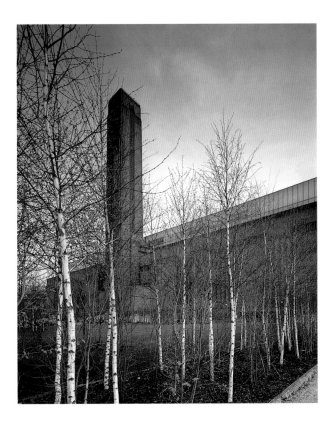

all galleries, rightly, have to be now. Tate Modern is not an obviously populist building like the Pompidou Centre. Would you say that the moves to make it accessible are to do with the planning of it? **NICHOLAS SEROTA** It's more to do with the programming and the way in which it addresses its publics, but the planning is certainly intended to make it a very easy building to use and not intimidating.

ROWAN MOORE From the outside it's still quite a challenging building. You have almost to brace up before you enter it.

JACQUES HERZOG That will change once the landscaping is done. Also once we have outdoor seating and the bridge you will approach it very naturally.

ROWAN MOORE Finally I'd like to come back to the issue of this being an industrial building. You have said that before you decided to go to Bankside you asked artists what spaces they wanted and you found that they tend to like industrial spaces

NICHOLAS SEROTA and yet we've created completely new, architect-designed exhibition spaces

ROWAN MOORE and that makes it sound as if it's the world's biggest loft or the world's biggest converted garage, and yet it isn't. It can't be a happened-upon exhibition space,

as you are a major institution. So what exactly is it? Is it a new kind of hybrid between a found art space and an institution?

JACQUES HERZOG Maybe it is a hybrid. It is a heterotopic place that, especially once the second stage is open, will have different sites that are expressing different ways of looking at the world. And that's it. If you look at the building from the outside it doesn't mean that everything on the inside has to be done in the same way. I guess that when the light beam is finished the light will shine out from the gallery windows and you will understand the life and the liveliness of the building.

NICHOLAS SEROTA The great potential at Tate Modern could be to make the Tate a less monolithic organisation, one that does things in only one way. The building could enable us to run fast or walk slowly, or act big or small.

The lesson I took from the artists was that they were looking for buildings with integrity: where when you saw a wall it was a wall rather than being a flimsy partition, where you accepted that there were rooms of given configurations that were sometimes awkward, but where you worked with those rather than having a supposedly infinitely flexible system; rooms where the wall met the floor, where there was sometimes light from above, sometimes from the side, where you wouldn't have the tyranny of the enfilade system of galleries with all the doors lined up, and so on.

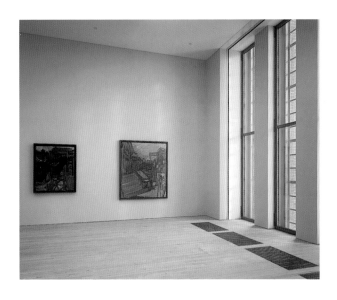

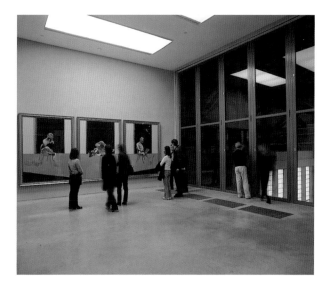

What you also have in most museums is a sense of artificiality about the space in which you're standing. In new buildings this can be induced when a whole range of considerations come into play, so the lighting engineer says we have to have absolutely even light falling on the wall from top to bottom and equal incidence of light on every wall. Well, first of all that's difficult to achieve and the only way you achieve it is by having lights in the ceiling in a very strange configuration so the ceiling becomes a very artificial surface and unlike any normal room. Secondly, if you take the room we're in now, the light is not the same on every wall and that doesn't disturb me. And if there were paintings on the wall I wouldn't be uncomfortable because I know that while that painting is less well lit than that one, it will change during the day. You accept that as part of the natural environment. We spent an immense amount of time trying to simplify the ceilings so that the ceiling of the gallery is not so different from the ceiling of the room you are normally in.

ROWAN MOORE So you are creating artificial rooms in the sense that they are completely constructed, new space, but you have to use a higher level of artifice to recover their normality.

JACQUES HERZOG Yes, artificial normality.

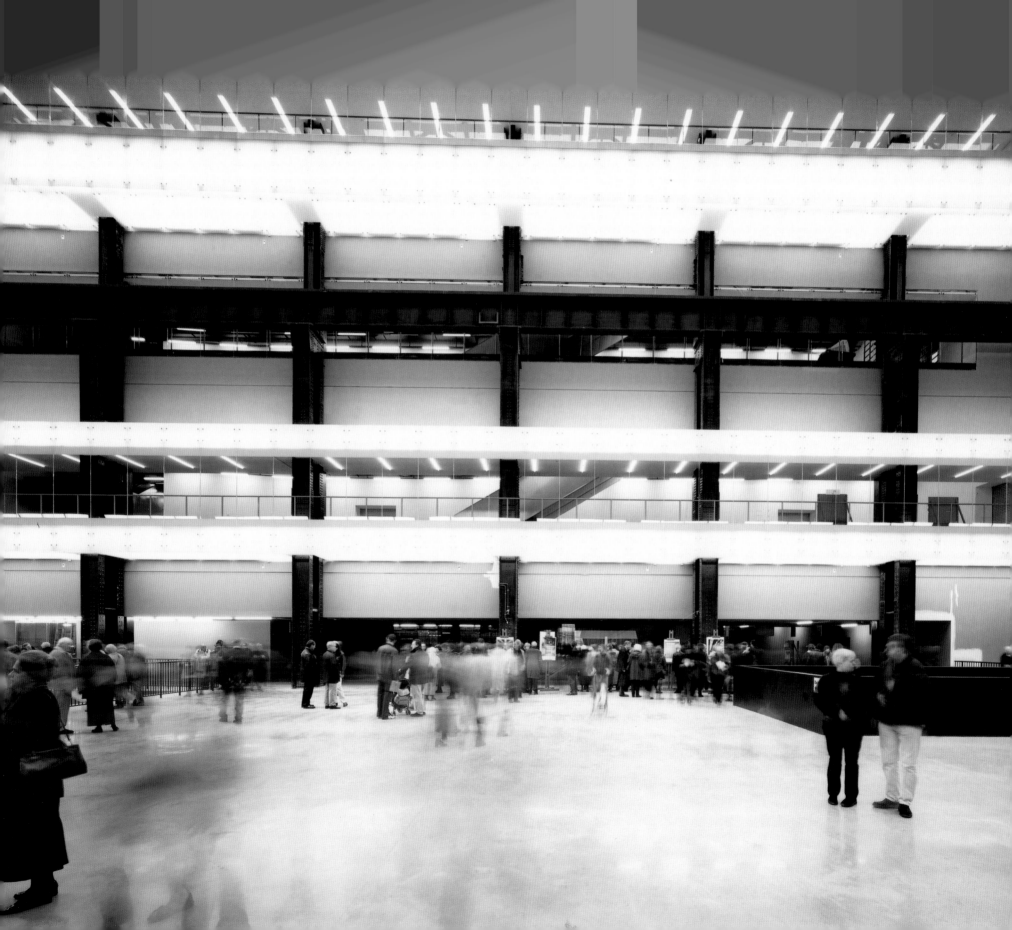

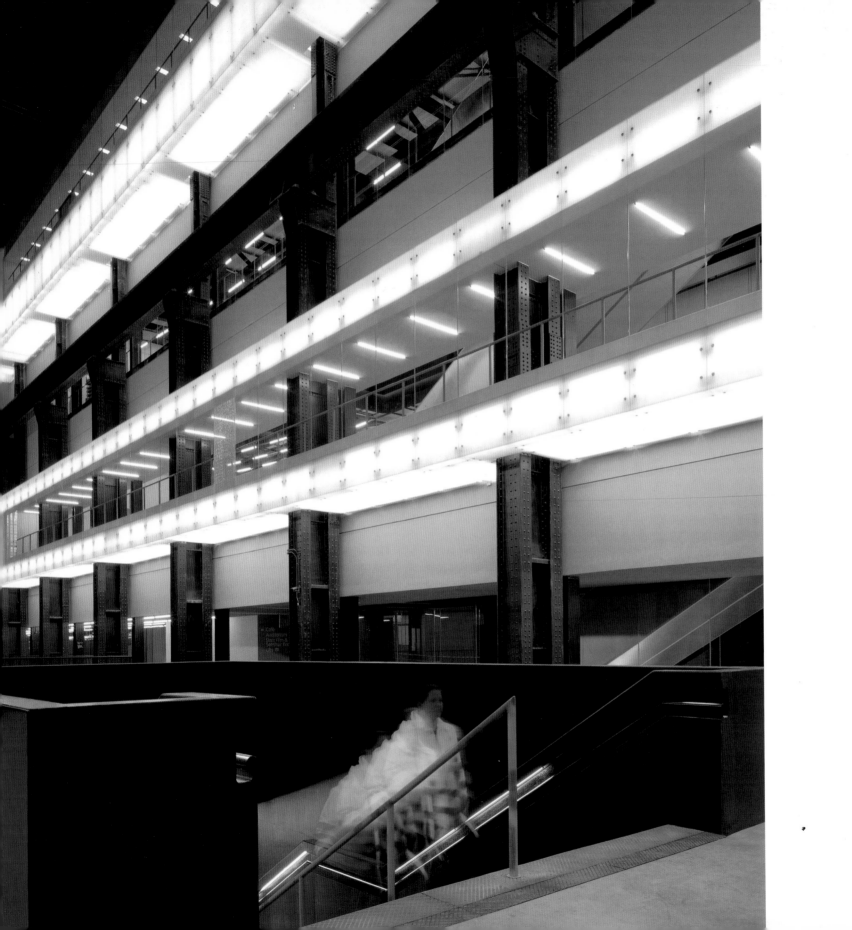

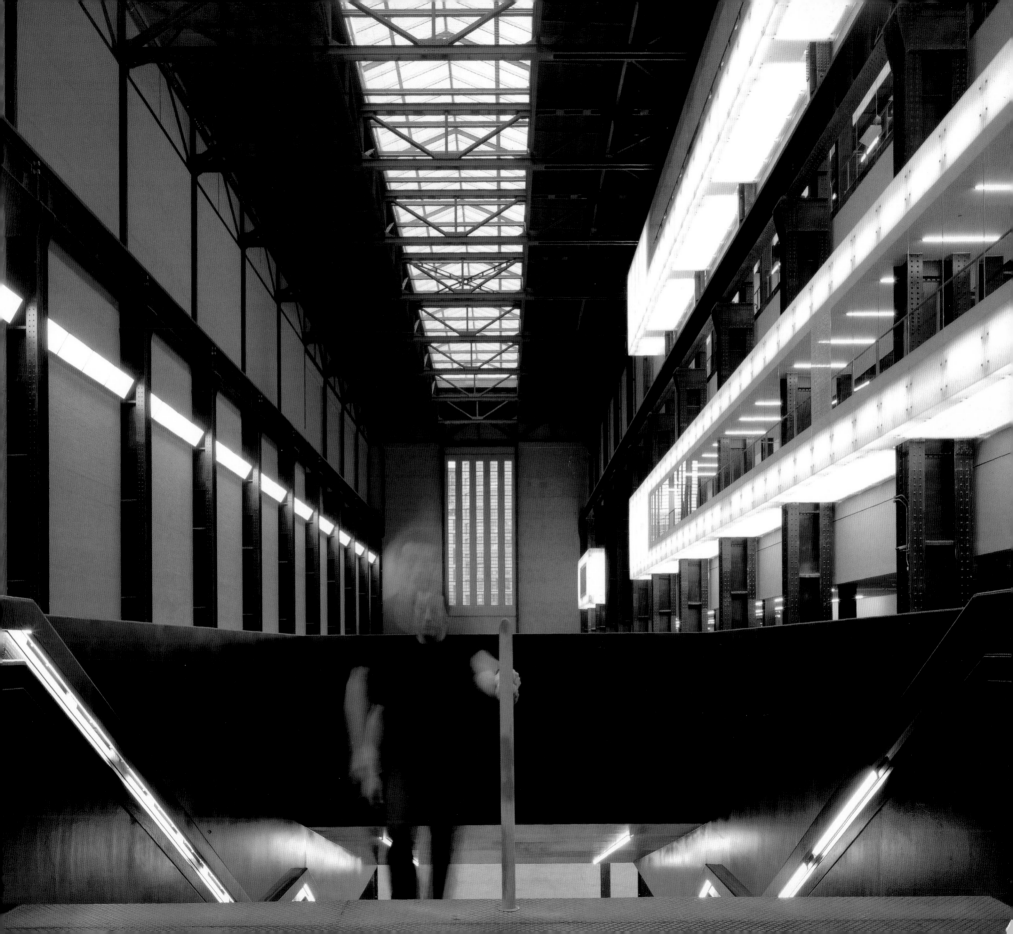

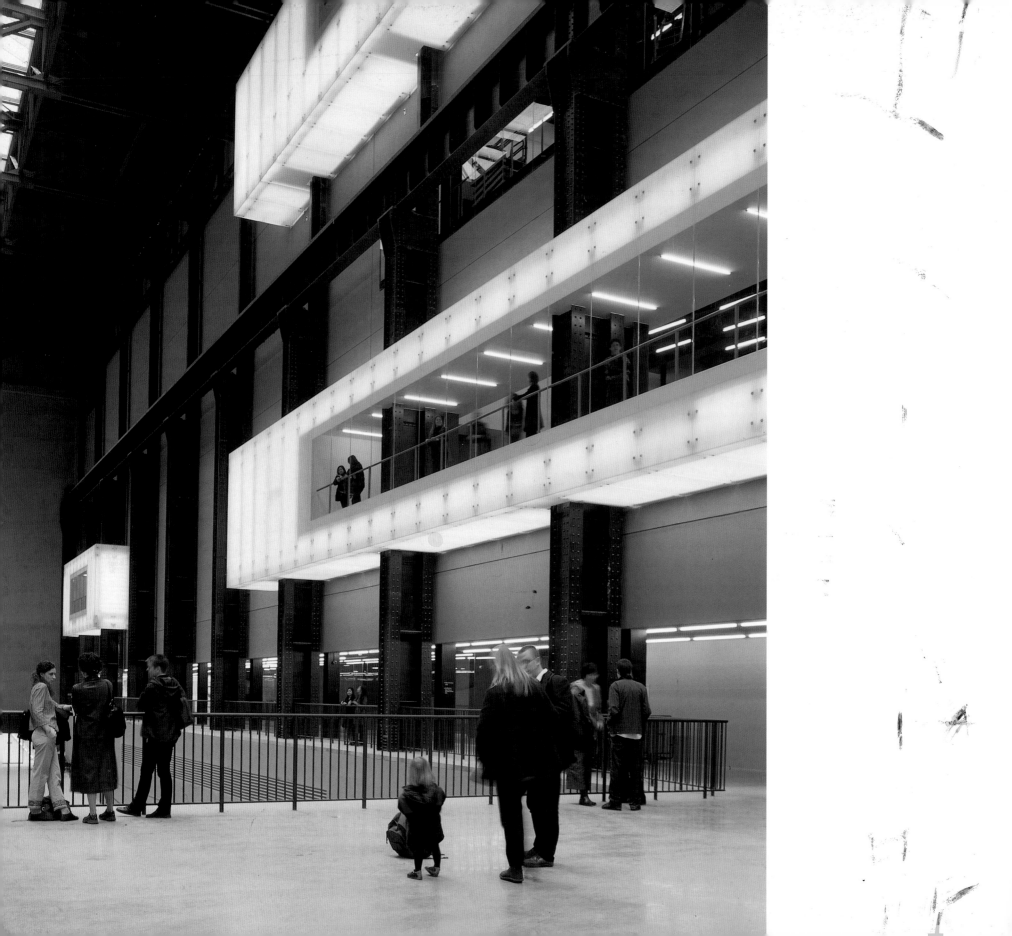

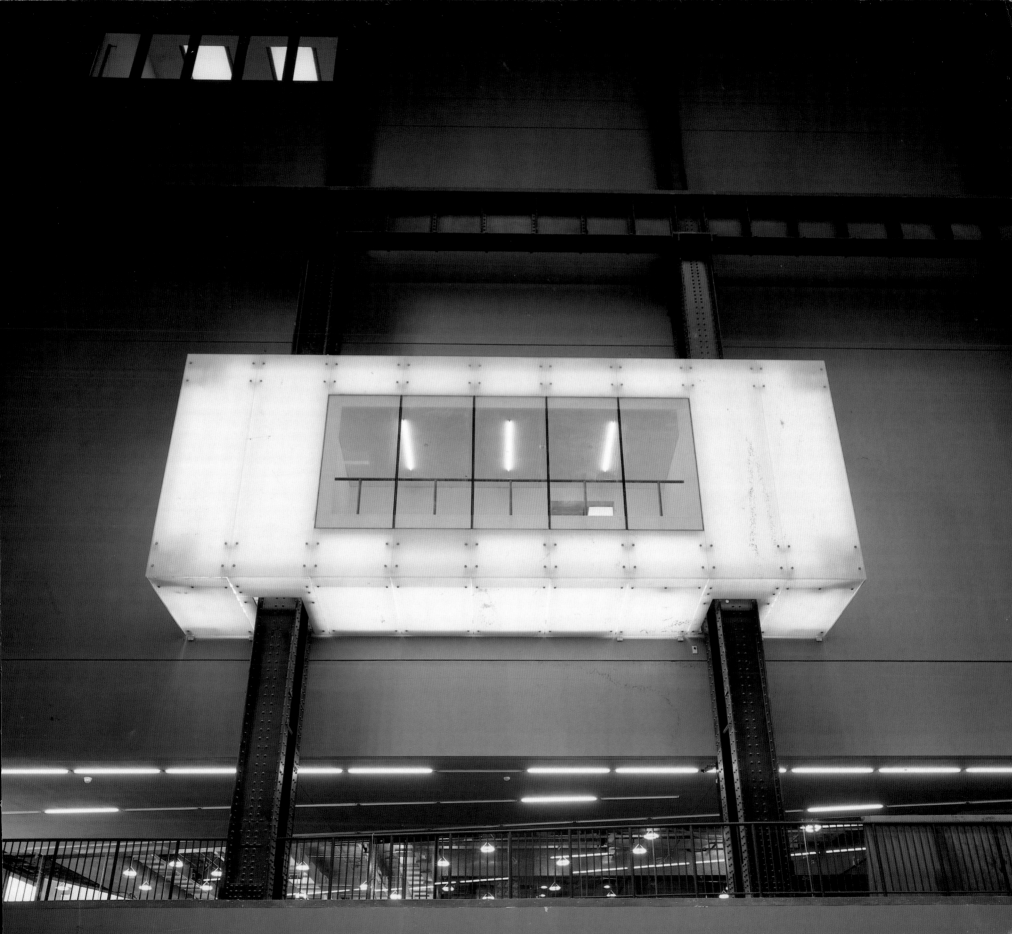

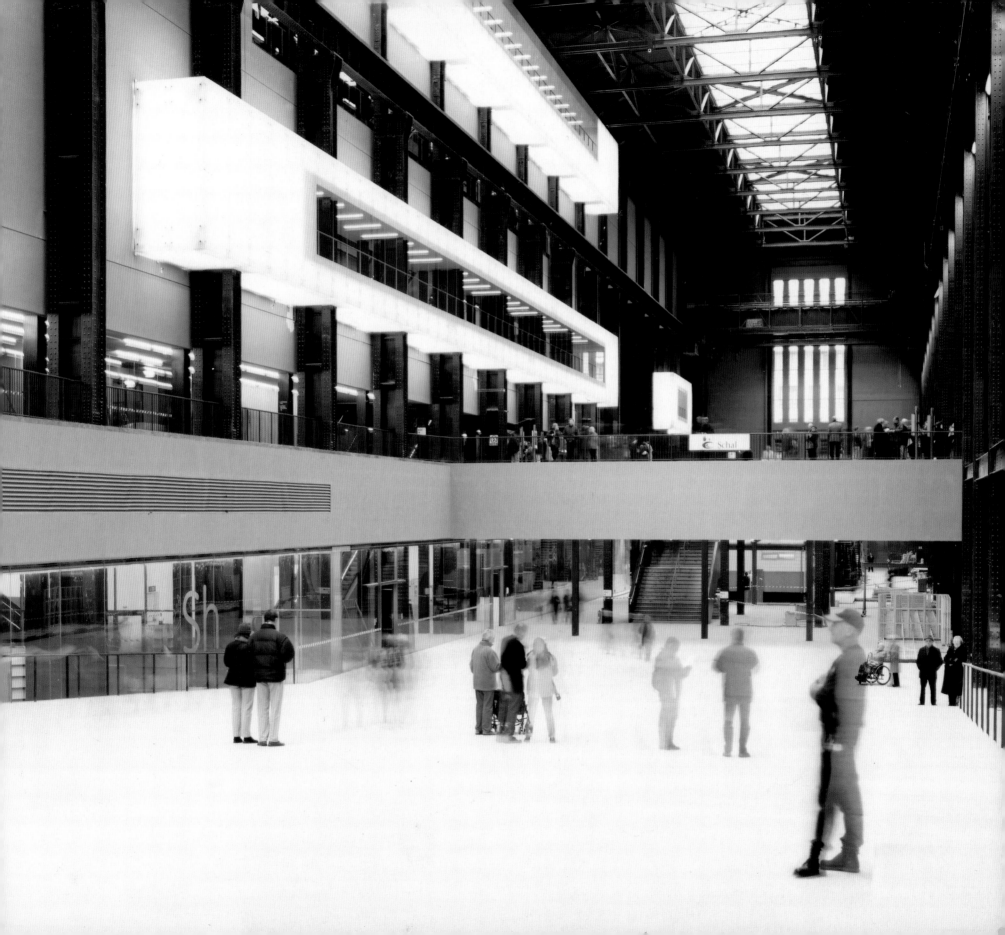

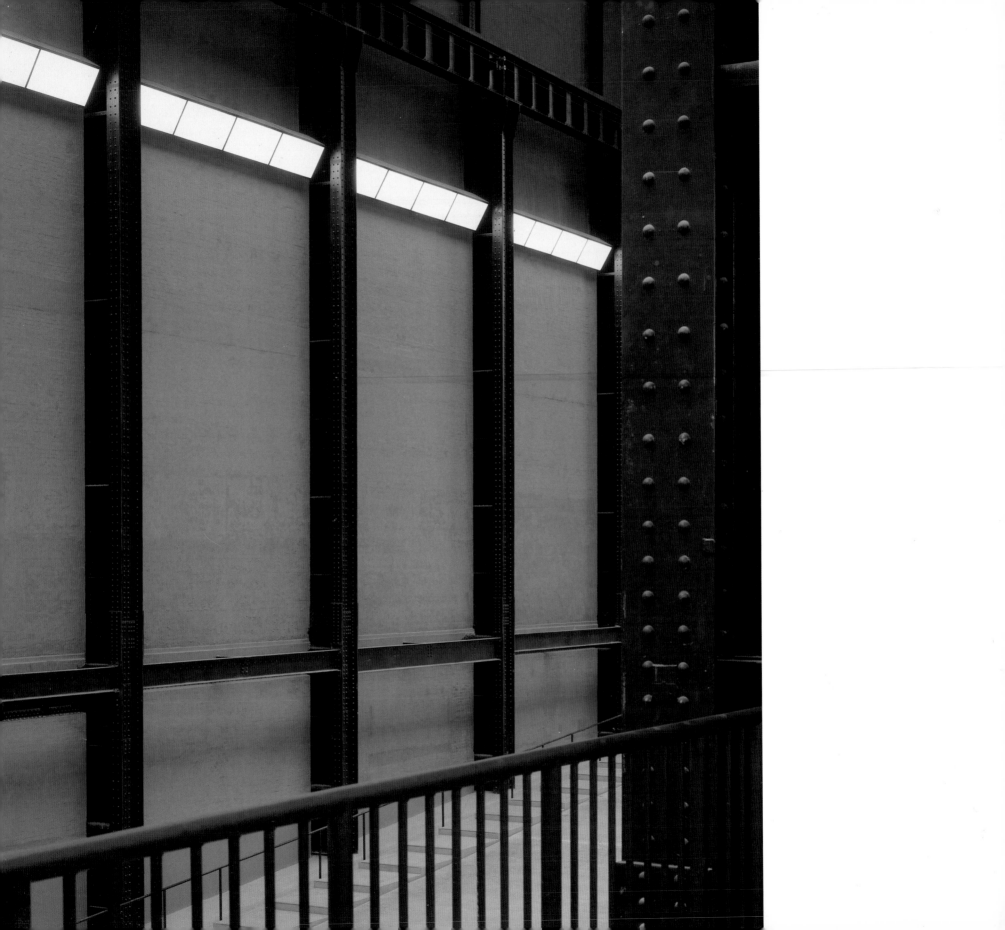

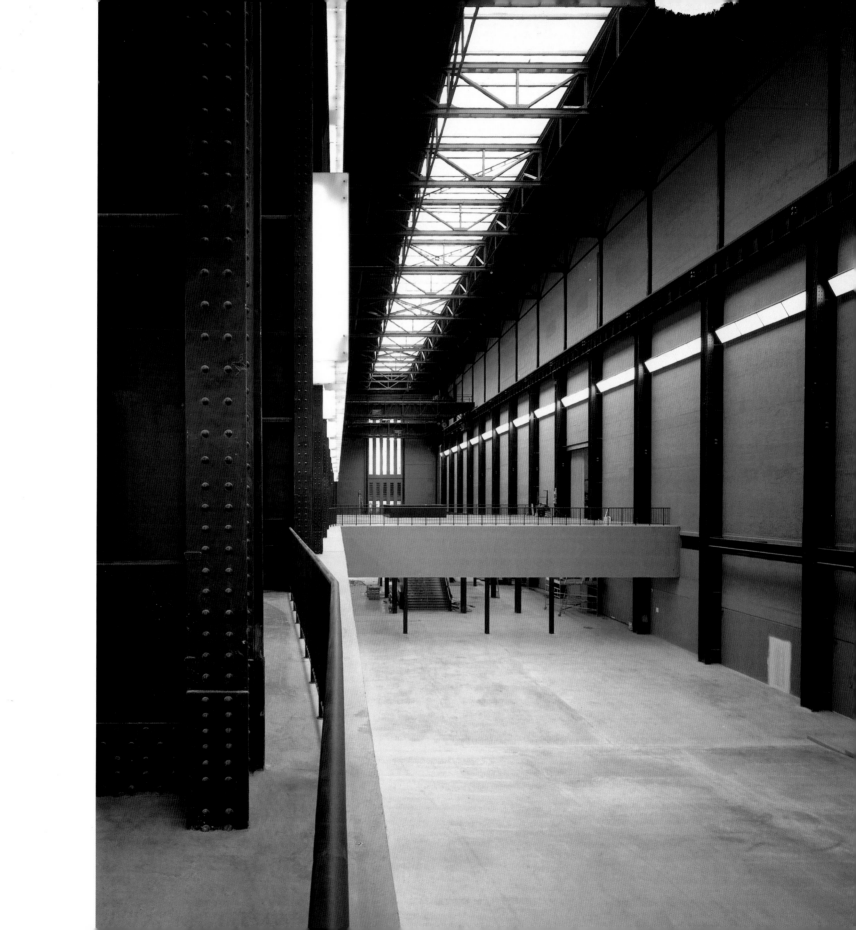

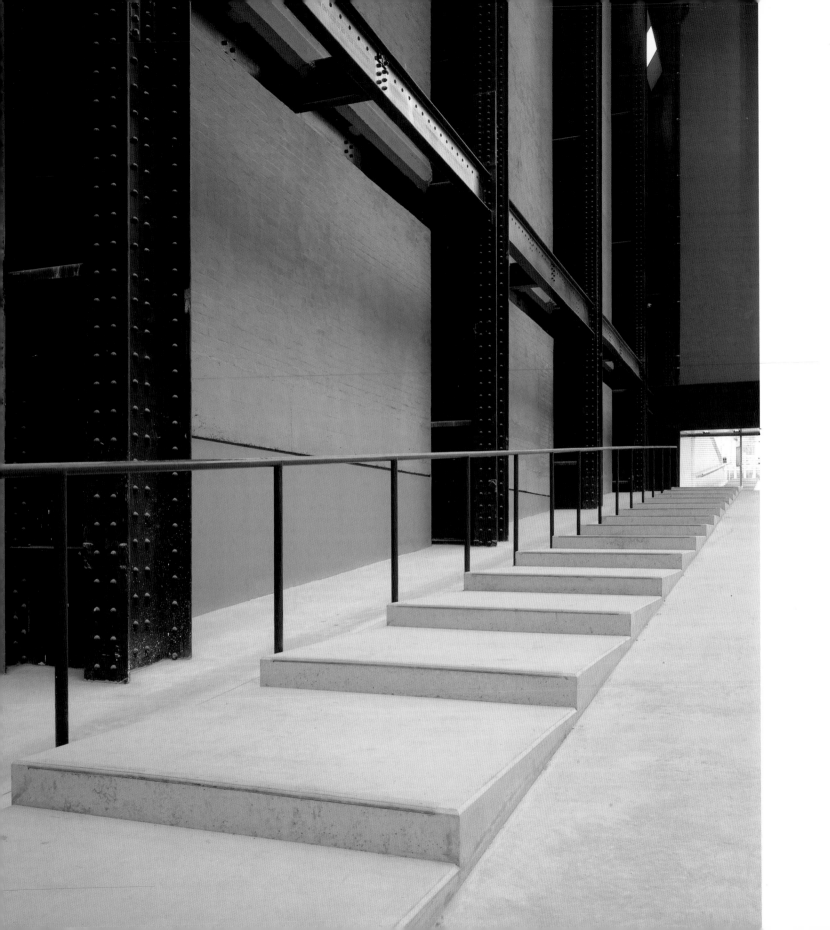

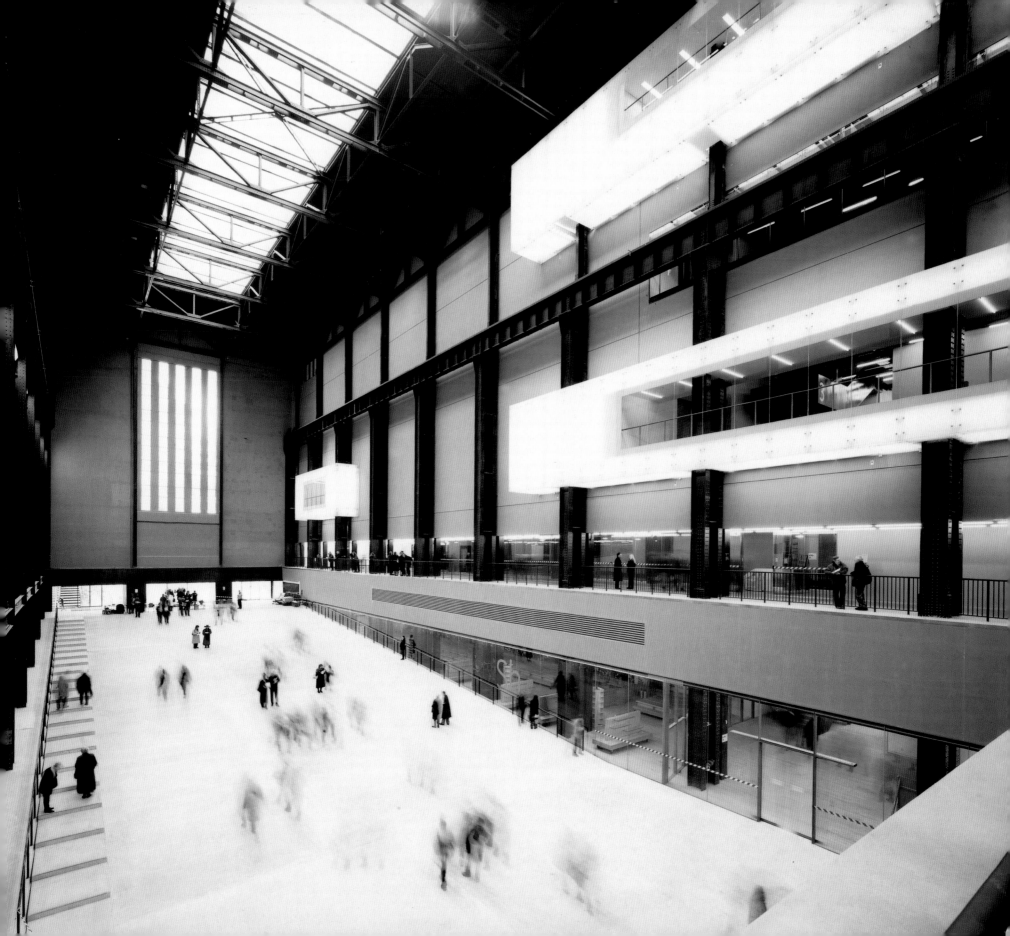

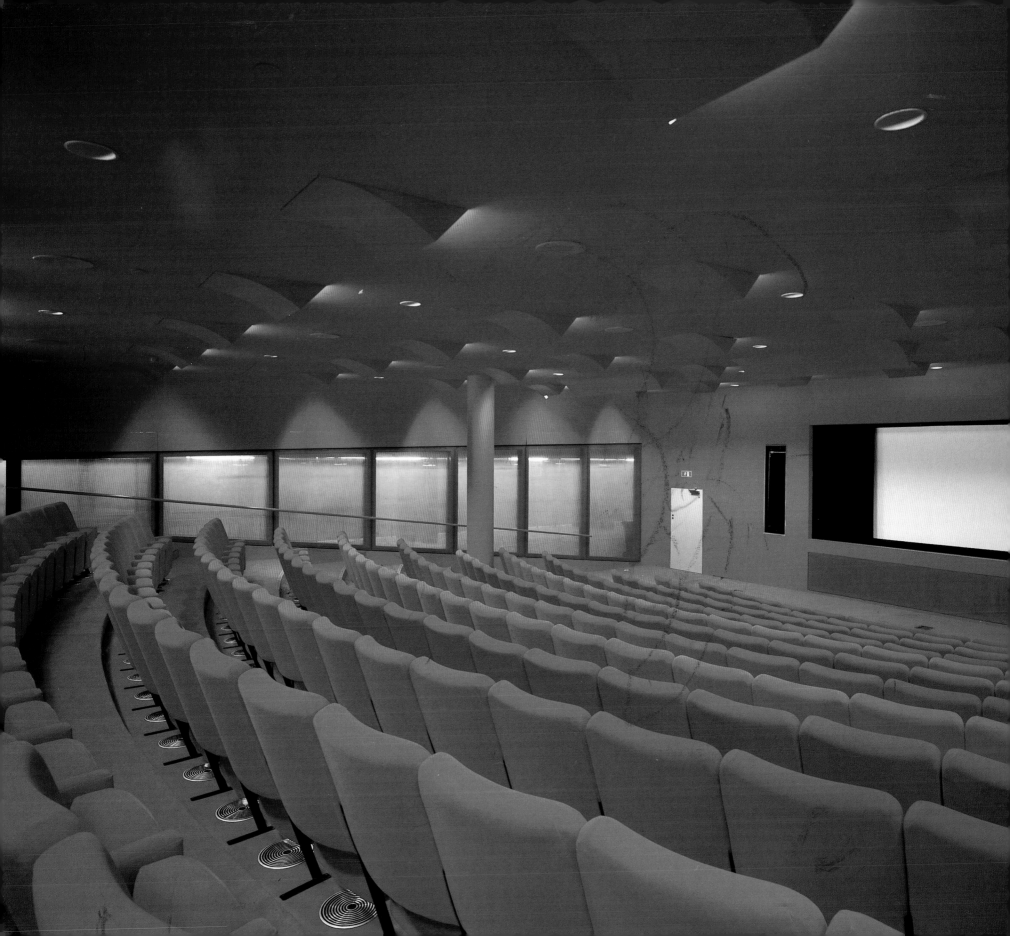

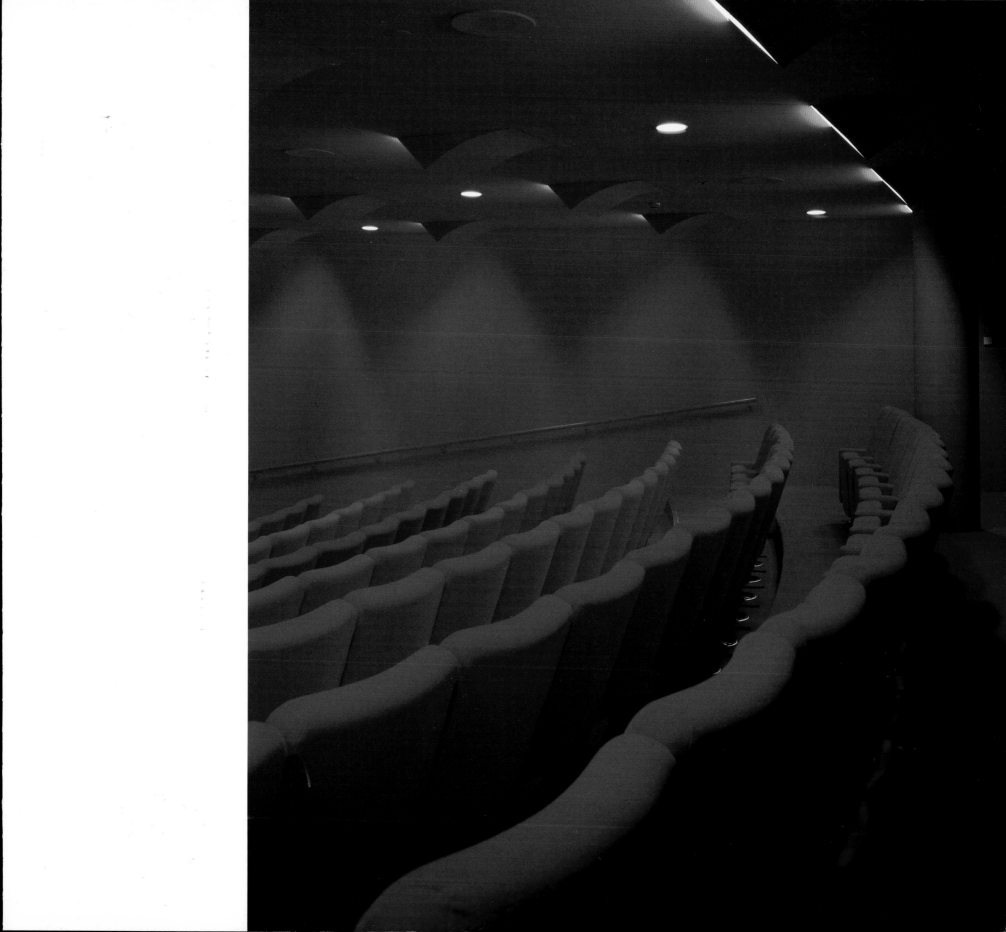

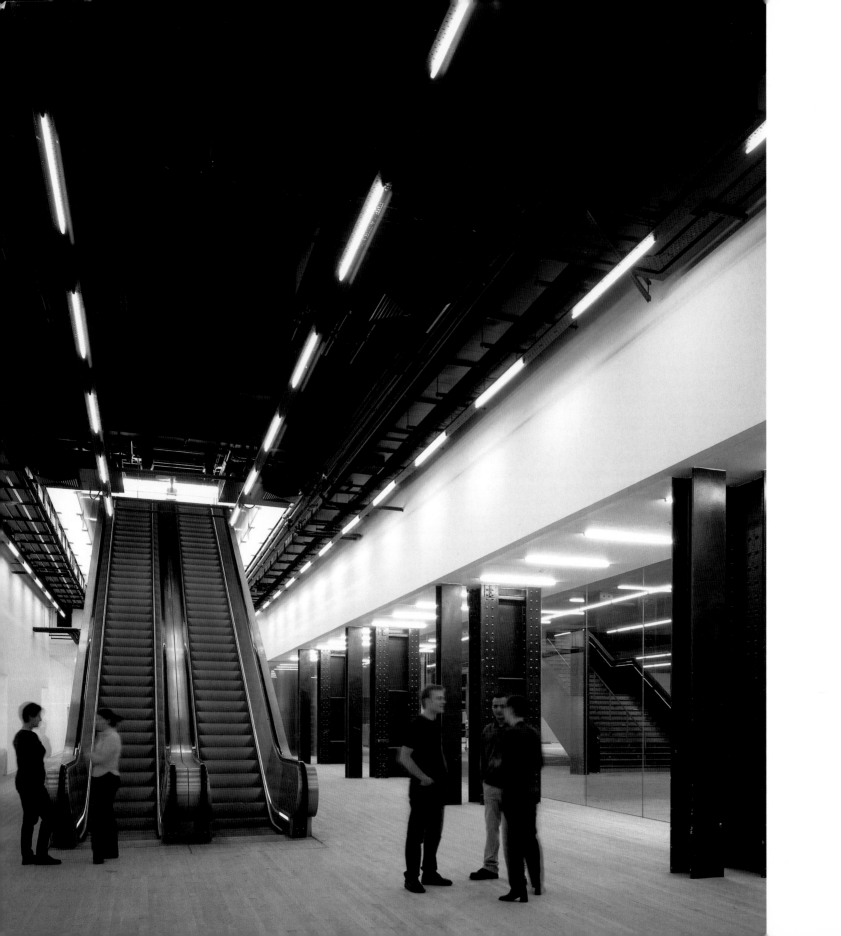

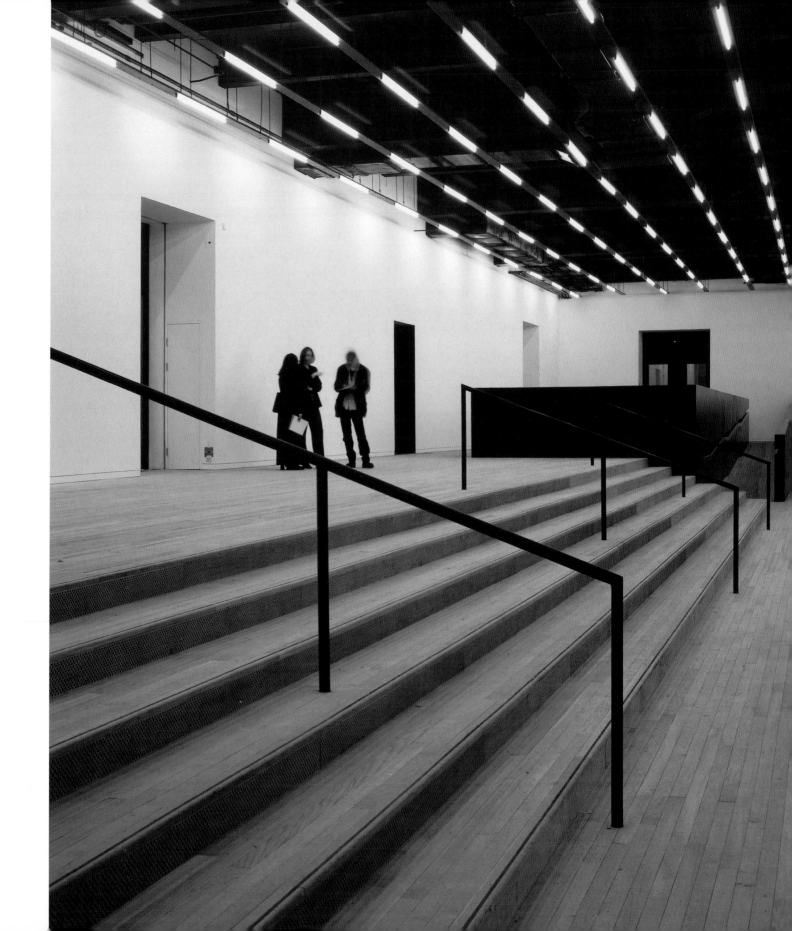

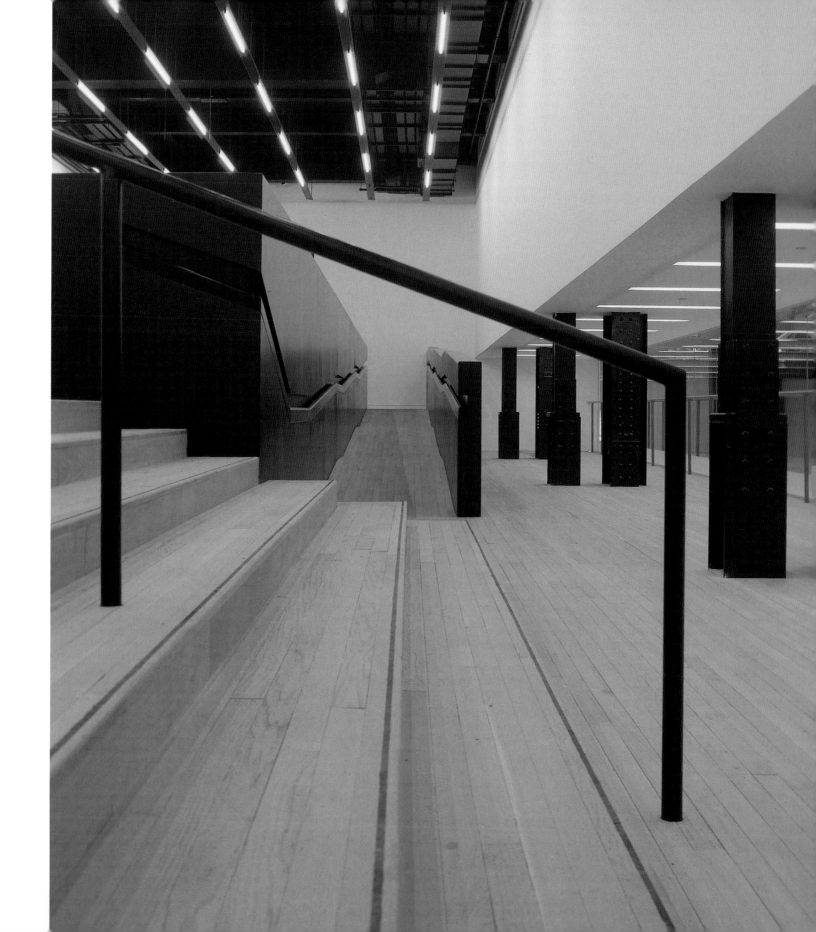

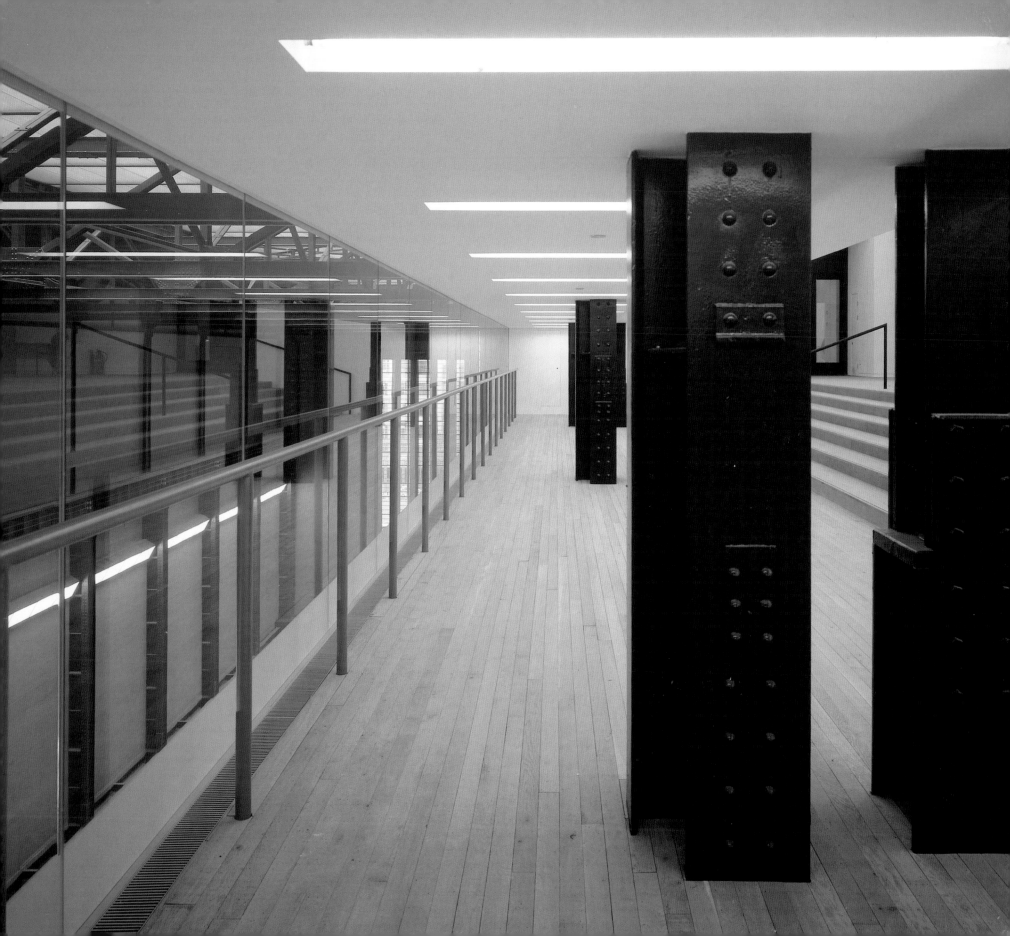

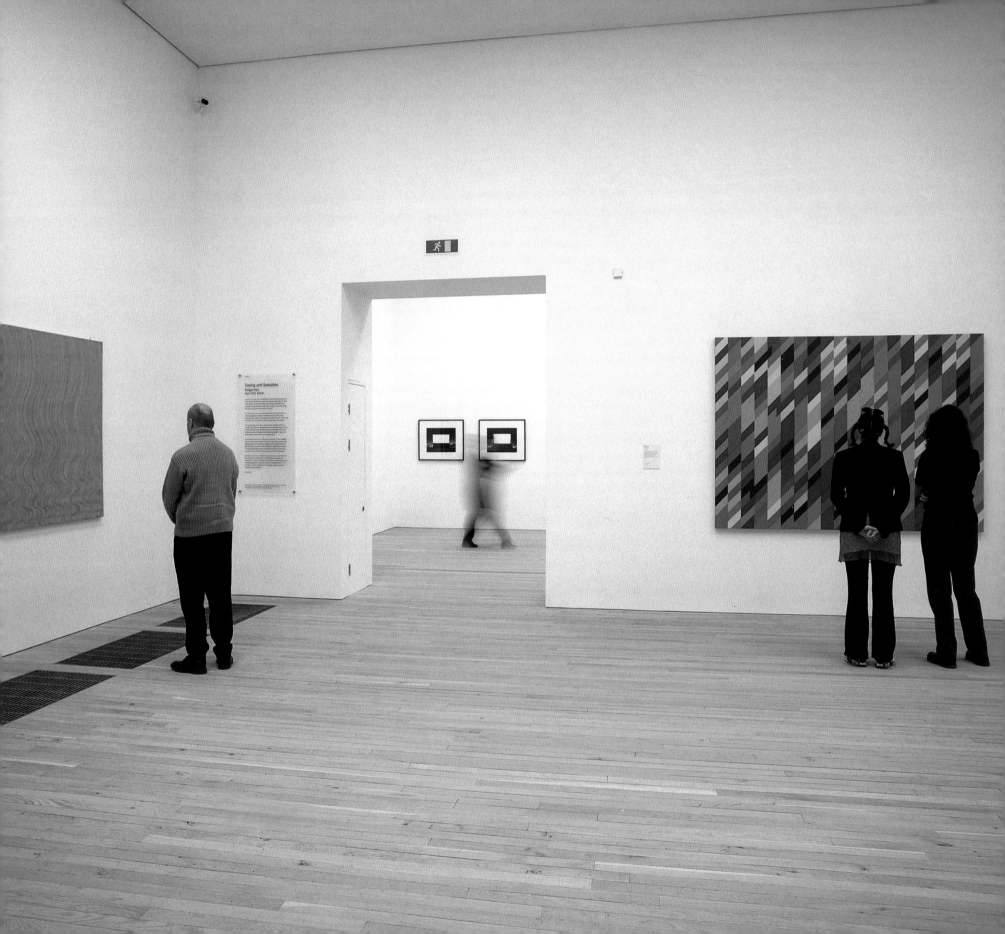

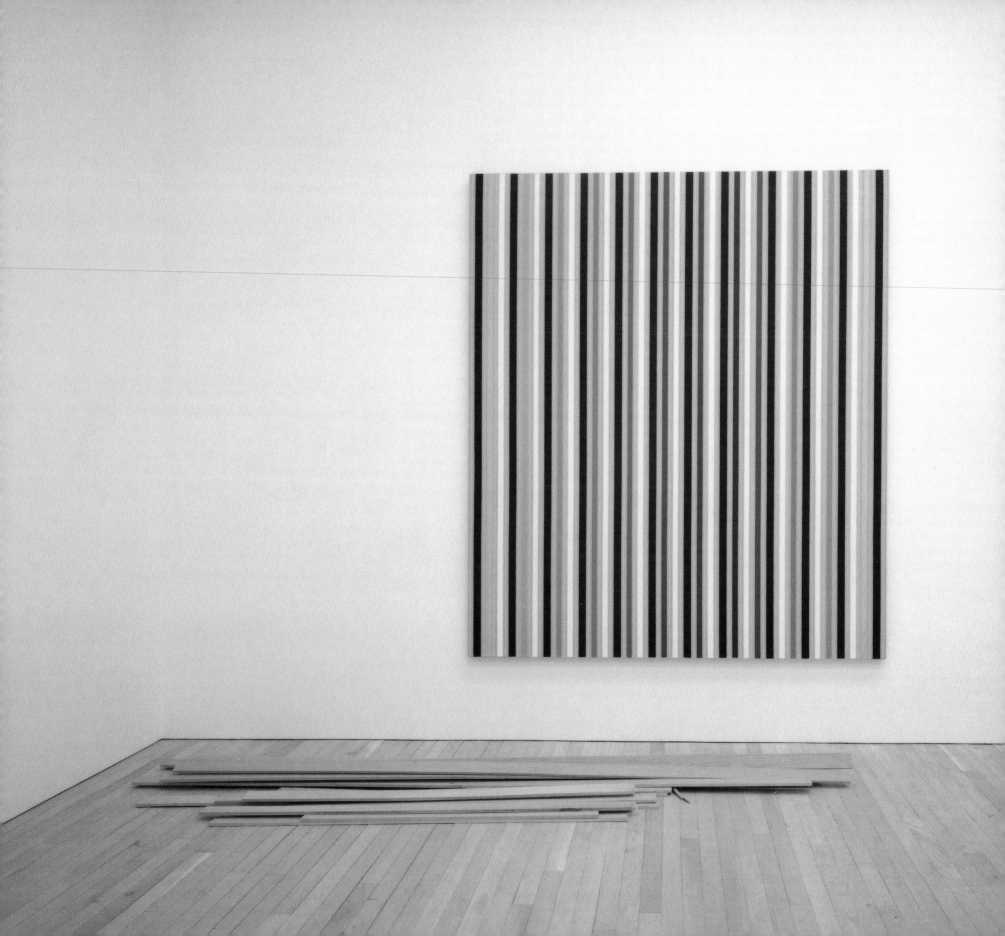

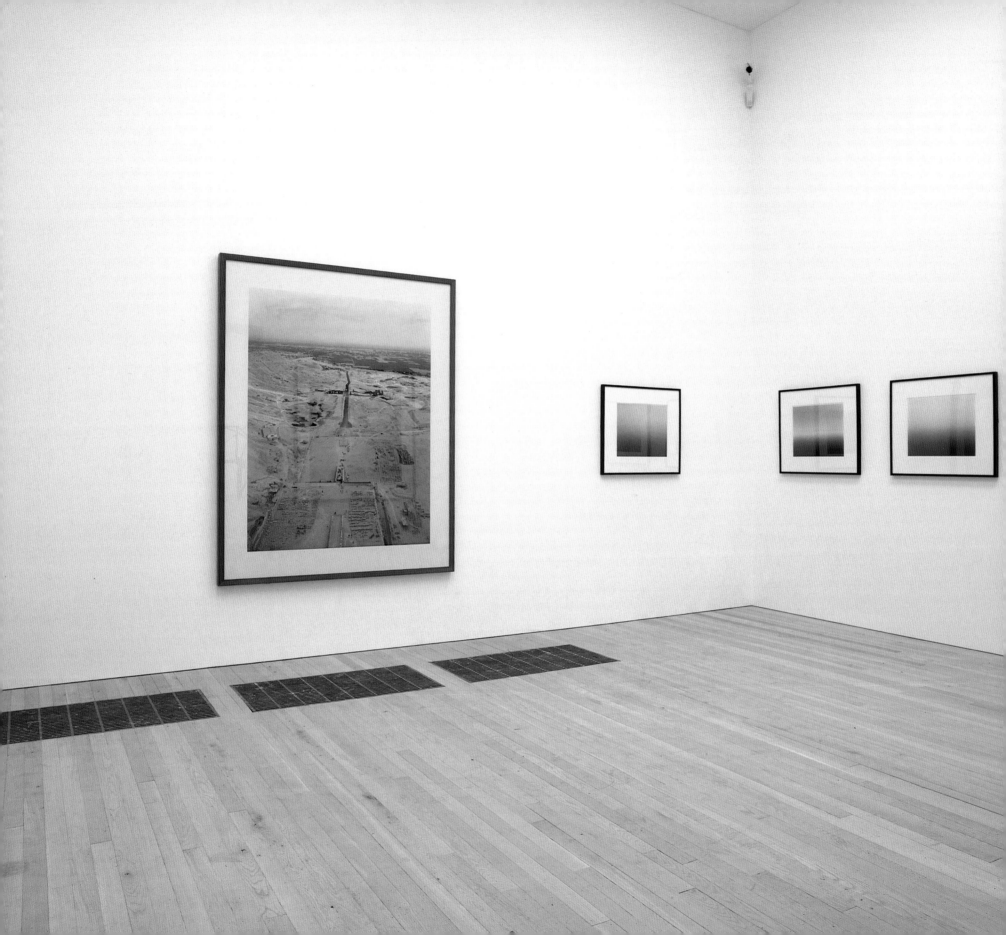

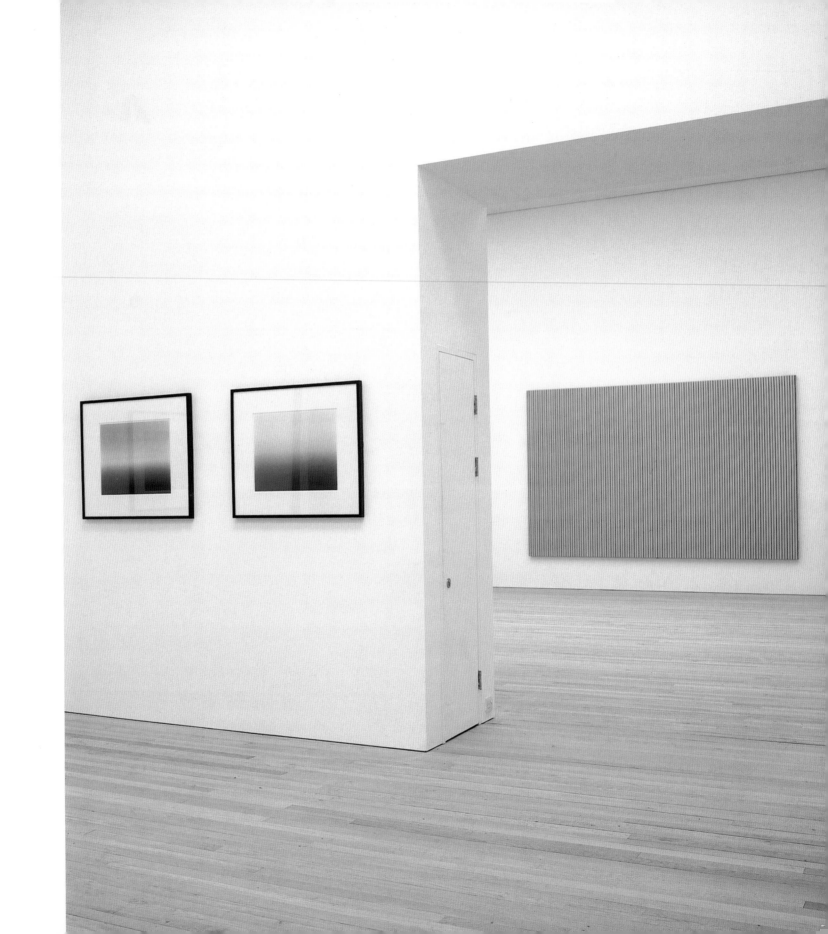

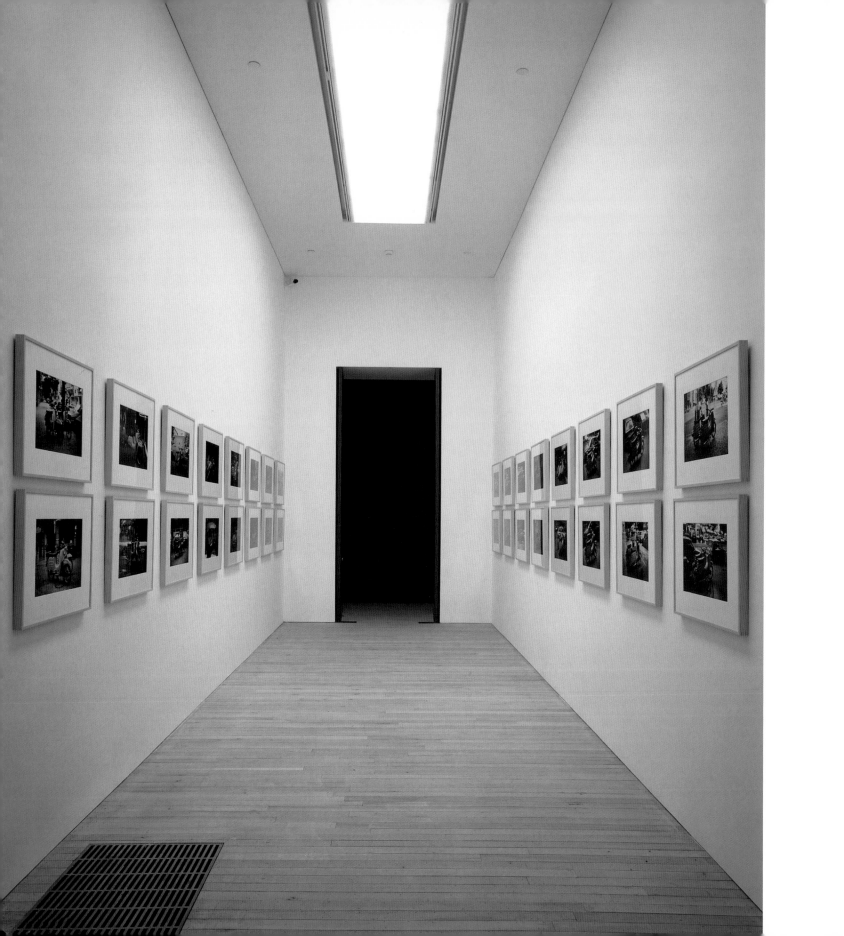

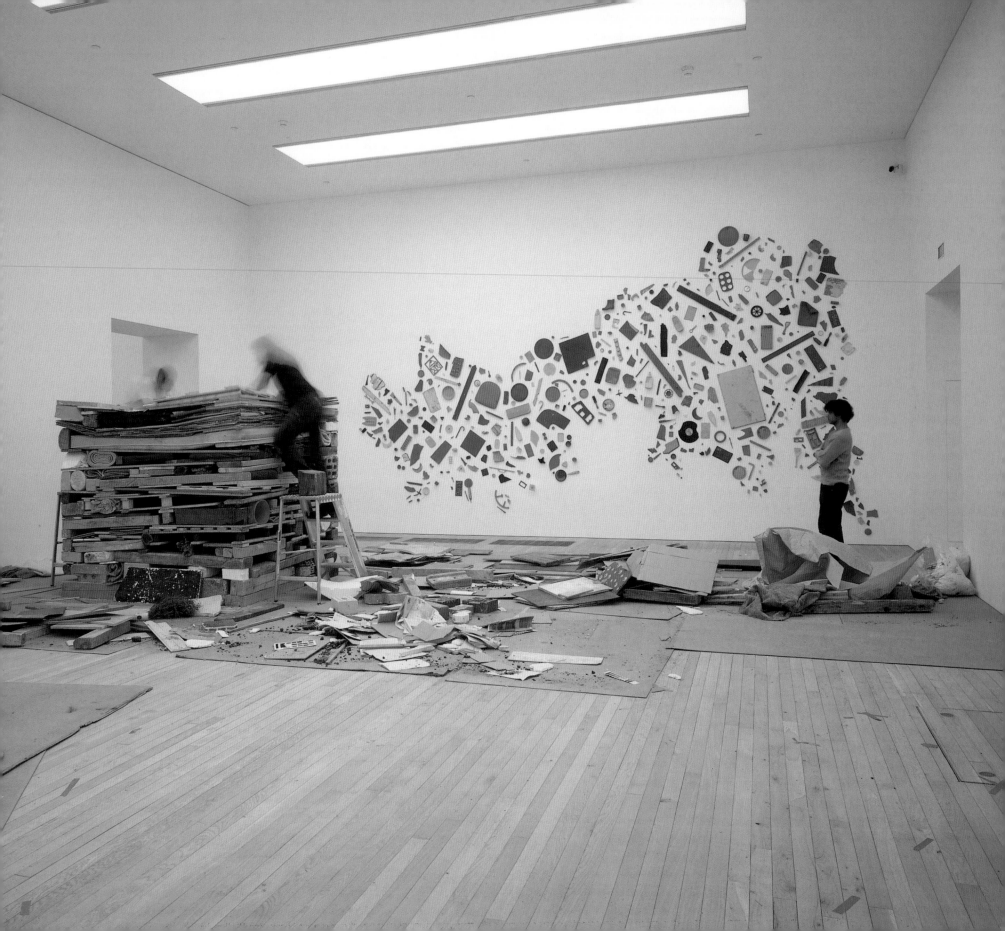

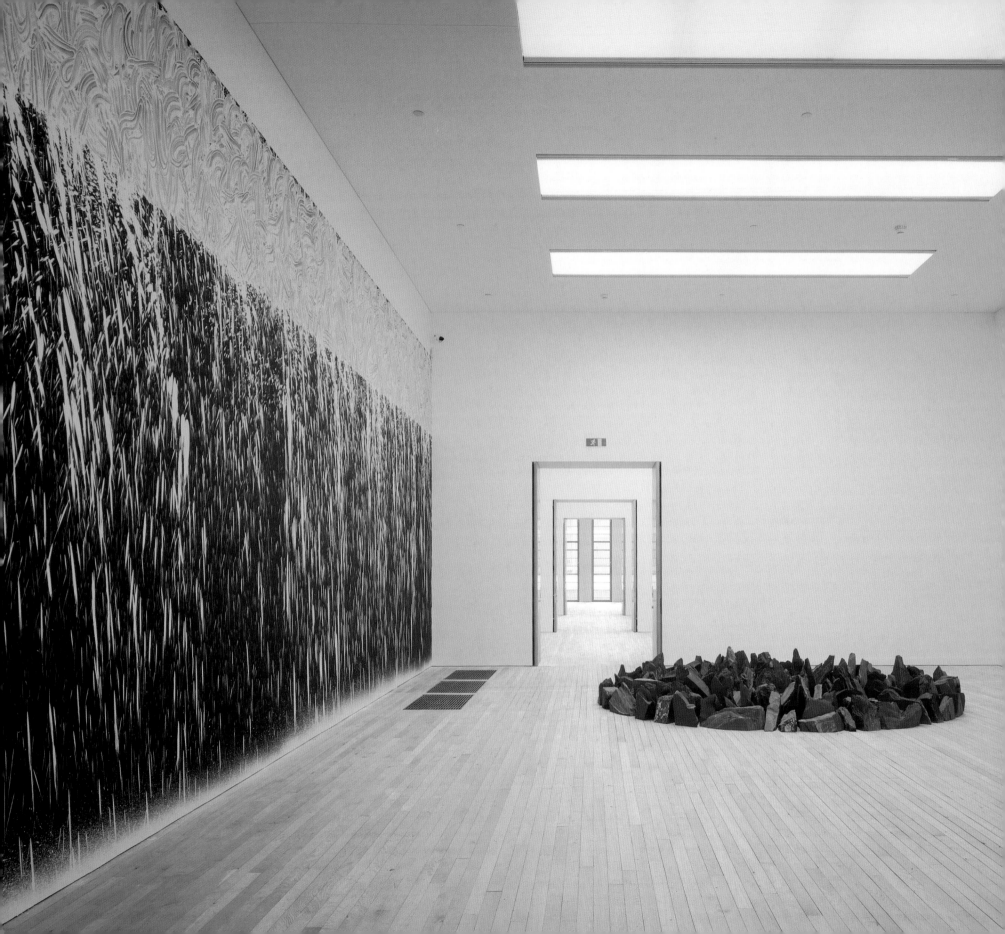

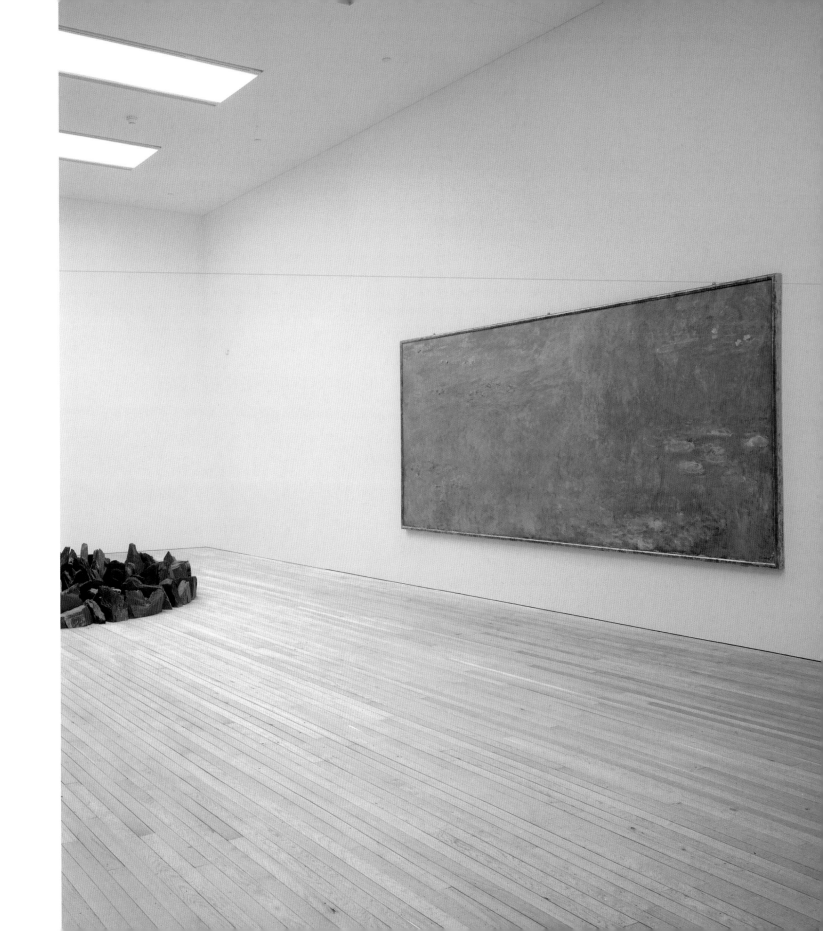

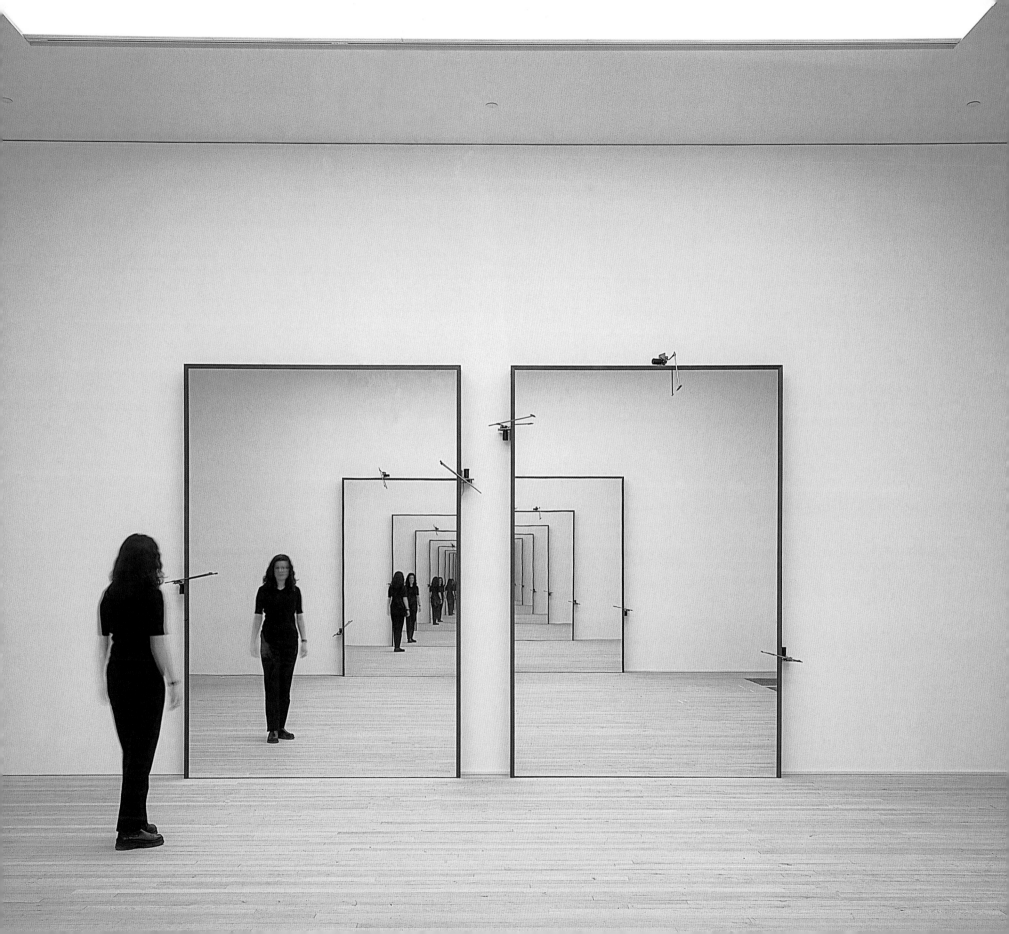

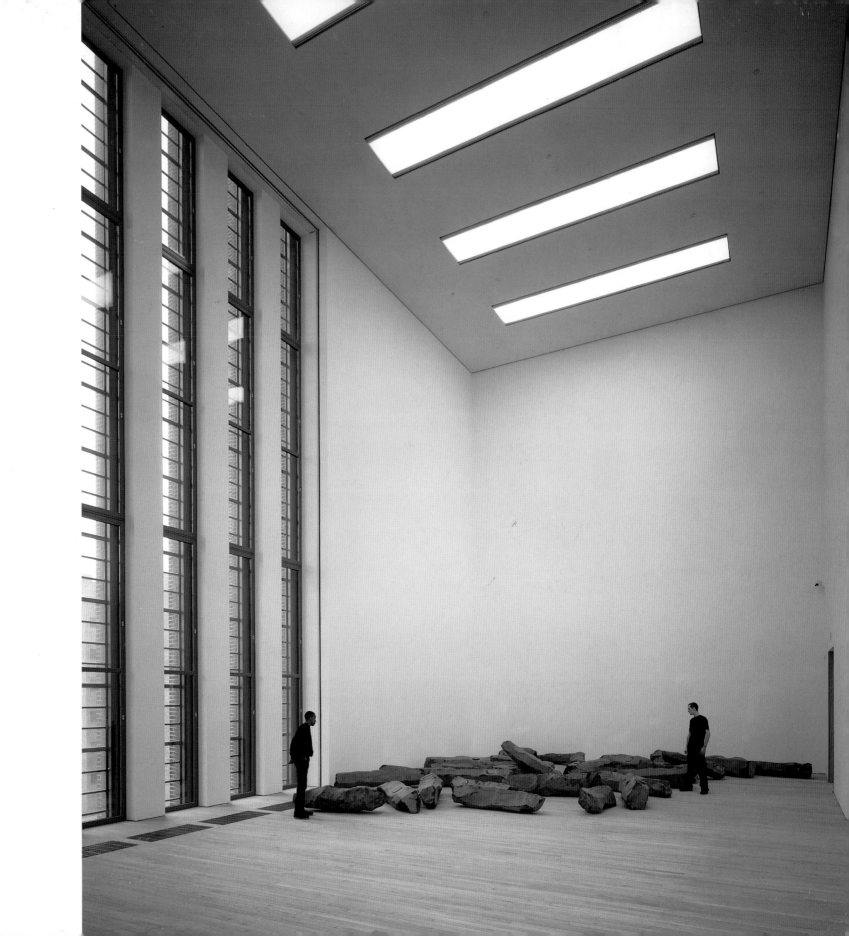

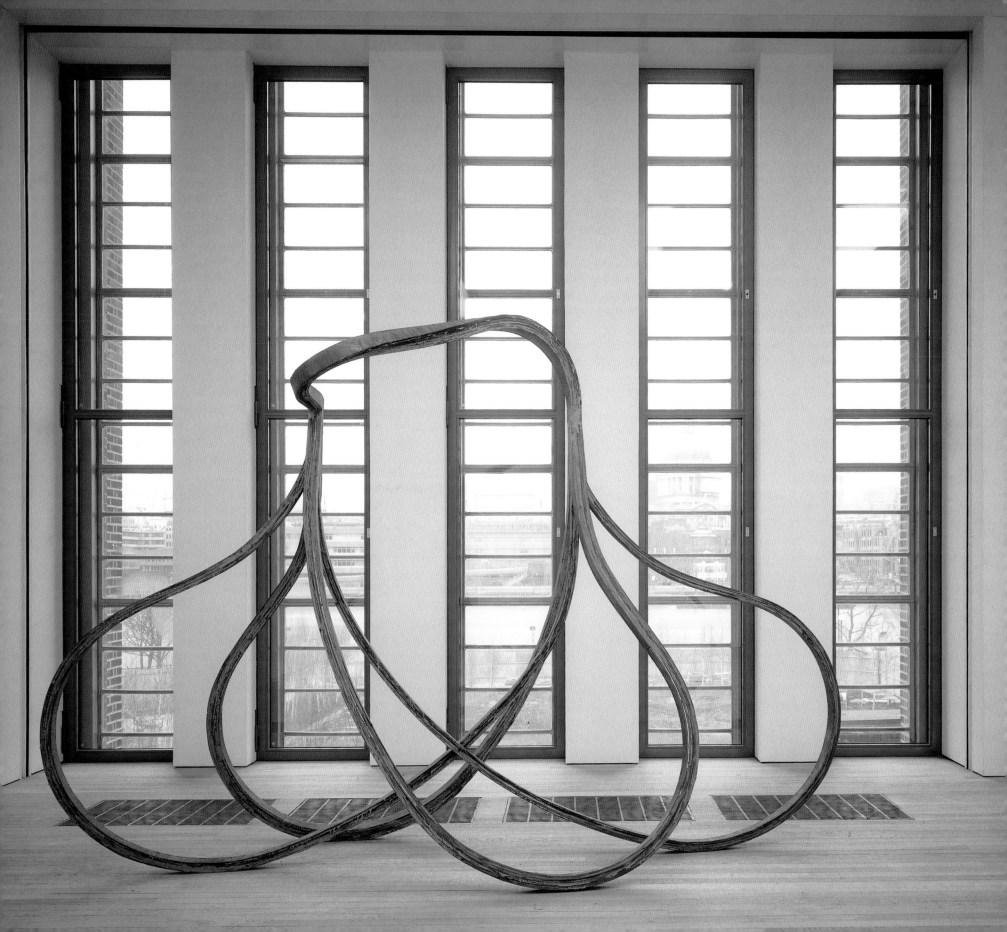

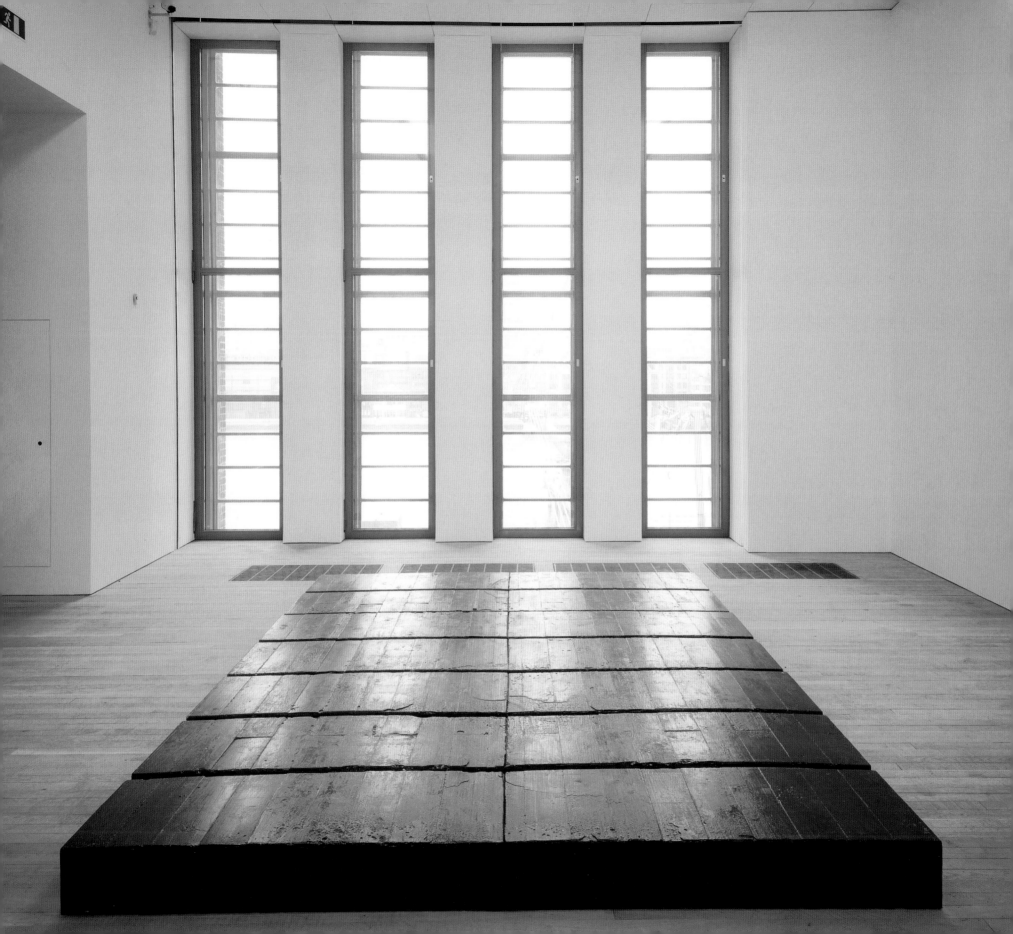

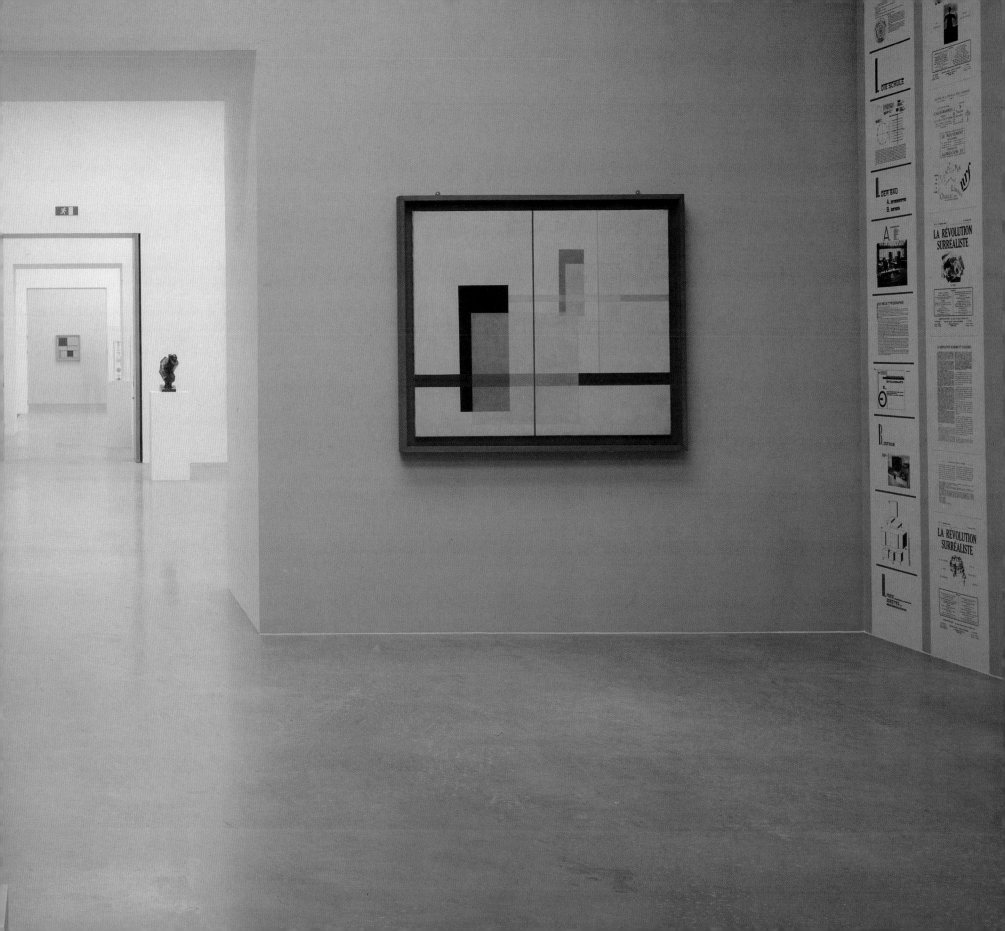

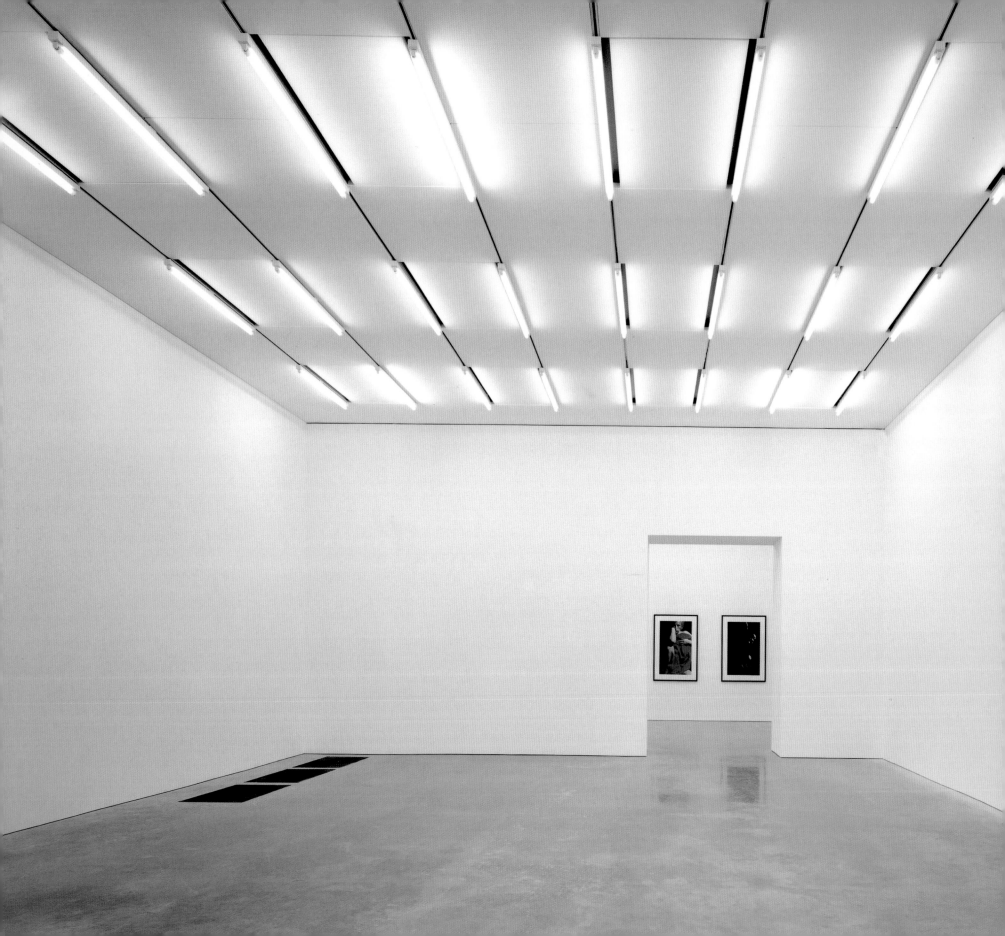

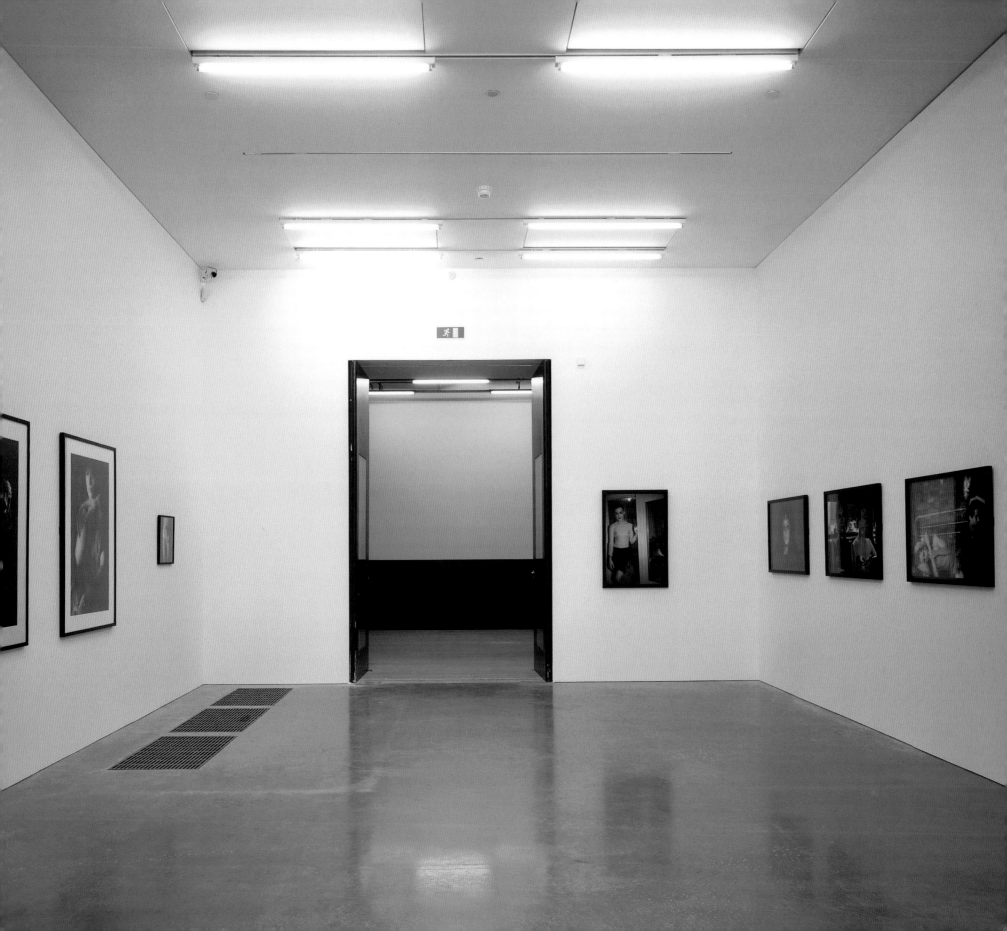

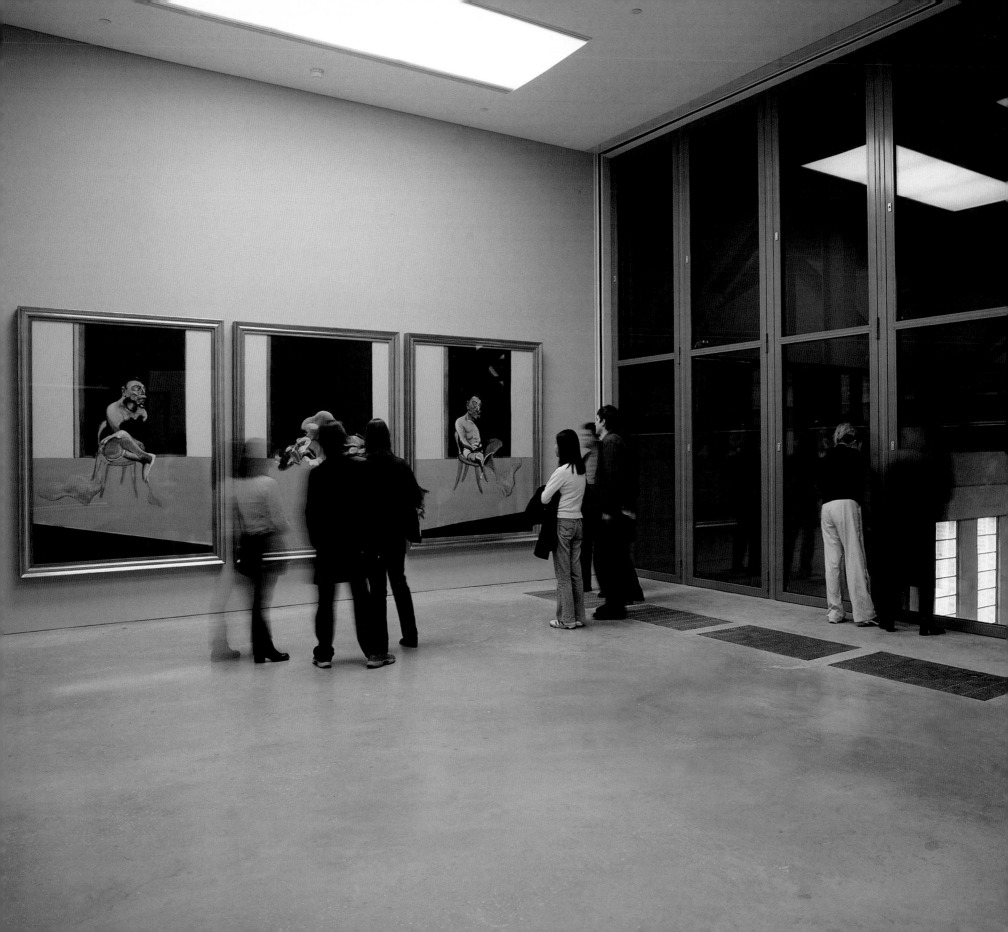

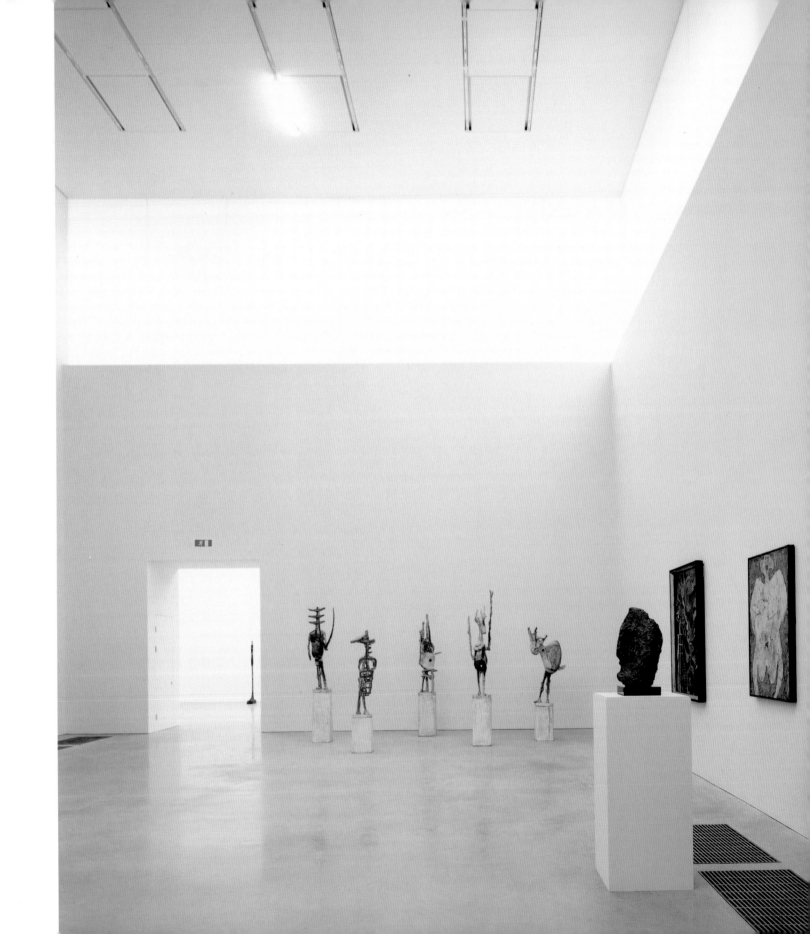

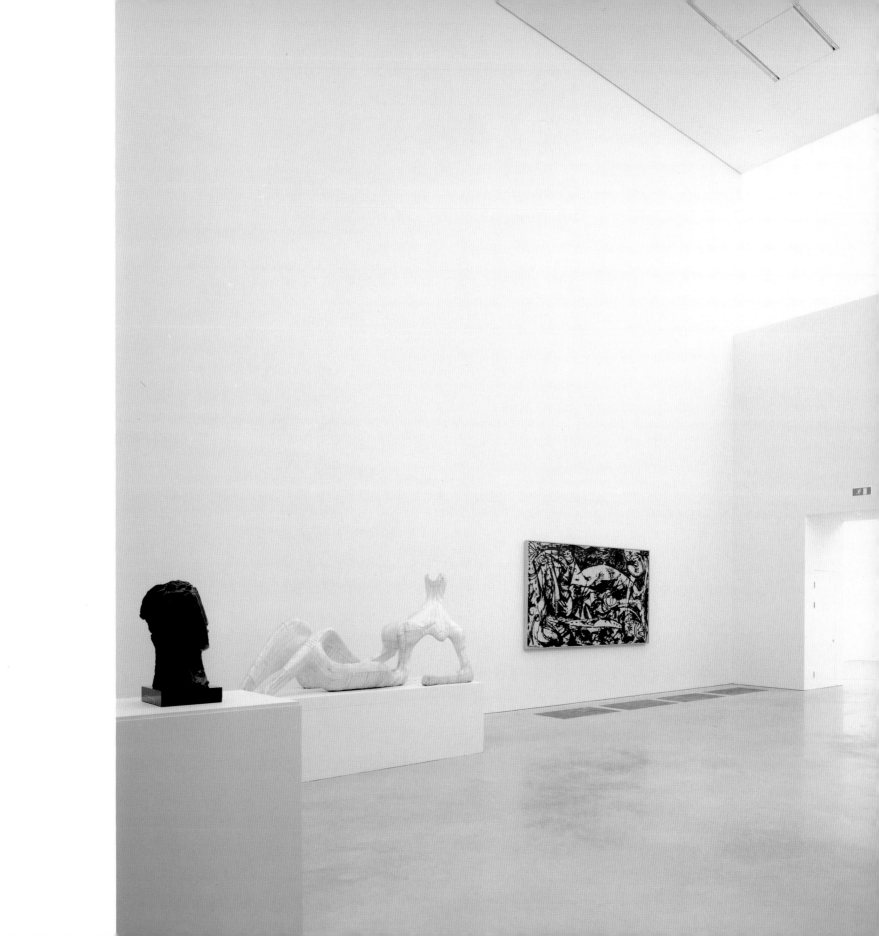

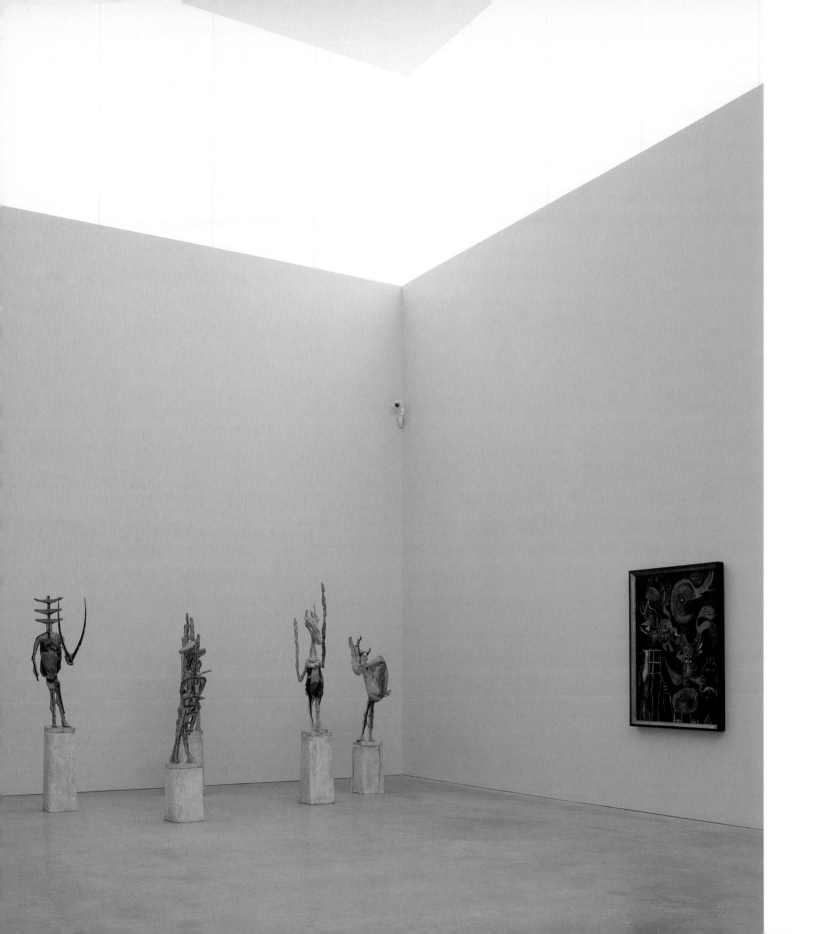

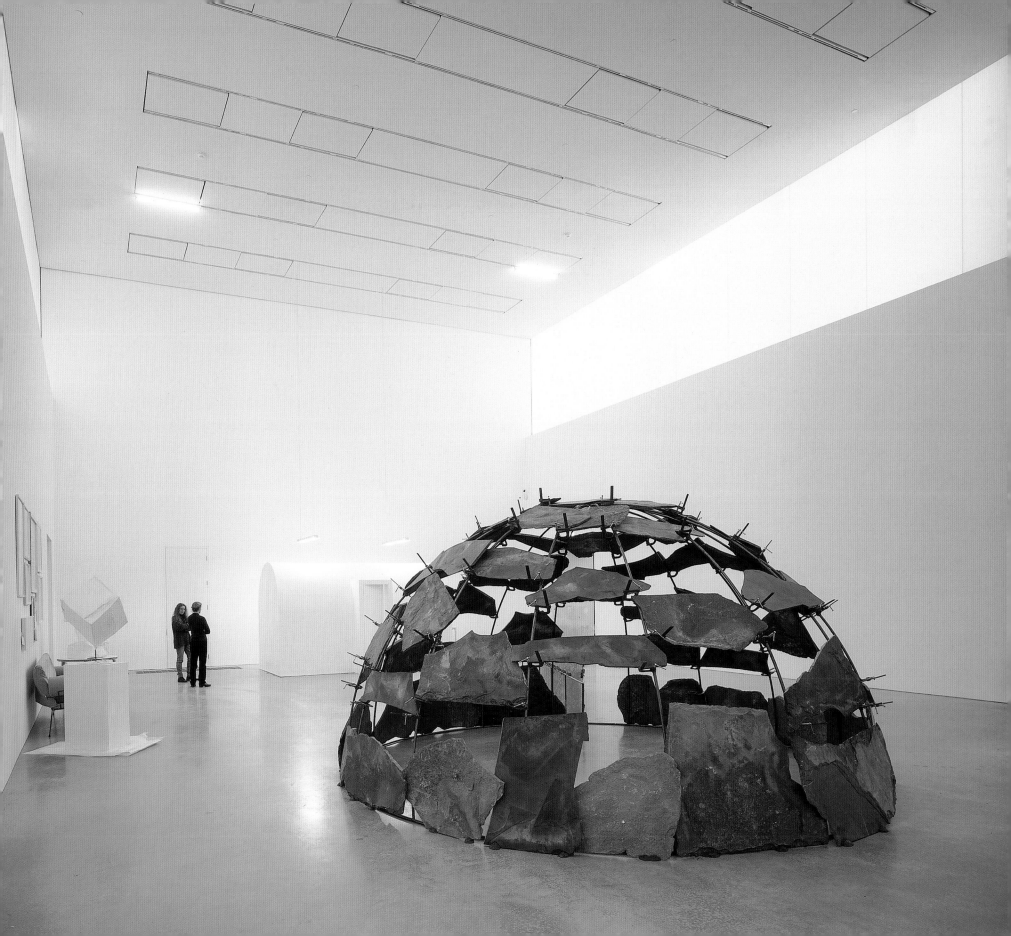

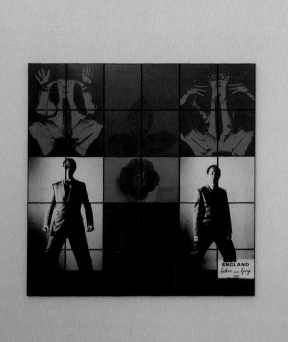

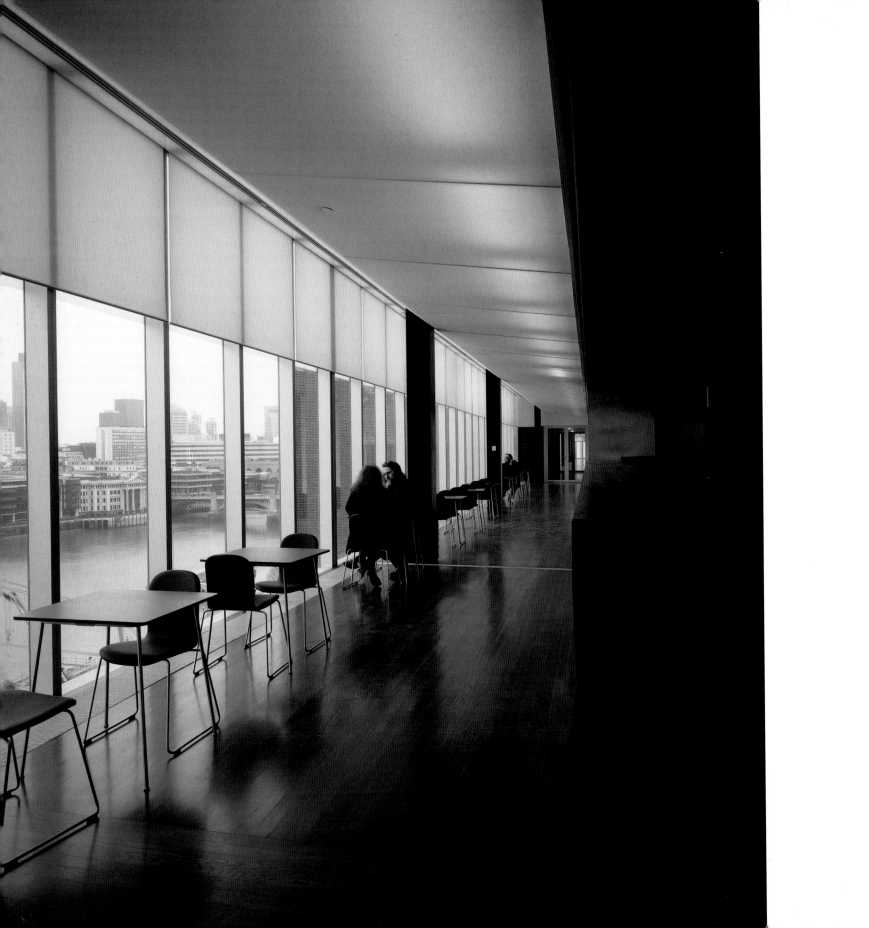

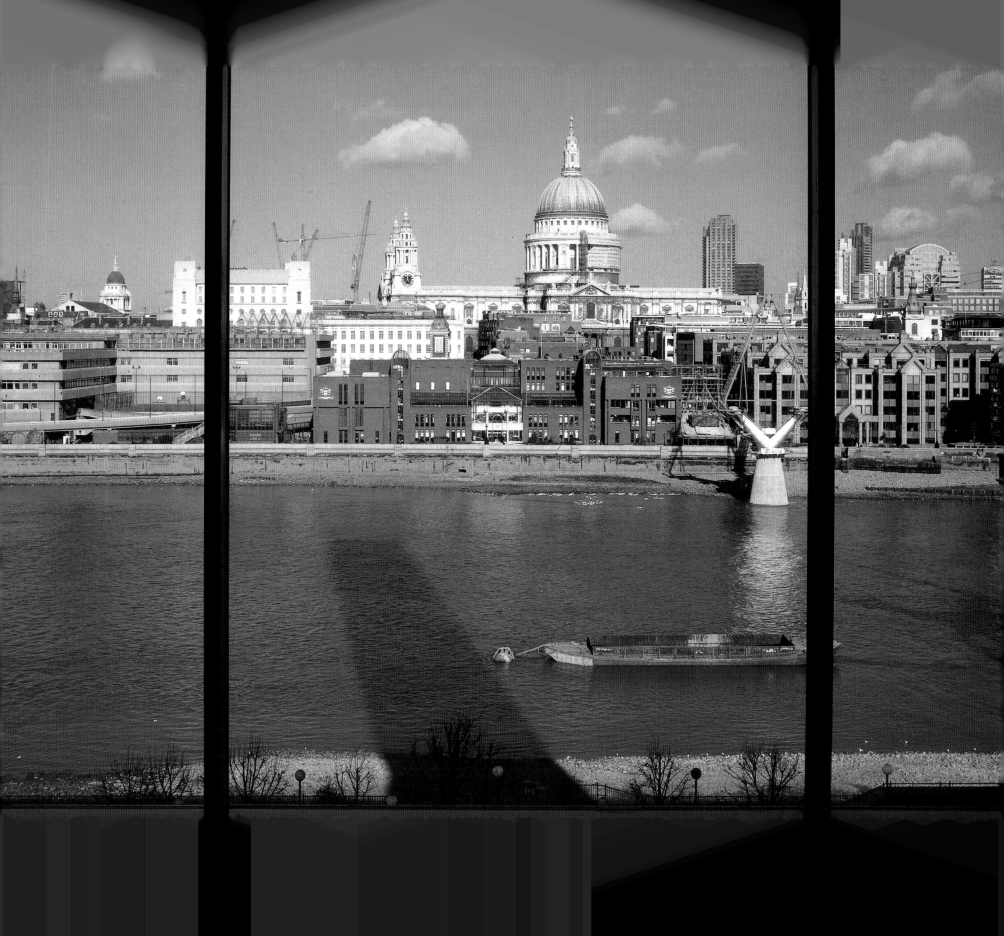

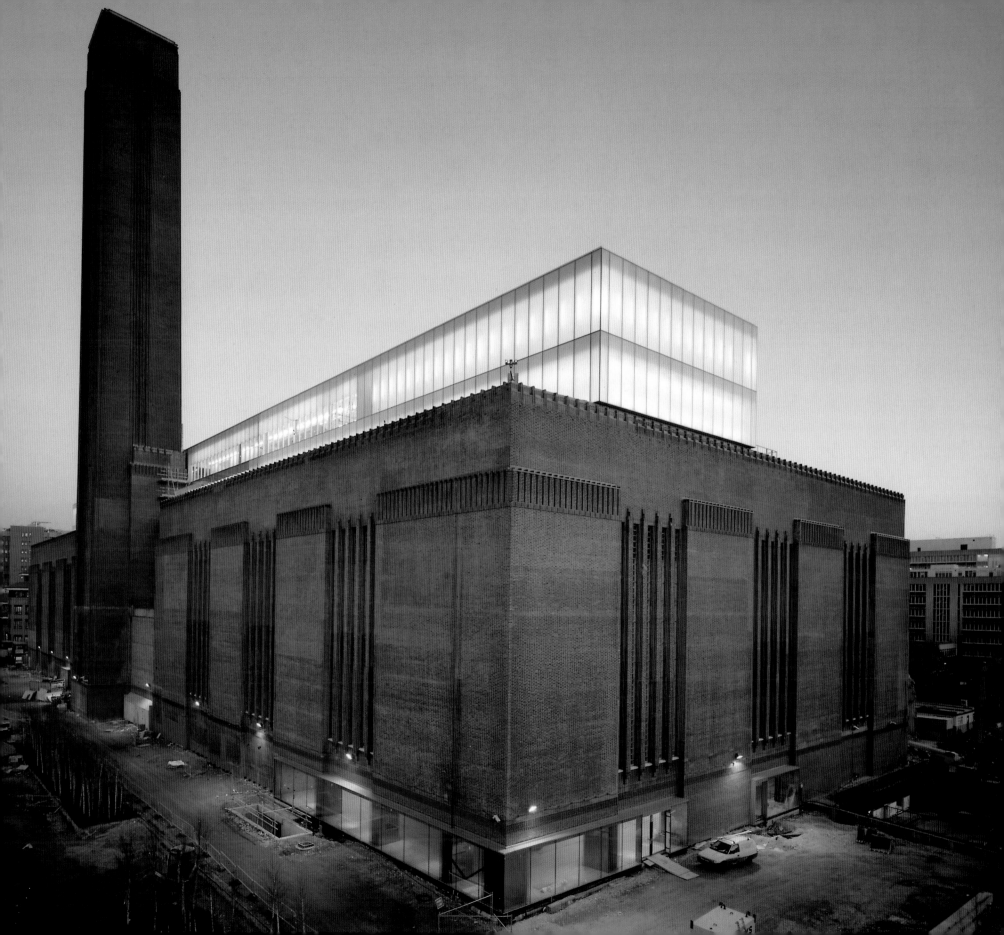

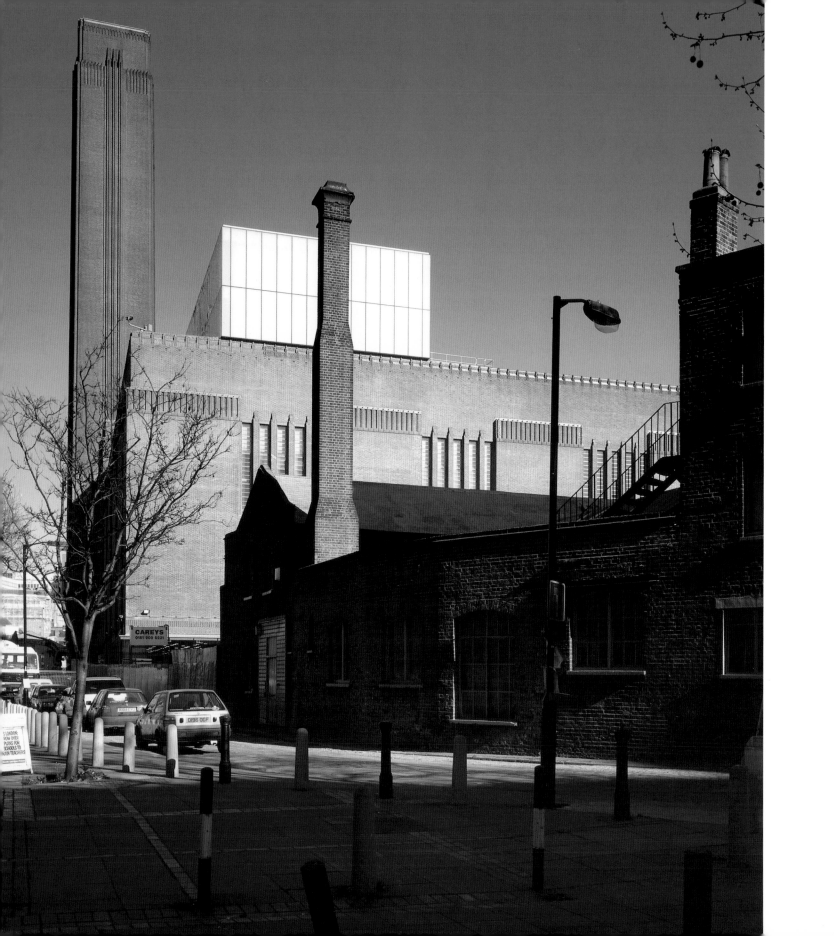

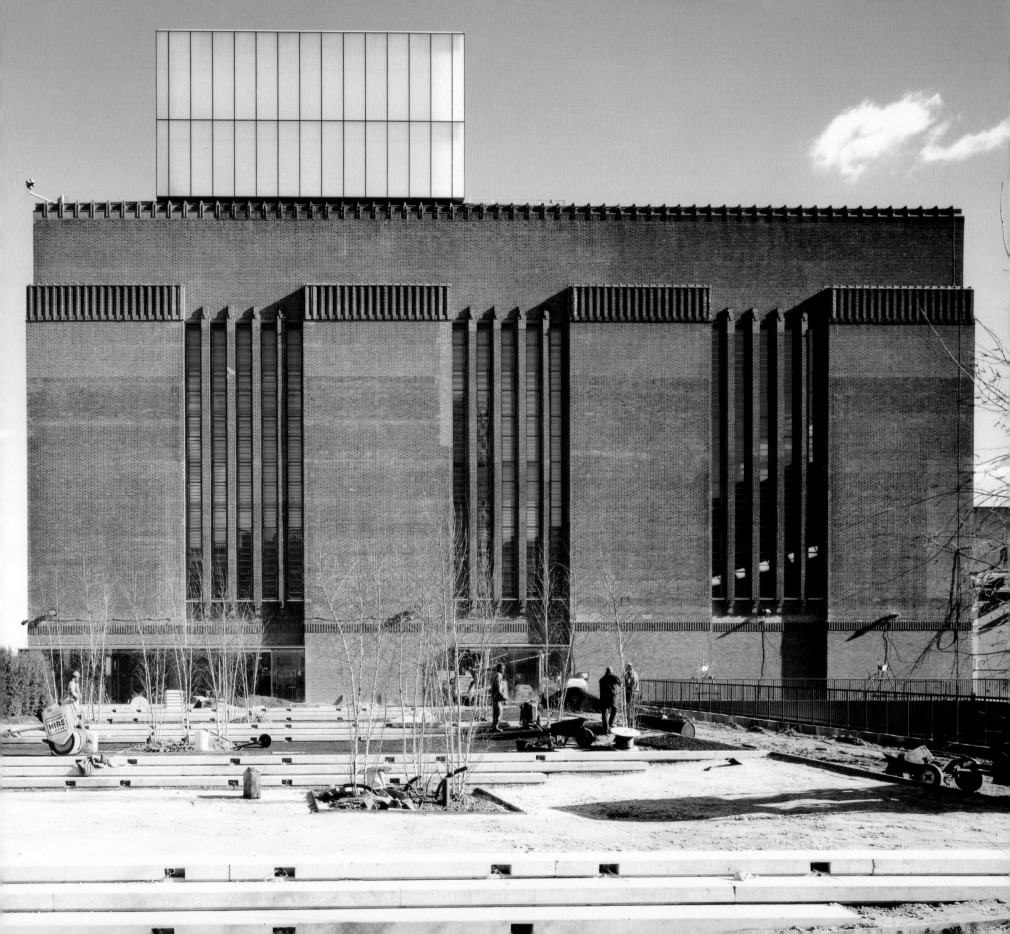

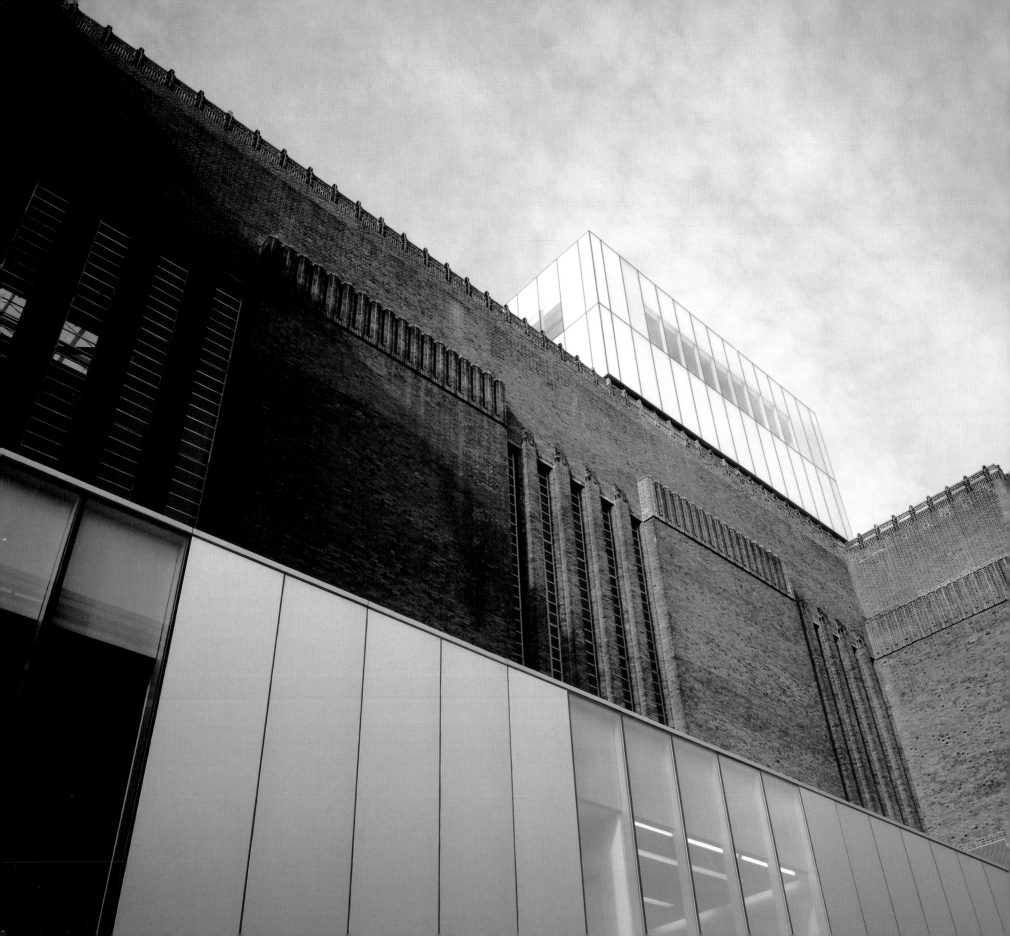

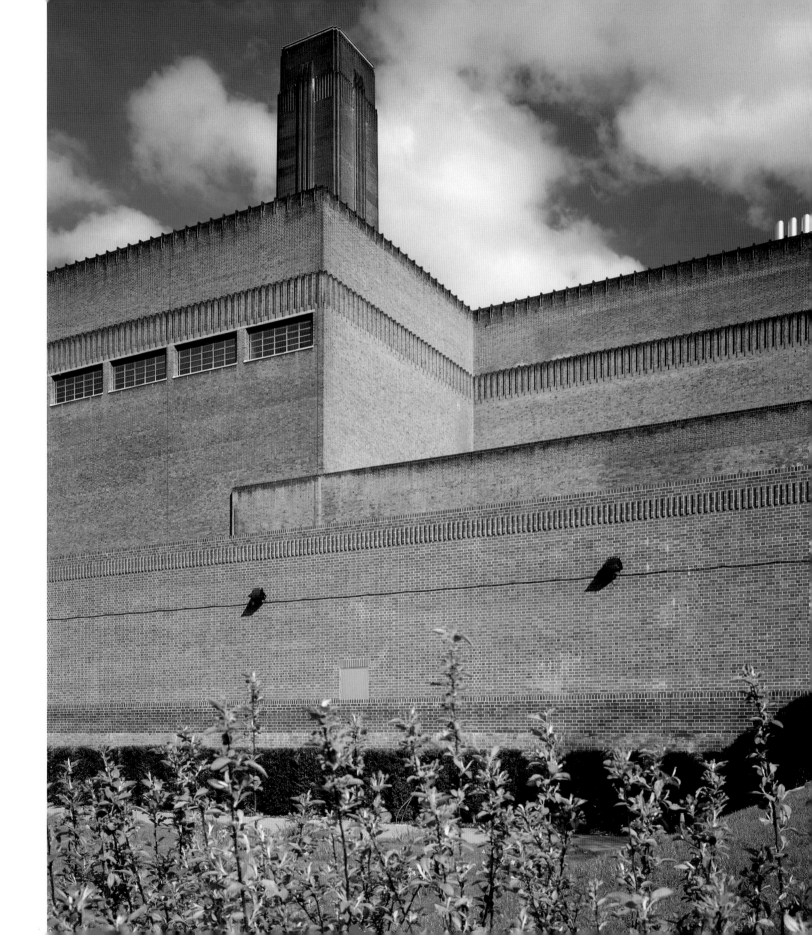

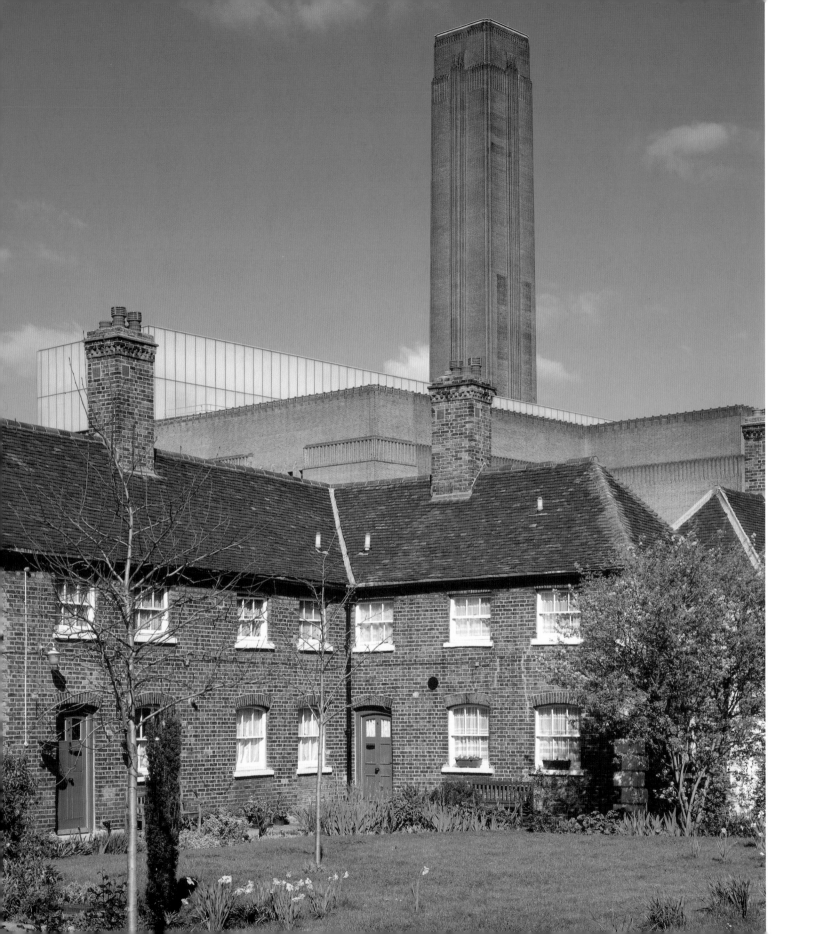

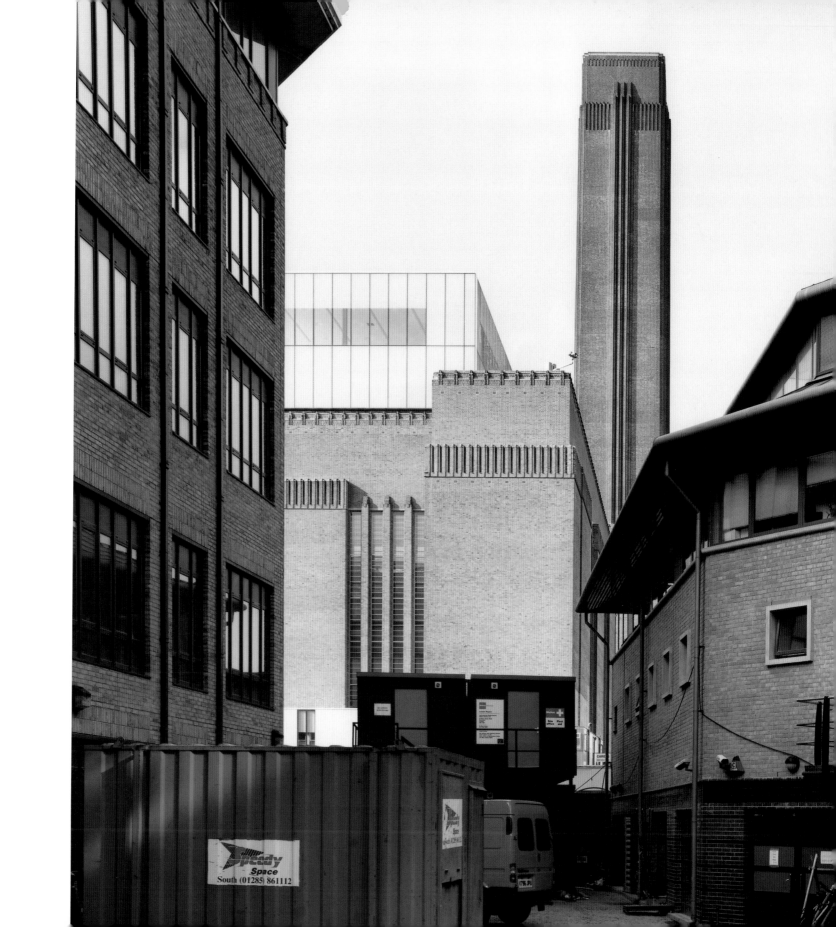

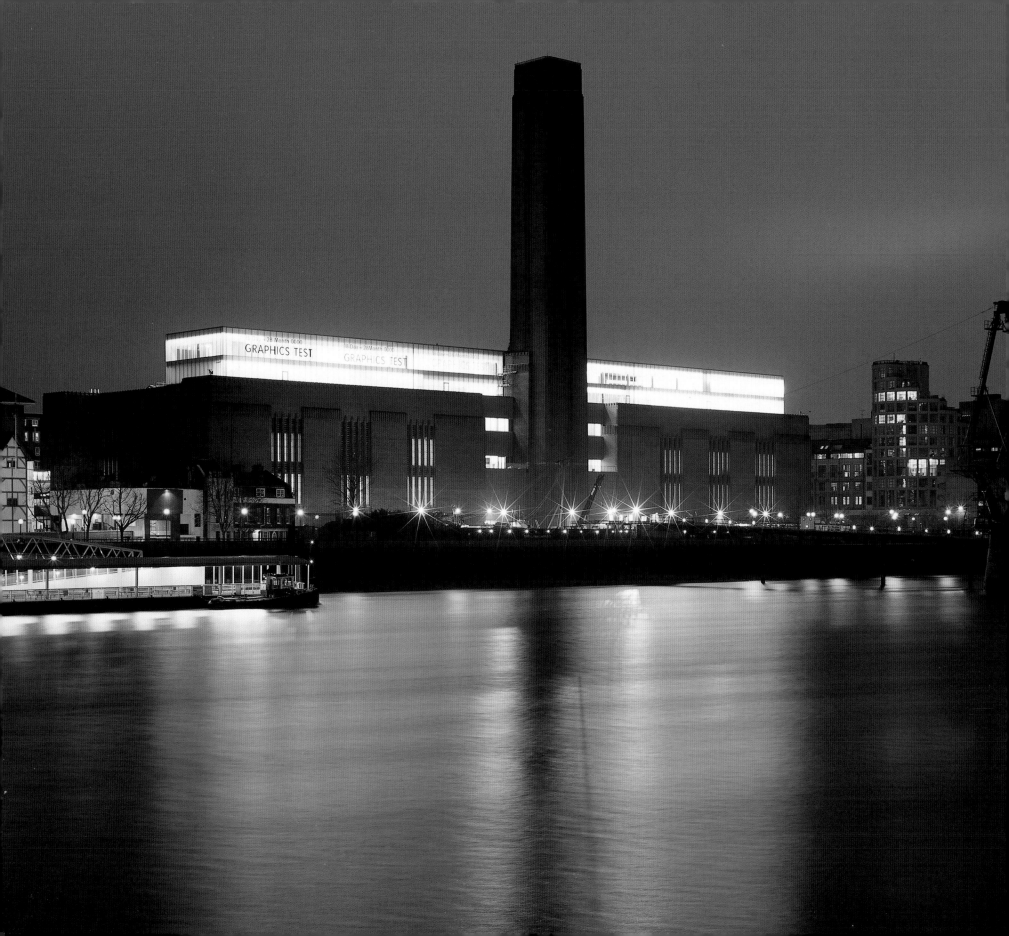

DESIGN AND CONSTRUCTION

'It is exciting' say Herzog & de Meuron 'to deal with existing structures, because the constraints demand a very different kind of creative energy. When you don't start from scratch you need architectural strategies that are not primarily motivated by taste or stylistic preferences. Our strategy was to accept the physical power of Bankside's massive mountain-like brick building and even to enhance it rather than breaking it up or trying to diminish it. This is a kind of Aikido strategy where you use your enemy's strategy for your own purposes. Instead of fighting it you take all the energy and shape it in an unexpected and new way.'

On Tate Modern the building and design work proceeded in parallel, with demolition of the existing building's interior taking place at the same time that Herzog & de Meuron were developing their designs, and details being worked out while construction of the new spaces was underway. The design was developed with a variety of means, including conventional architectural drawings, a large wooden model of the entire building, and simple cardboard models of individual exhibition spaces. Full-scale mock-ups of key elements were made on site. However, to an unusual degree, the project was conceived in words, with the architects preparing written documents on their approaches to particular aspects of the building, which were then discussed with the clients, the engineers Ove Arup and the contractors. A key figure in steering the project through the construction process, without losing sight of the intentions of the design, was the Tate Gallery's Director of Buildings and Gallery Services, Peter Wilson.

A great deal of design effort was expended on seemingly modest details, such as ventilation grilles, handrails or the position of sprinklers, as these modify the experience of the completed space. The degree to which the original building should be altered was a constant theme, with the conclusion usually being to alter less rather than more. Budget was also a powerful factor, as Tate Modern was built to about 75 per cent of the typical cost per square metre of an international art gallery. At one stage the exhibition galleries on Level 4 were omitted from the planned building, and they were only progressed with when funding became available.

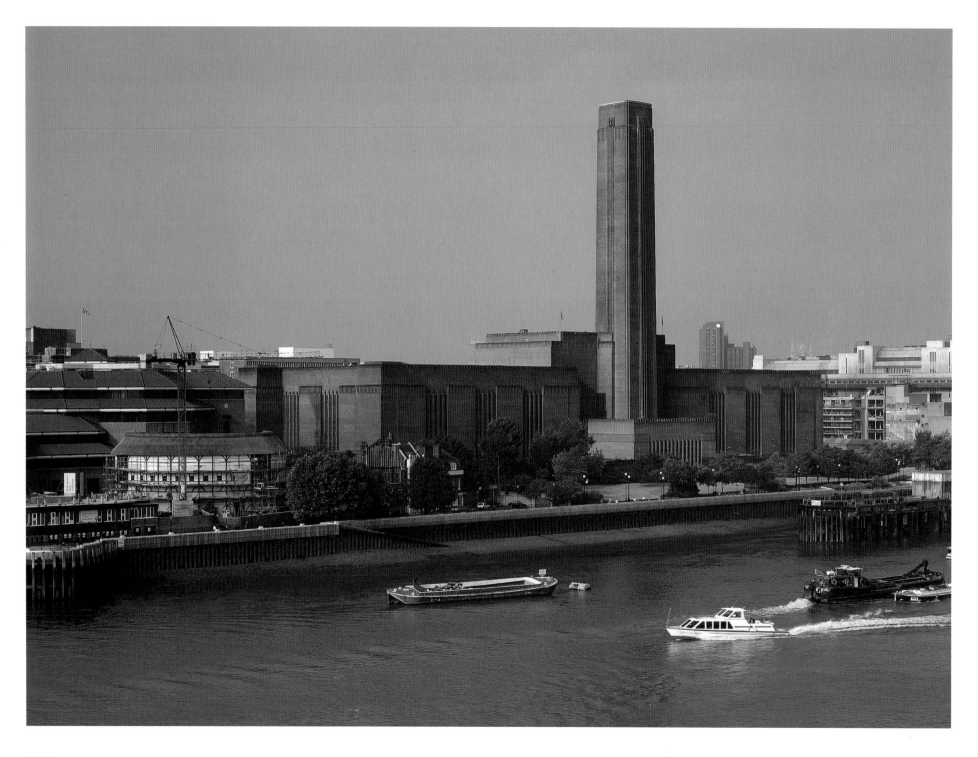

THE RIVER ELEVATION

From the very beginning, when Herzog & de Meuron started thinking about the project during the competition in 1994, they entertained the idea of a huge body of light hovering above the heavy brick structure of the former power station. This body of light was to pour daylight into the rooms on the top floor of the gallery and, at night, the direction of the artificial illumination would be reversed and magically shine into the London sky.

The conspicuously horizontal shape of the light beam forms a distinctive equipoise to the vertical thrust of the brick tower, designed by Giles Gilbert Scott as a counterpoint to St Paul's Cathedral just across the river. Scott's intention of explicitly responding to Christopher Wren's building has been accentuated and updated by the luminous beam of light. Like the Cathedral, Bankside has now become a public site accessible to all the people in this city.

Several ideas were tested for the building's riverside elevation. One was for a glass strip at ground level, running most of the length of the building, to give the brick skin the appearance of weightlessness. Others included breaking up the mass of the chimney with glass panels; puncturing the façade with new windows to correspond with the internal arrangements; replacing the recess on either side of the chimney with a black brick and glass wall flush with the existing walls; and a series of narrow slits that echoed the vertical rhythm of the original windows. Eventually it was decided to disrupt the existing elevation relatively little. Accretions to Scott's original design were removed, such as the gas-washing plant on the roof, immediately behind the chimney, and a ground-level structure in front of the chimney.

The chimney performed an important function in the former power plant since all the flues from the boilers were gathered into it. The

127

load-bearing structure of the chimney, centred on the boiler house side of the power station, is separate from the rest of the building. In a second building phase, the chimney will be converted into an observation tower with two staircases and two lifts. At a height of 93 metres, it will afford a breathtaking view of the whole of London.

Looking at the chimney from outside, one realises that technical and functional requirements do not entirely explain its architecture. The chimney was primarily designed as an urban landmark that enters into a dialogue with St Paul's on the opposite bank of the Thames. The vertical symmetry of the chimney is a direct response to the central dome of the Cathedral.

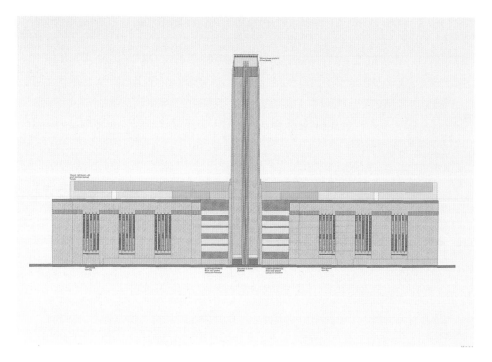

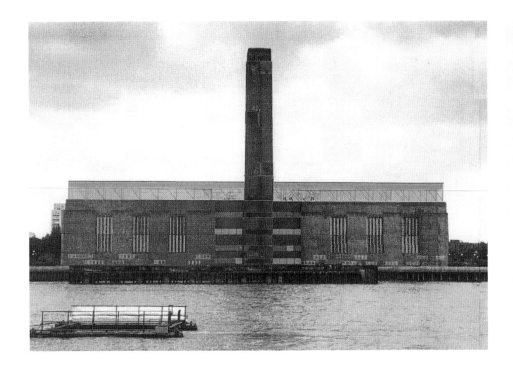

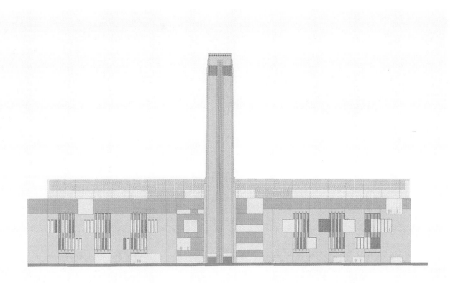

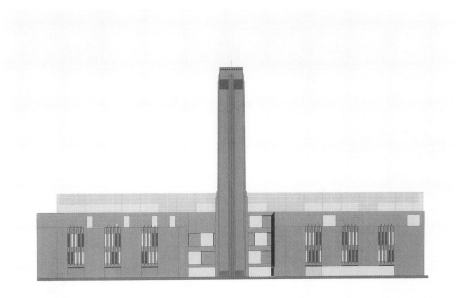

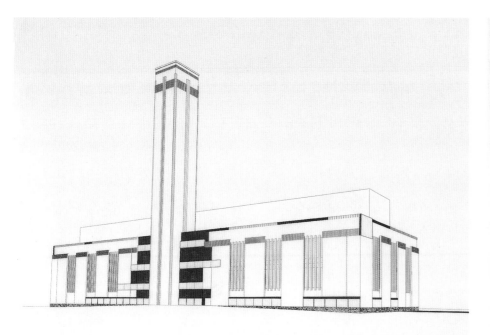

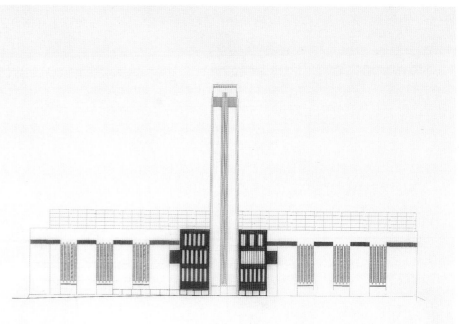

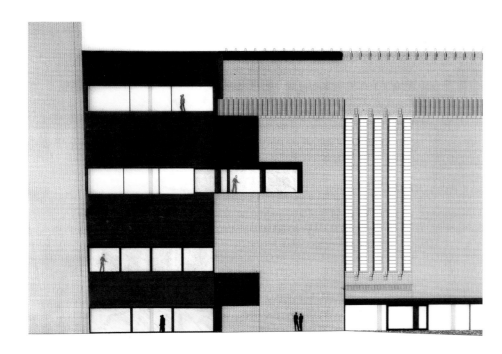

GODS AND HEROES OCTOBER - JANUARY 2001
JACKSON POLLOCK AUGUST-DECEMBER 2000

RITES OF PASSAGE 15.6.2000 - 3.9.2000
RICHARD LONG JANUARY 2001-JUNE 2001

North Elevation

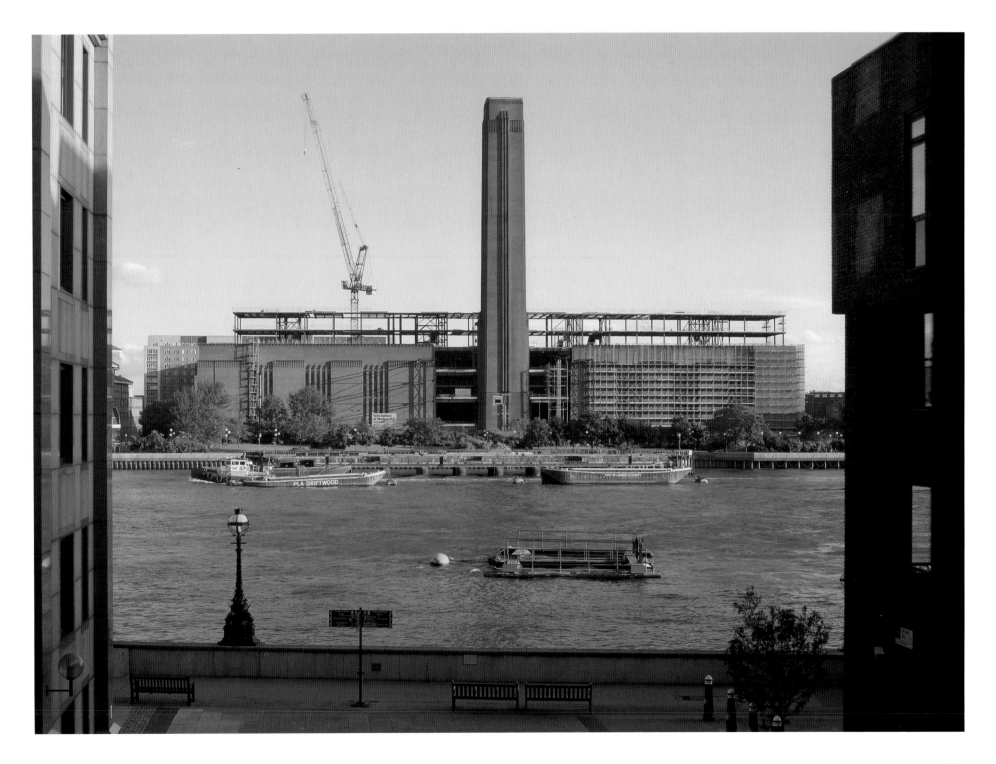

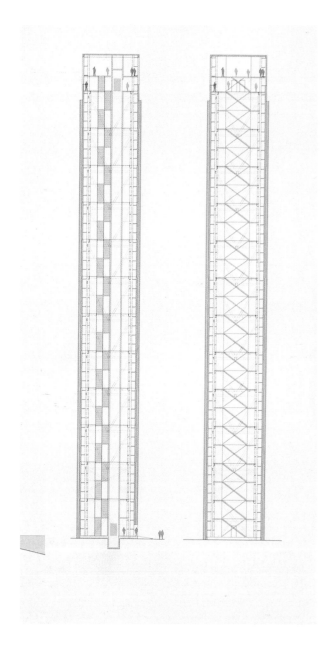

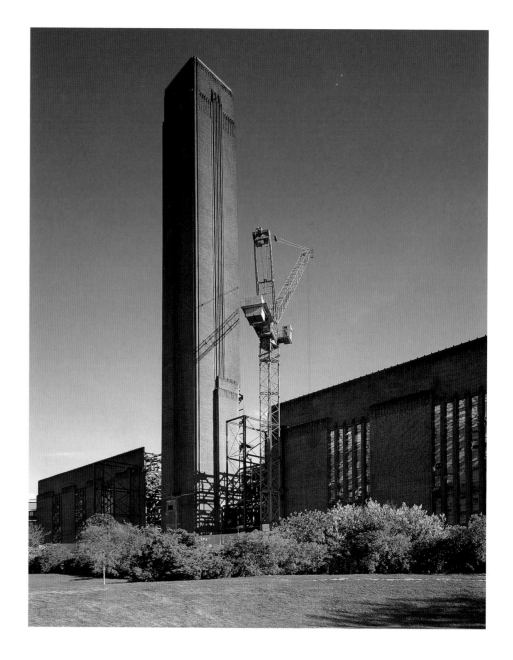

The chimney from inside the
boiler house after demolition of
the surrounding fabric

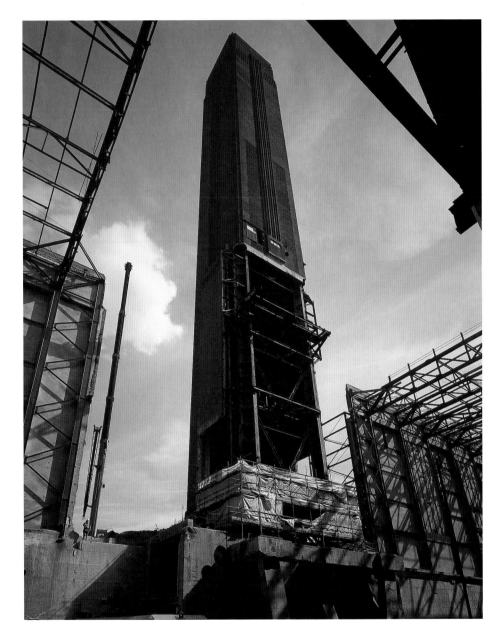

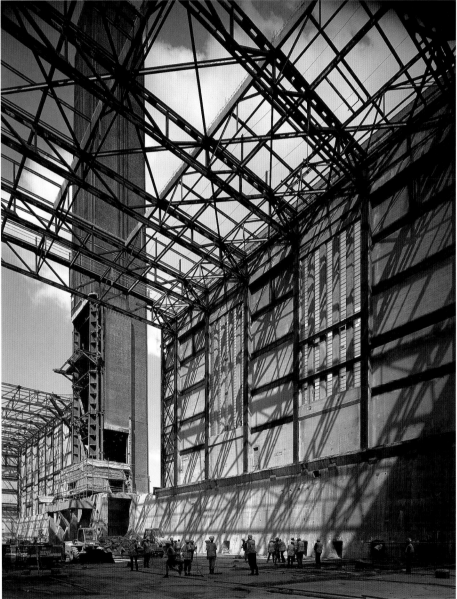

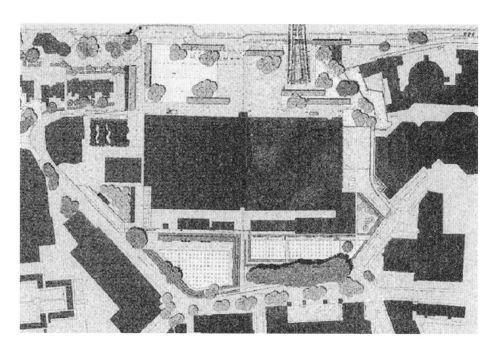

THE LANDSCAPE

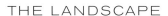

Herzog & de Meuron's architectural strategy was to transform Bankside Power Station into a landscape accessible and open to the public from all four directions. The gardens therefore mediate between the space of the city and the building and blur the distinction between inside and outside. Thus the ramp on the west side is a salient feature of both the gardens in the west court as well as the turbine hall. The plaza that spreads out between the riverside promenade and the chimney extends into the turbine hall where it becomes the platform.

Bankside Gardens (North)

The spacious Bankside Gardens, designed by the landscape architects Keinast Vogt Partner, are divided into three areas. A plaza is centred in front of the north entrance to Tate Modern and framed by stands of birch trees. To the west the arboretum, a lawn dotted with groups of foreign birch trees,

offers a site of rest and repose. The garden on the east side of the plaza, with its smaller groups of birch, forms the transition to the domestic scale of the adjoining buildings.

The gravel, used throughout as the ground covering, has been chosen to match the colour of the brick façade of the building. Like other types of aggregate, it may be loose, bonded, or rolled into the asphalt. The soft surface texture of the gravel links the plaza with the lawns and, at the same time, suggests an extension of the riverbank.

The groves of domestic birch trees resemble the wooded growth along riverbanks. But birch is also a pioneer tree that thrives on fallow urban and industrial land and therefore symbolises the transformation of abandoned terrain. The groups of foreign birch planted on the lawns challenge the accustomed image of this tree with their bark of different colours – snow white, salmon, grey or black.

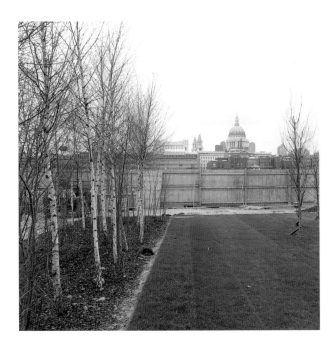

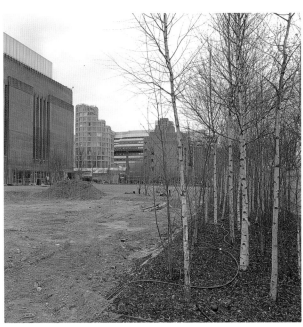

West Court

The landscaping of the west court mediates between the expansive, open area of the Bankside gardens and the framed spaces of the south terraces. The visitors' ramp leading into the turbine hall is placed in the centre. To the north, in front of the restaurant, outdoor seating on a stepped slope is marked by evenly planted groups of birch. The arrangement of these multi-stem trees is related to the groups of birch in the Bankside gardens, while the single-stem birches to the south of the ramp reflect the single plantings in the south terraces.

South Terraces

In contrast to the Bankside gardens, which respond specifically to the expansiveness of the river, the south terraces are divided into two clearly defined gardens surrounded by hedges. The introspective, contemplative character of these spaces invites visitors to rest or play. The hedges, consisting of coniferous yew trees, white flowering quince and white apple blossom shrubs, blossom at different times, thereby mirroring the seasons of the year. Old and new maples, linden trees and plane trees along the southern border along with the topographical design of the lawns heighten the spatial effect of the gardens. Thousands of yellow and white daffodils bloom on the lawns in spring. They are planted in squares, but this geometry will fade in years to come.

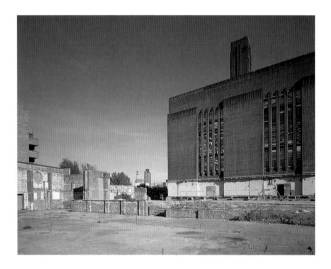

°THE RAMP

The ramp is one of the main architectural modifications that convert this industrial building, once closed to the public, into a gallery that attracts thousands of visitors daily. The ramp begins to descend outside the building so that visitors immediately recognise it as the west entrance.

The ramp is not only an entrance but a prominent meeting point – like the tower to the north and the gate to the south, which will be opened to the public in a later building phase. It is part of the strategy which does not treat the gigantic complex as a closed shell, but has transformed it into a landscape with different topographies that visitors can approach and use from all four directions. The ramp takes visitors down to the base level of the building, the floor of the turbine hall, situated below the water level of the Thames.

Model: the west court and ramp

Model: the turbine hall interior
showing the ramp

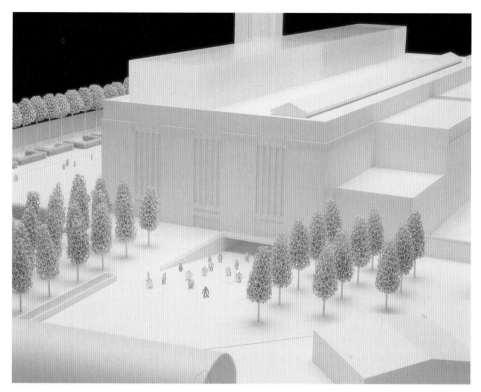

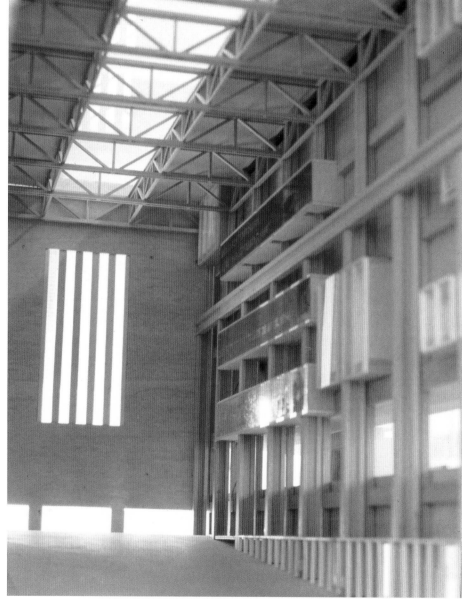

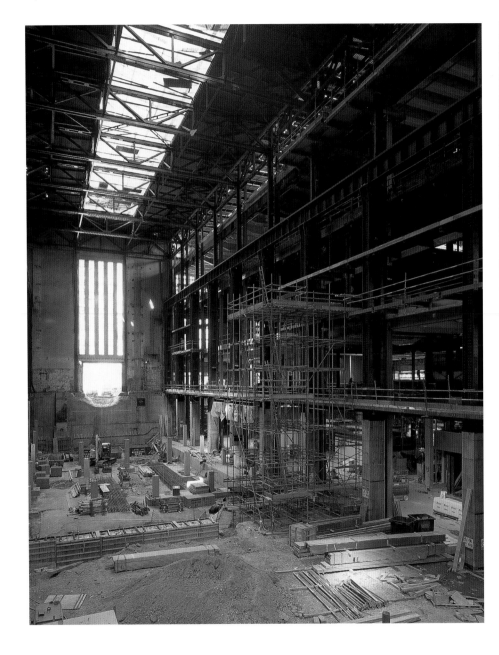

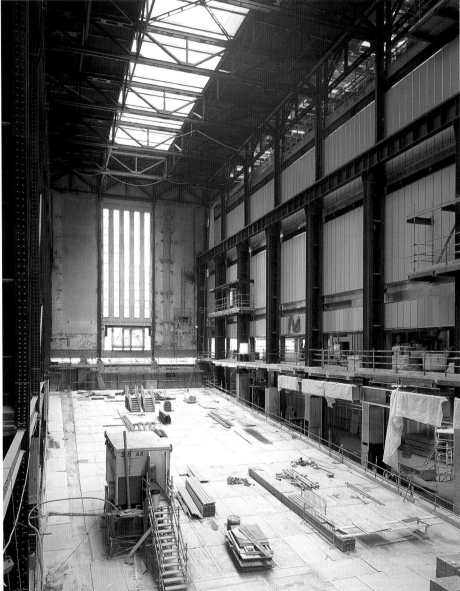

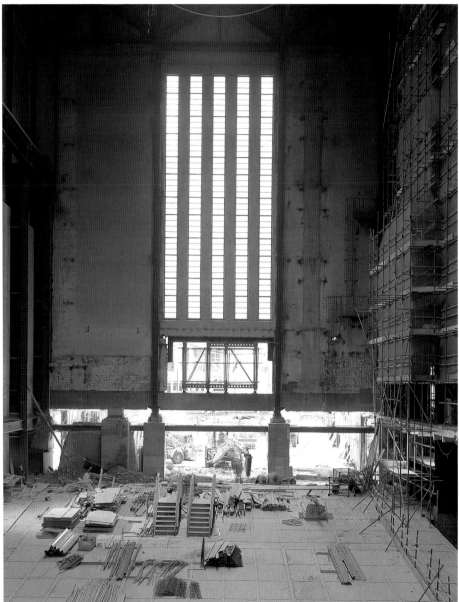

The Herzog & de Meuron competition
entry, showing a section through the
north entrance and turbine hall
platform

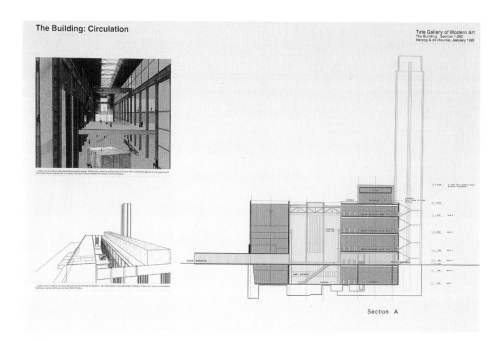

THE TOWER CONCOURSE AND THE PLATFORM

The north entrance is a space that is more than simply a thoroughfare. Its sloping ceiling stretches out between two mighty architectural elements: the brick tower on one side and the turbine hall on the other. The glass shaft of the escalator is a body of light that suffuses floor and ceiling; it is akin to the light beam on the roof and the bay windows in the turbine hall.

The properties of this area, close to one of Tate Modern's main entrances, make it a multi-purpose exhibition space that complements the other display areas.

The platform is a remnant of the flooring that once stretched the entire length of the turbine hall. The removal of this flooring allows visitors to experience the extraordinary scale and dimensions of the turbine hall in their entirety. Today the platform is like a bridge between the former boiler house to the north, containing the galleries, and the switch house to the south, which will be converted into additional exhibition space in a second building phase.

The platform is conceived not only as a bridge between two wings of the building but also as an instrument that addresses the urban surroundings. The promenade along the Thames moves straight into the centre of Tate Modern through the north entrance. From there, the path will eventually cross the platform, pass through the gate to the switch house, and lead to the new Tate garden to the south and on to Southwark.

This makes the platform an important crossroads both for the building itself and for the entire neighbourhood. The platform is a piece of urban topography and also a meeting point, like the ramp to the west of the turbine hall.

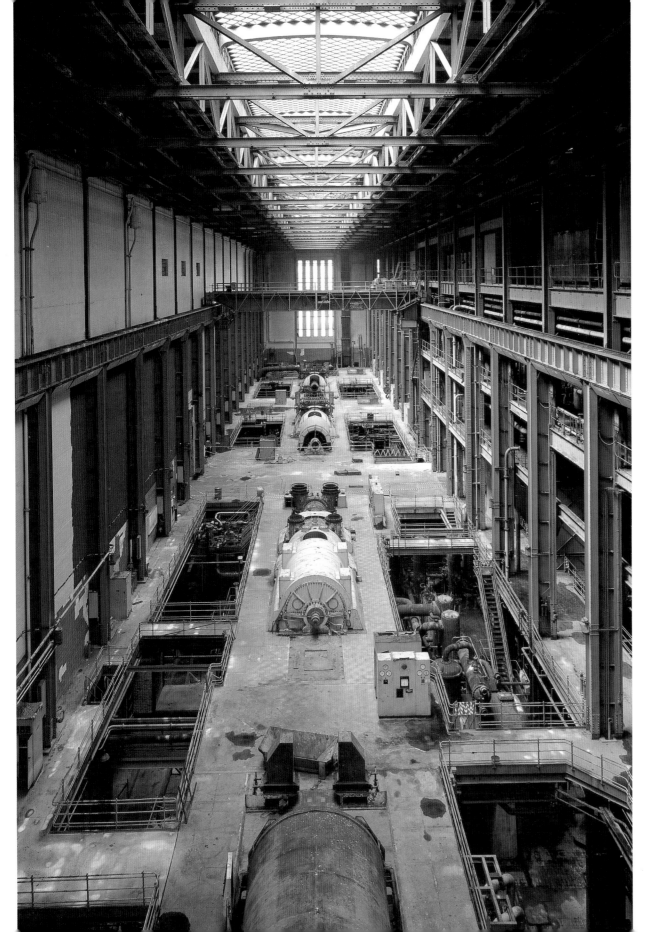

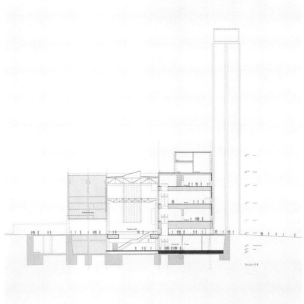

The turbine hall in 1994, before
the removal of the flooring

Section through the tower
concourse (bottom)

143

Competition entry, site plan

Competition entry, ground floor
plan

Competition entry, showing the
proposed row of shops on the
south side (bottom)

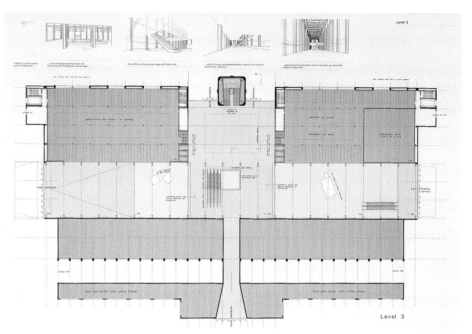

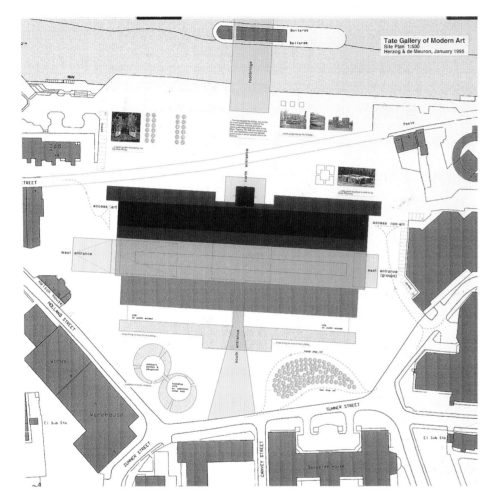

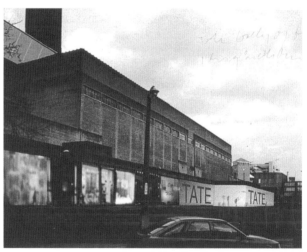

Removing the flooring in the
turbine hall

Competition entry: the turbine
hall platform

The platform stairway: details
(bottom)

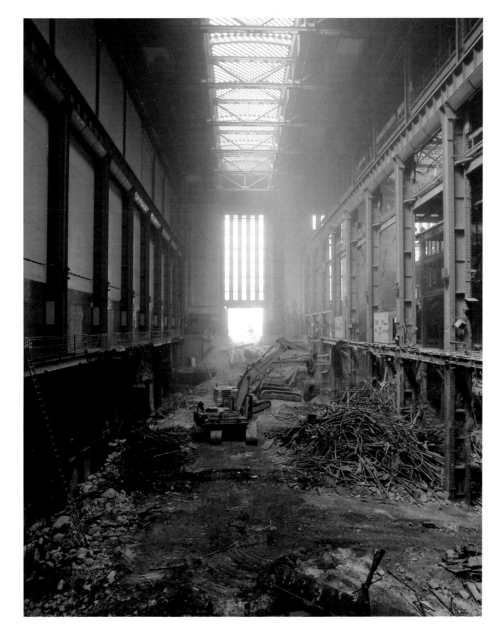

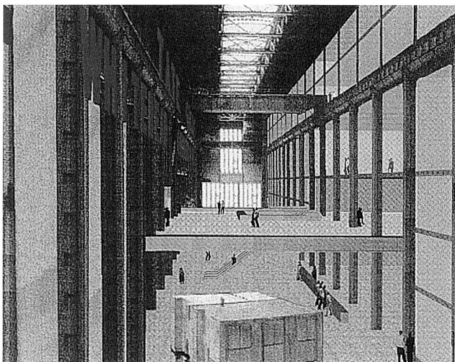

The turbine hall is the area that establishes the link between inside and outside. The hall runs like a street through the entire length and height of the building. The new façade of the gallery rises to the left, revealing its interior structure at a single glance: entrance, shop, cafeteria, educational facilities, auditorium, concourses and exhibition spaces.

Like a covered plaza or galleria, it is open to everyone – to people who have come in order to visit the galleries or to take a look at the annual installations created by artists specifically for this space, or simply to share in the atmosphere.

The elevation of the actual gallery rises on the north side of the turbine hall. It occupies the site of what was once an open-work steel structure with no floors or ceilings, in which countless boilers and other machines were installed.

Several alternatives were explored for this elevation, including: one in black brick and glass, with illuminated glass strips marking each floor slab; a wall in dark brick with a low-ceilinged mezzanine containing circulation, toilets and services but no exhibition spaces; and an elevation in what Jacques Herzog called 'the blackest brick you have ever seen', which proved impossible to achieve. A glowing, all-glass wall, immediately in front of a solid partition with openings cut in it where required was rejected as 'too elegant' and therefore too distracting from the gallery's exhibits. A stripped-down version with painted render walls and simple glazing was designed, after which projecting bay windows and glazed signs were introduced. These were modified into the final design where the bays and signs were fused to produce illuminated boxes containing the bay windows.

In all the experiments with this elevation one idea remained constant, which was that it should represent what was happening in the galleries and circulation spaces behind, but it was only through testing different ideas that the architects could discover the best way of treating the existing structure. In the final design the existing building's row of steel pillars is revealed on both sides of the elevation, but their rhythm is interrupted by the bay windows.

The boiler house in 1994

The turbine hall, looking towards
the boiler house, in 1994

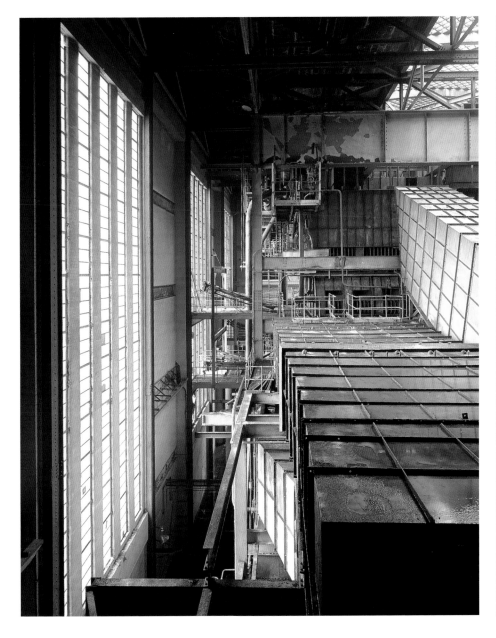

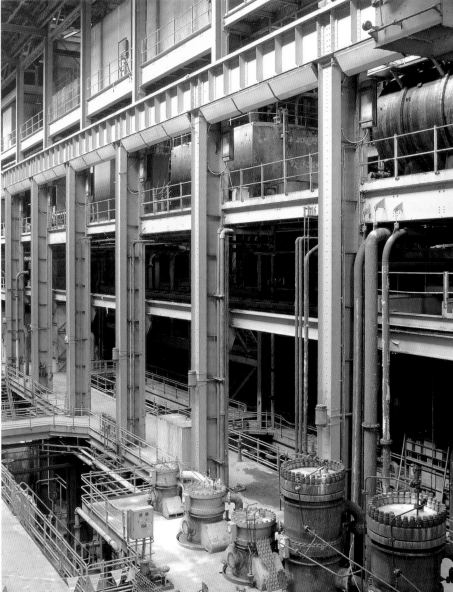

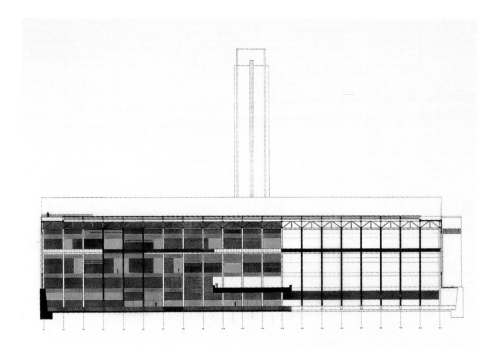

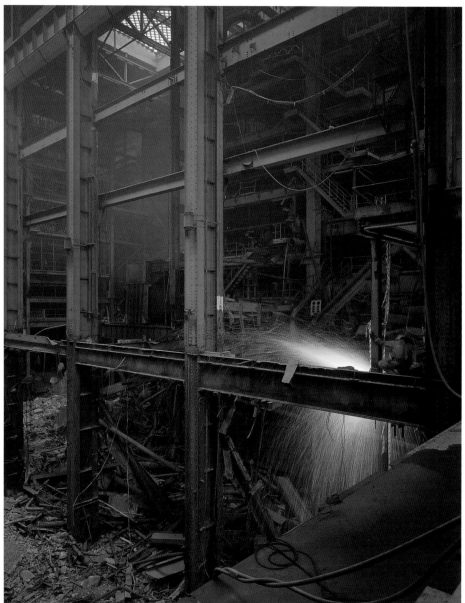

The elongated, light-filled bay windows afford an interior view of the gallery block and its exhibition activities. They are also architectural features that break up the mighty, vertical steel supports of the façade and generate an optical instability. Depending on lighting conditions, they sometimes seem to be suspended, brightly illuminated, in front of the façade, thereby toning down the monumentality of the industrial architecture.

The façade on the south side of the turbine hall is opaque at present; the rooms behind them will be made accessible in a later building phase.

Proposals for the boiler house
elevation

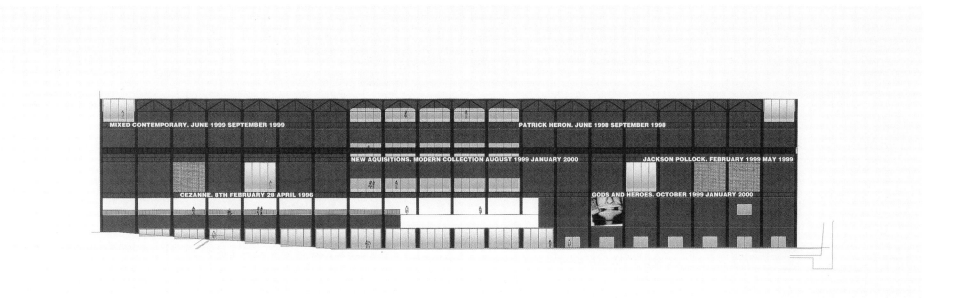

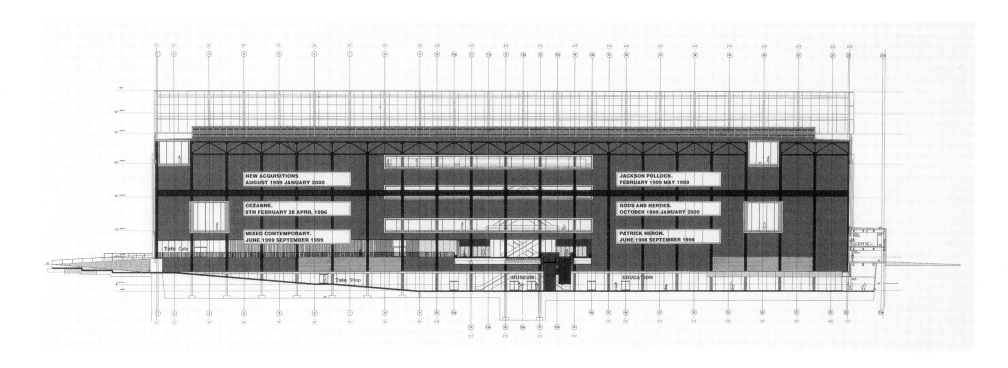

149

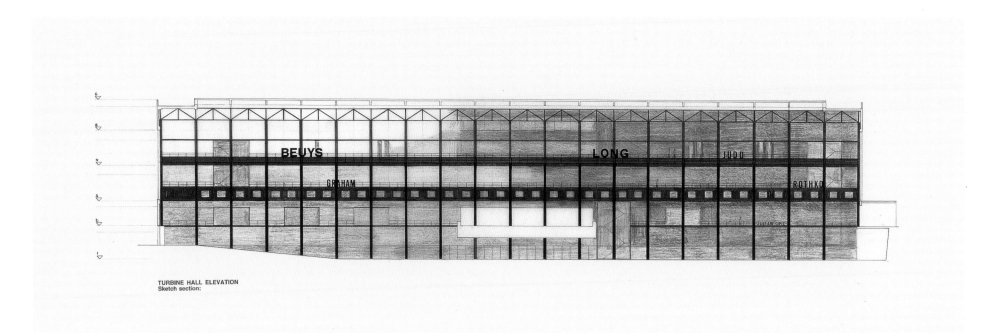

TURBINE HALL ELEVATION
Sketch section:

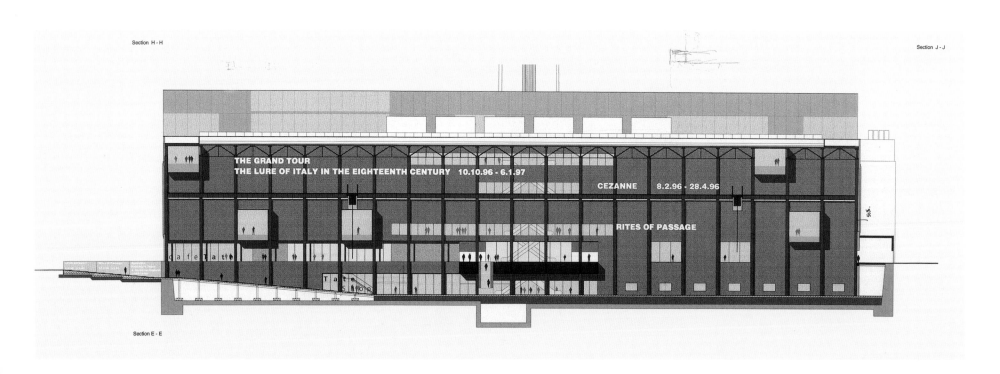

Section H - H

Section J - J

Section E - E

The boiler house, seen from the
turbine hall, after removal of
the plant

Proposed cross-section through
the well between the boiler house
and the turbine hall

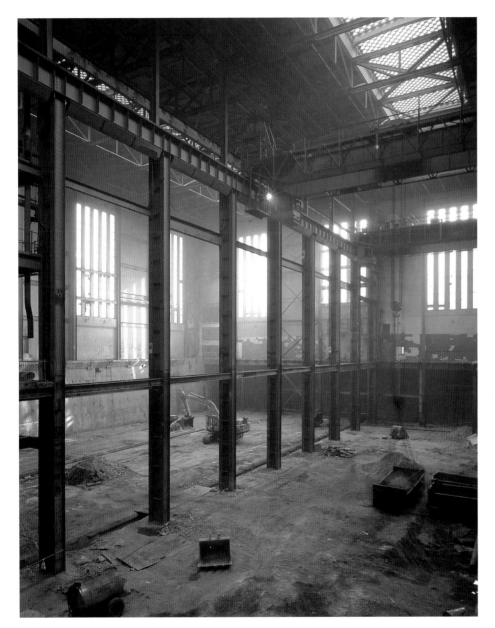

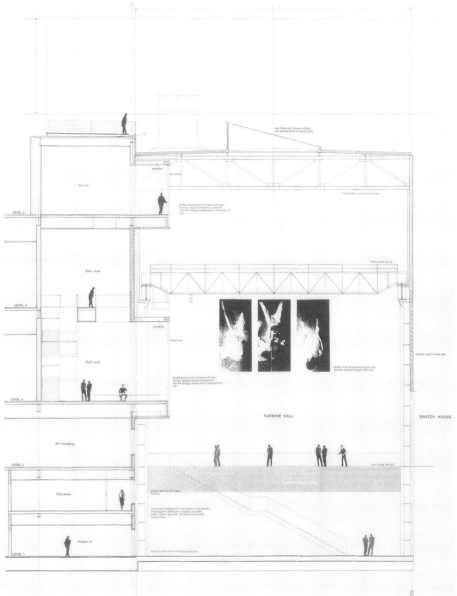

Section through (left to right) the
boiler house, turbine hall, switch
house and oil tanks

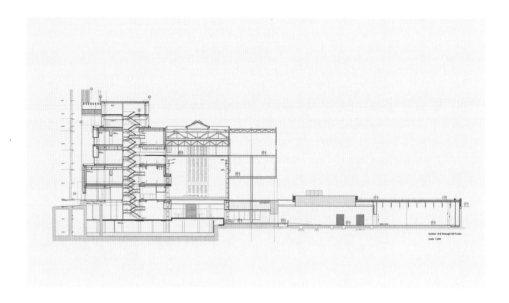

HIDDEN SPACES

The power station, as designed by Giles Gilbert Scott, was organised in three parallel spaces, each of which served a specific function. The boiler house was installed to the north facing the Thames, the huge turbines were placed in the middle, and the switch house lay to the south. The latter still contains switching stations today, which have been supplied with electricity produced outside London since 1982, when the power station was decommissioned. In a later building phase, the switch house will also be incorporated in the new gallery complex.

Probably the most dramatic spatial composition in the former power station are three cylindrical spaces, arranged like a three-leaf clover, which once housed the oil tanks. They will one day be accessed directly from the garden to the south. The ground-level rooms, now containing the transformers, will be directly connected to the gardens. These rooms and the floors above them could, for example, house a department of design and architecture, a library or other exhibition spaces and seminar rooms.

Upon completion of the second building phase, the turbine hall will reveal its full potential as a covered street. The soft hum of the ventilation equipment, now required to cool the transformers, will then be eliminated.

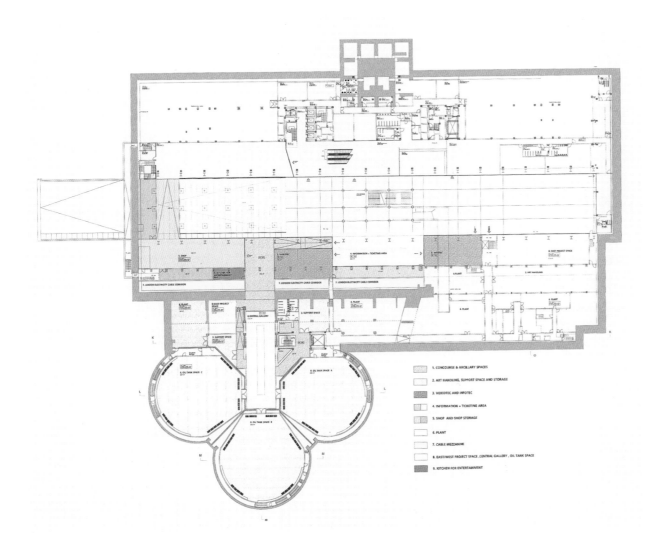

1. CONCOURSE & ANCILLARY SPACES

2. ART HANDLING, SUPPORT SPACE AND STORAGE

3. VIDEOTEC AND INFOTEC

4. INFORMATION + TICKETING AREA

5. SHOP AND SHOP STORAGE

6. PLANT

7. CABLE MEZZANINE

8. EAST/WEST PROJECT SPACE ,CENTRAL GALLERY , OIL TANK SPACE

9. KITCHEN FOR ENTERTAINMENT

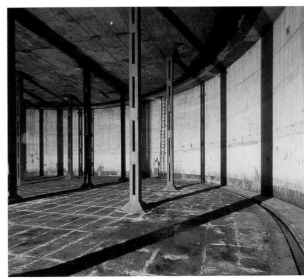

THE STAIRWAY

The stairway connecting all seven storeys of the gallery, functionally complements the other two vertical transport systems: the lifts and the escalators.

However, it plays an entirely different role as well. The heavy steel construction with its flush, wooden handrail, its continuous band of light and its distinctively compact proportions adapted to human movement represents an independent piece of architecture. The balcony-like landings offer visitors surprising, unanticipated vistas between the storeys. While moving up and down the stairs, one feels disengaged from the stream of visitors, the rhythm of one's steps changes and slows down in response to the height of the treads and the placement of the landings.

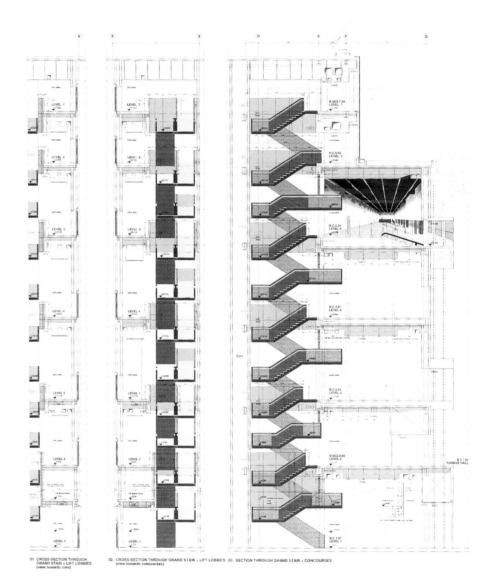

01. CROSS-SECTION THROUGH GRAND STAIR + LIFT LOBBIES (view towards core) 02. CROSS-SECTION THROUGH GRAND STAIR + LIFT LOBBIES (view towards concourses) 03. SECTION THROUGH GRAND STAIR + CONCOURSES

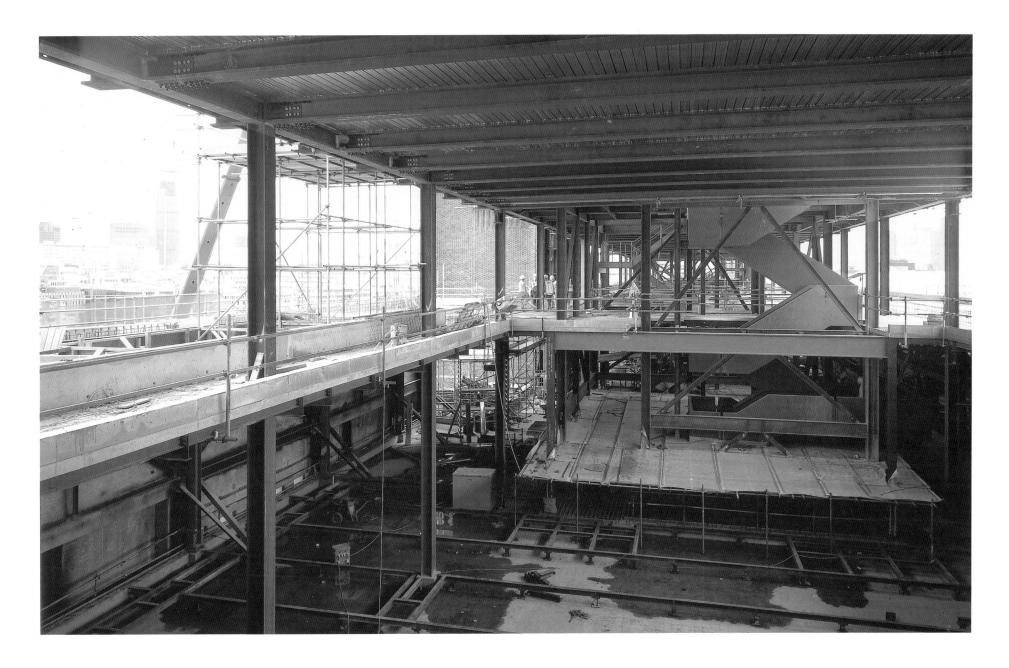

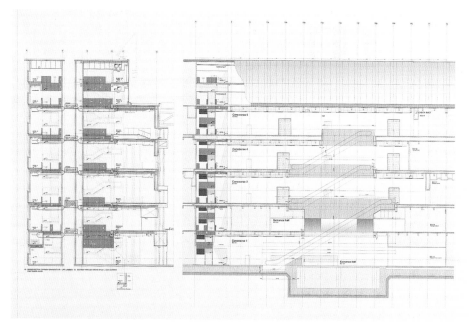

THE BAY WINDOWS AND THE CONCOURSES

The bay windows are self-contained, architectural spaces of more intimate proportions than the adjacent concourses or galleries. They provide moments of rest and contemplation or merely a place to stop between gallery visits. They are also convenient meeting places and offer breathtaking views of the people and works of art in the turbine hall. Seen from the turbine hall, the bay windows look like floating bodies of light – or vitrines with people sitting on benches, relaxing or waiting for someone.

The bay windows belong to the same architectural family as the light beam placed outside on the heavy brick body of the former power station.

The concourses on the exhibition floors are an important source of orientation. They provide views of the turbine hall through the bay windows; they house the vertical transport systems, the stairs and lifts; and they provide access to the individual galleries.

In keeping with their function, they are clearly set off from the galleries and designed as open spaces. The ventilation system, concealed above the plaster ceilings in the exhibition spaces, is visible in the concourses, as if the ceiling had receded to open up the view overhead. Although the concourses are almost identical in size, they each have a character of their own. The concourse on Level 3 hovers directly above the platform in the turbine hall; on Level 4 the concourse yields to the track for the crane; and on Level 5 part of the concourse ducks under the mighty steel beams of the turbine hall. The sweeping steps, which follow the rhythm of the ceiling, are an inviting place to stop and rest.

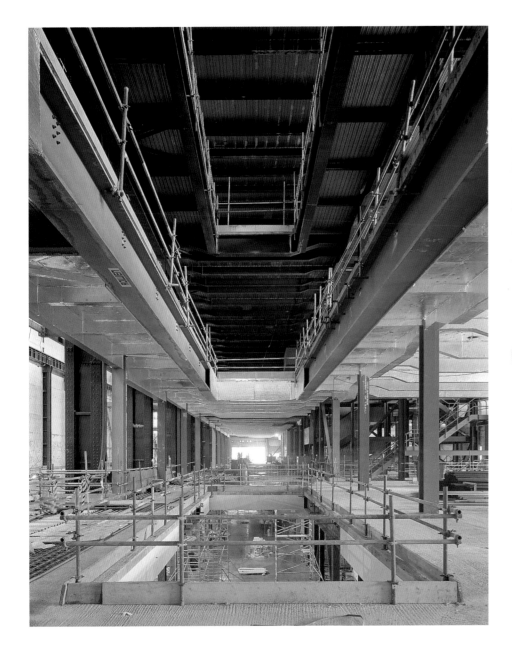

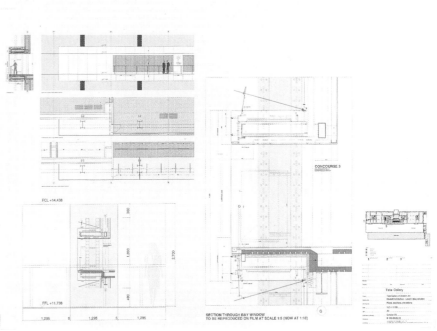

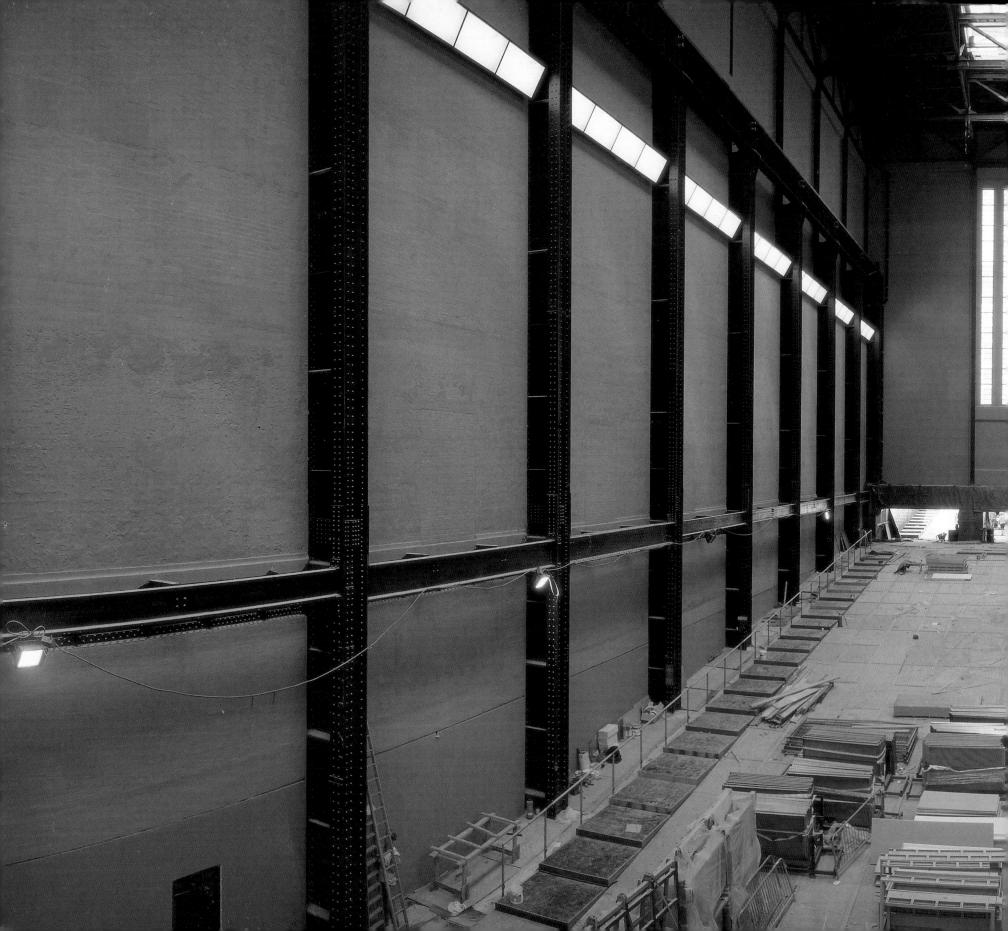

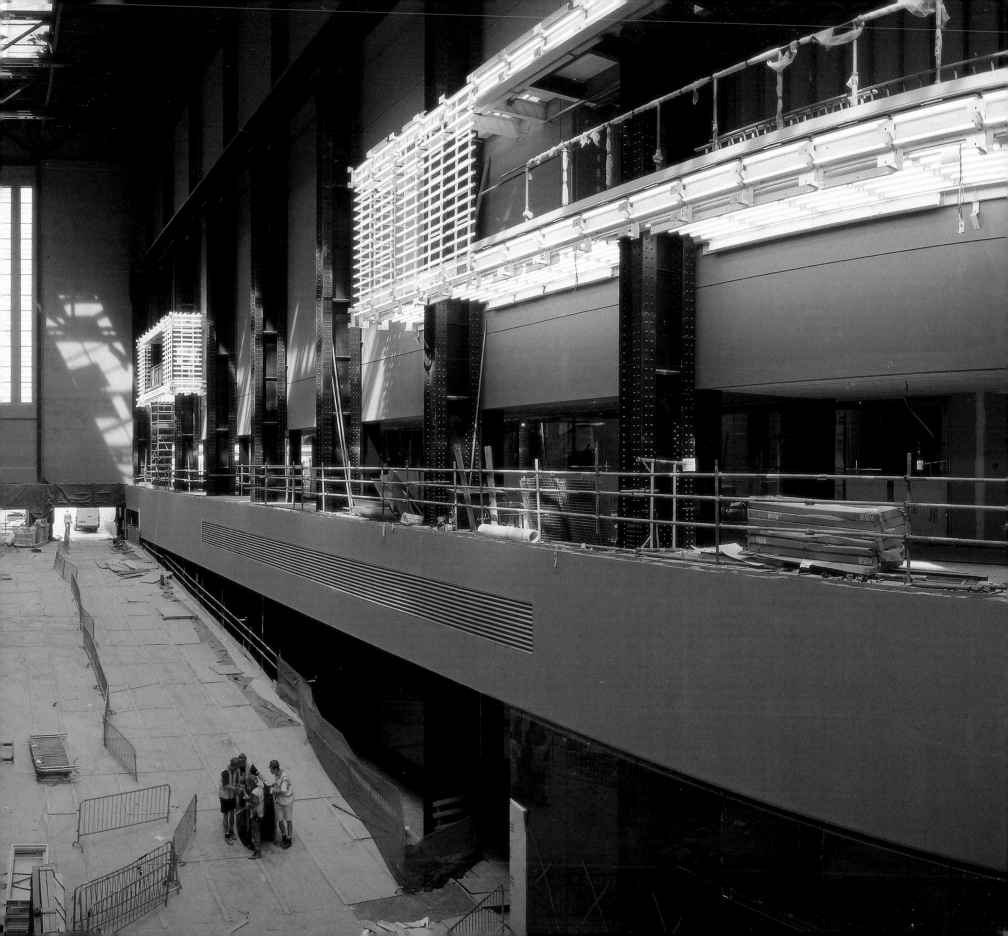

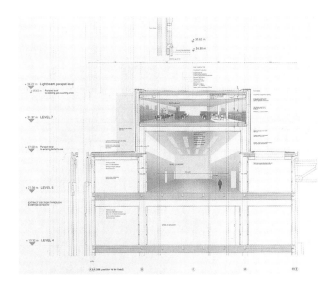

THE CLERESTOREY

The galleries on Level 5 lie above Scott's huge cathedral windows so that daylight can be supplied only from above, via the clerestorey windows within the light beam.

Conservation and the different needs of individual works of art call for precise lighting control. For this reason the glazing in the clerestorey must be translucent to prevent direct sunlight and shadows, but without unduly reducing the intensity or distorting the colour of the daylight. There are two layers of glass with two sets of blinds installed between them: one to adjust the intensity of the light, the other to darken the galleries completely.

The clerestorey also provides artificial illumination, which is designed to duplicate the colouring of daylight.

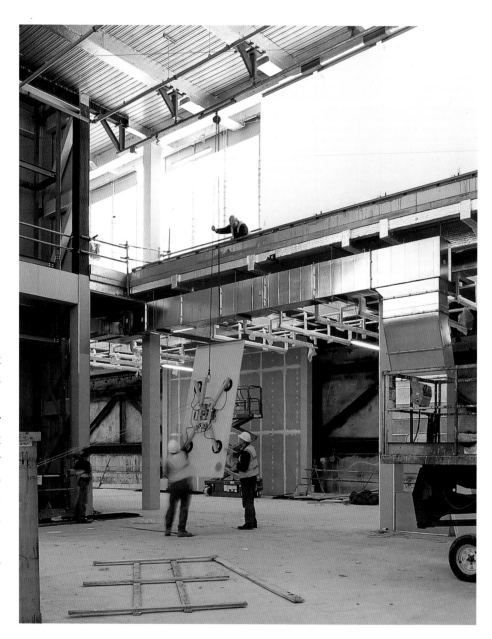

THE GALLERIES

In gallery design there are two extremes: there is the highly specific gallery, which can tend to be overpoweringly spectacular and individualistic, and there is the type which, like a supermarket, gives good orientation and an overview that puts everything in the same light. Herzog & de Meuron have tried to take the best things from both poles: from the supermarket and from a highly specific venue, like the Sir John Soane Museum in Lincolns Inn Fields.

There are three floors of exhibition spaces, none of which is given higher status than another. There is no main level with large, high rooms for monumental works, and different storeys for smaller formats, such as photographs or drawings. All the spaces are at least 5 metres high and some are significantly higher, like the top-lit suites on the fifth floor and the double-height room on Level 3, which rises the entire 12 metre height of the former cathedral window in Scott's brick shell. This vertical room with its dramatic dimensions is not only an exciting experience for visitors; it also offers unprecedented potential for different installations of art.

The spatial variety is considerable; almost all the rooms are different in size and proportion. In addition, walls can be added or removed at certain places, allowing dimensions and scale to be tailored to the needs of special installations.

Lighting is a decisive factor in the perception of art works. Slightly different in every room, it alternates between daylight, artificial illumination and a mixture of both.

The artificial illumination comes from glass panels set flush with the ceiling: potential variations in adjusting the colouring and intensity are almost unlimited. The considerable technical facilities and machinery that make this possible are concealed above the plaster ceiling. All that are visible are the light, the space and, above all, the works of art on display.

Study by Jacques Herzog of
circulation routes through the
galleries

The natural illumination reveals the seasons of the year and the daily weather: sunshine, passing clouds or rain. The fenestration is defined by the immense cathedral windows, placed by Scott in the brick shell. The layout of floors and walls has been designed to establish direct contact between the gigantic windows and the galleries in order to provide a self-evident, direct link between interior and exterior. In the rooms where the light comes in laterally through these wall-height windows, visitors can look out on the backdrop of London and find their bearings in relation to the building.

There are no lateral windows on Level 5 since the floor lies above the cathedral windows. Daylight falls directly from above through glass panels placed flush with the plaster ceiling. They are almost identical to the glass panels for artificial lighting in the two floors below, so that visitors will barely notice the difference.

In the large and high central galleries on Level 5, the walls end at the top in broad strips of glass so that the rooms are flooded with daylight. The light enters the exhibition spaces through the glass front of the light beam. Inside, visitors sense the quality of the light outside as it comes in through the bands of glass without interfering with the perception of the works of art.

Although the rooms vary in size and proportion, they are all plain and rectangular. They are ordinary and self-evident, yet have a powerful impact. The views of London are, of course, spectacular. But the simplicity and directness that produce this impression of self-evidence are also

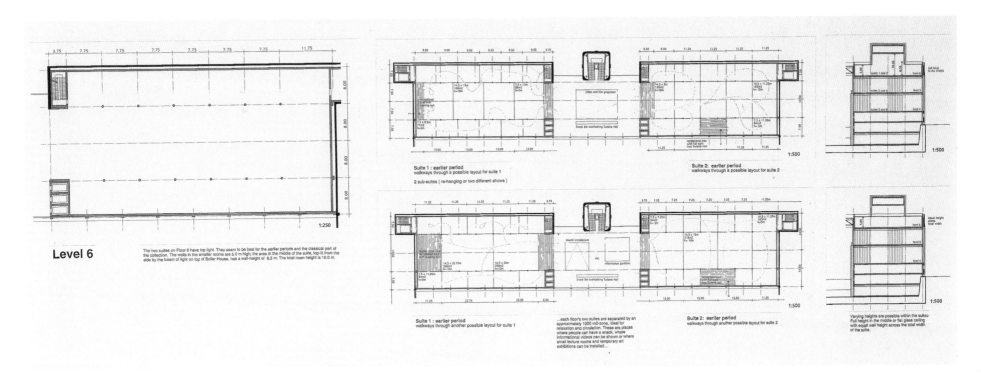

Level 6

1:250

The two suites on Floor 6 have top light. They seem to be best for the earlier periods and the classical part of the collection. The walls in the smaller rooms are 5.0 m high; the area in the middle of the suite, top-lit from the side by the beam of light on top of Boiler House, has a wall-height of 6.5 m. The total room height is 10.0 m.

Suite 1 : earlier period
walkways through a possible layout for suite 1

2 sub-suites (re-hanging or two different shows)

Suite 2: earlier period
walkways through a possible layout for suite 2

1:500

1:500

Suite 1 : earlier period
walkways through another possible layout for suite 1

...each floor's two suites are separated by an approximately 1000 m2-zone, ideal for relaxation and circulation. These are places where people can have a snack, where informational videos can be shown or where small lecture rooms and temporary art exhibitions can be installed...

Suite 2: earlier period
walkways through another possible layout for suite 2

1:500

1:500

Varying heights are possible within the suites: Full height in the middle or flat glass ceiling with equal wall height across the total width of the suites.

striking and unusual. There are no connecting joints between walls and floors or floors and ceiling. The ceilings are flat and unarticulated. The oak floors are untreated and add an unexpected sensuality to the rooms, while the dark concrete floor on Level 5 forms an unaccustomed contrast with the works of art, especially those of classical Modernism. The cast-iron grilles for ventilation, set into the flooring, look as if they were part of the former power station. The vertical slots of these grilles are angled to face the walls close to where the grilles are located, so that it is impossible for visitors to look through them to the voids underneath, which would be disconcerting.

As a whole, one has the impression that the exhibition spaces have always been there, like the brick façades, the chimney or the turbine hall.

This impression is, of course, deceptive. In the interior of the building everything has been re-invented and re-conceived, but the new and old building components have been interrelated and attuned to each other in such a way that they are sometimes indistinguishable. Something new has emerged that gives more than the simple preservation of an existing structure and is more complex than a completely new building.

Competition entry: cross-section
showing different gallery types

Competition entry: sketch
sections showing lighting
alternatives (bottom)

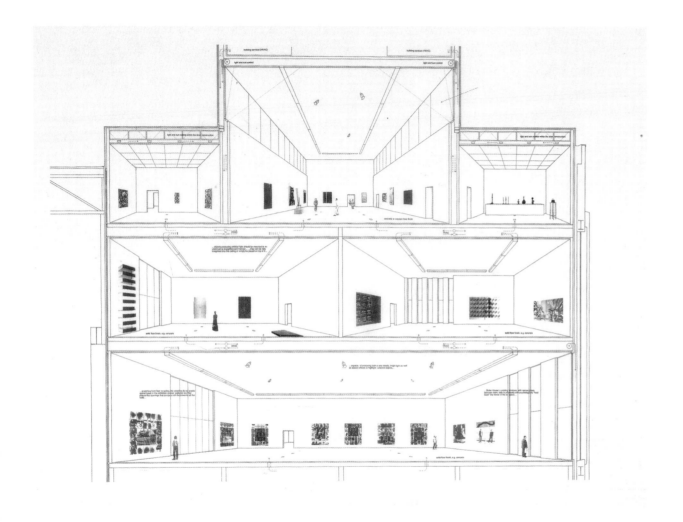

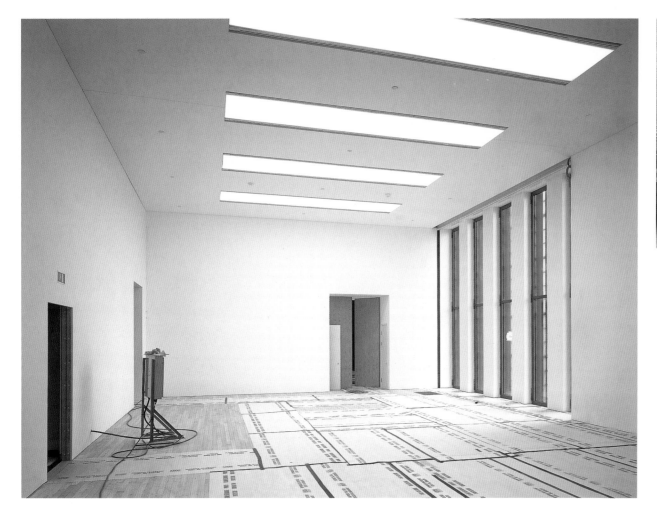

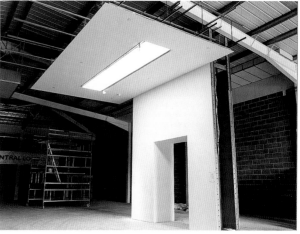

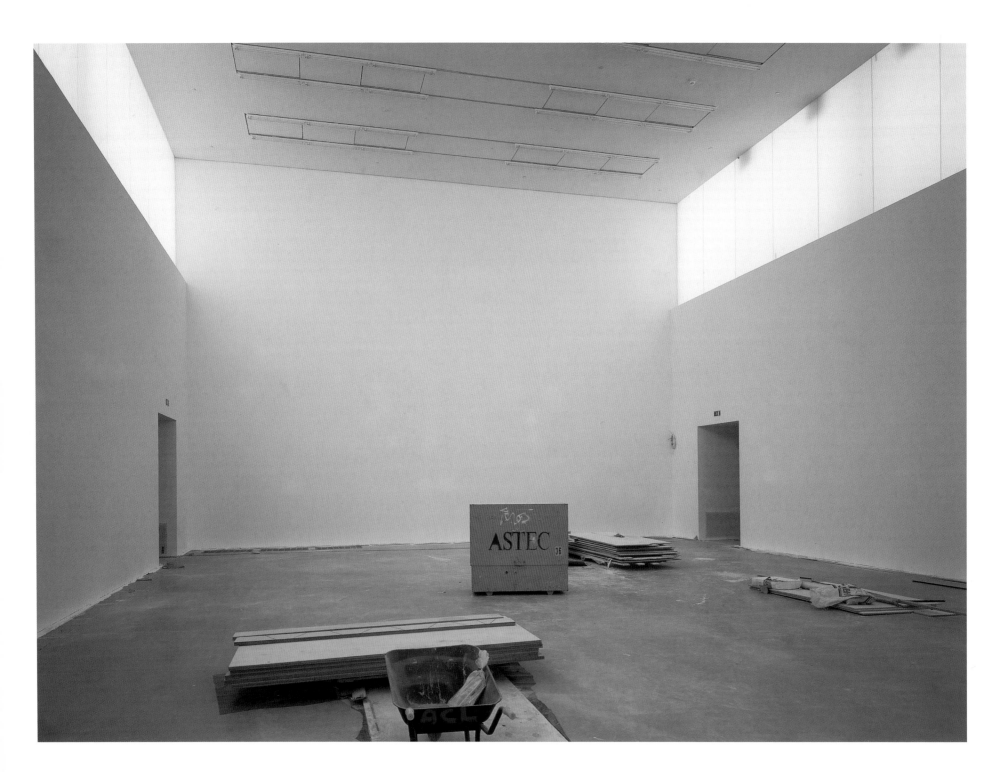

PLANS AS BUILT

Level 1

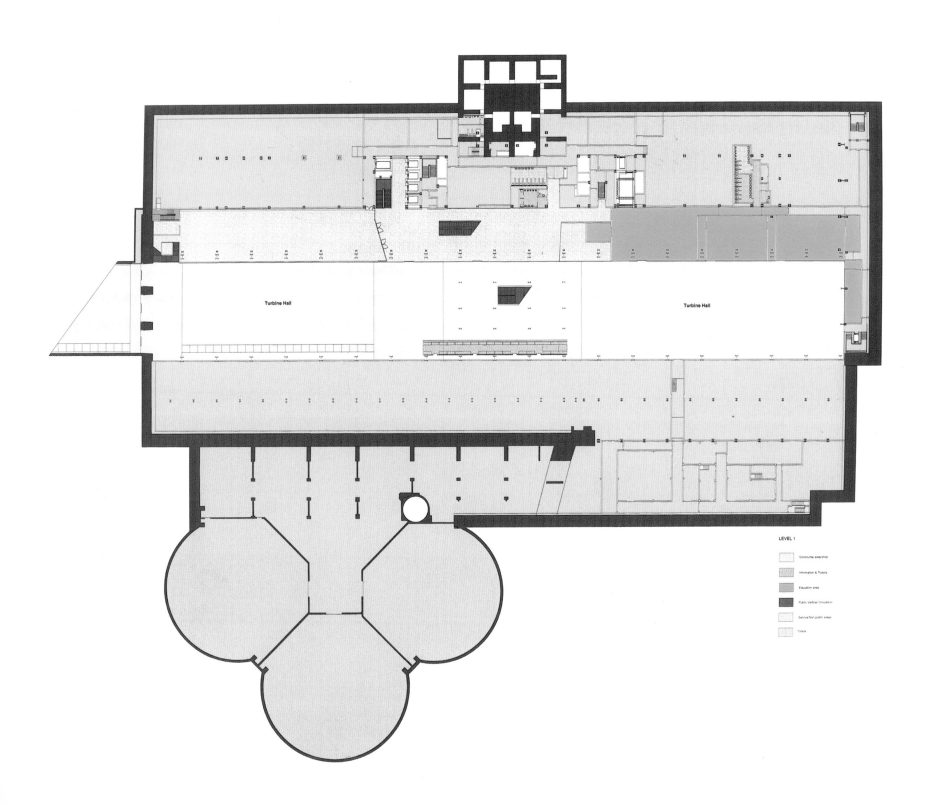

Turbine Hall

Turbine Hall

LEVEL 1

Concourse area/shop

Information & Tickets

Education area

Public Vertical Circulation

Service/Non-public areas

Toilets

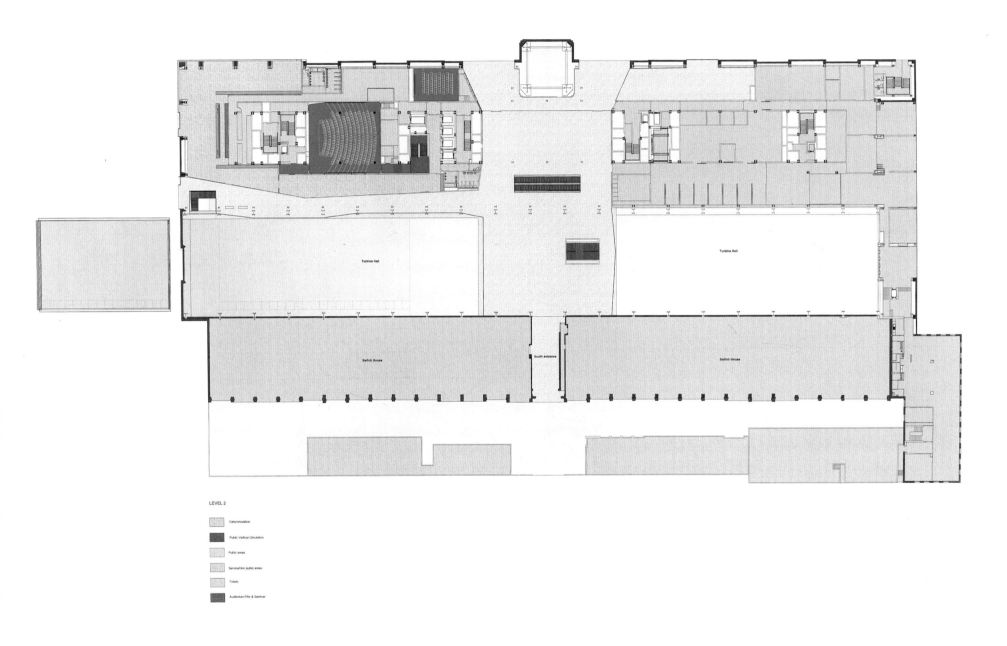

LEVEL 2

Cafe/circulation

Public Vertical Circulation

Public areas

Service/Non public areas

Toilets

Auditorium/Film & Seminar

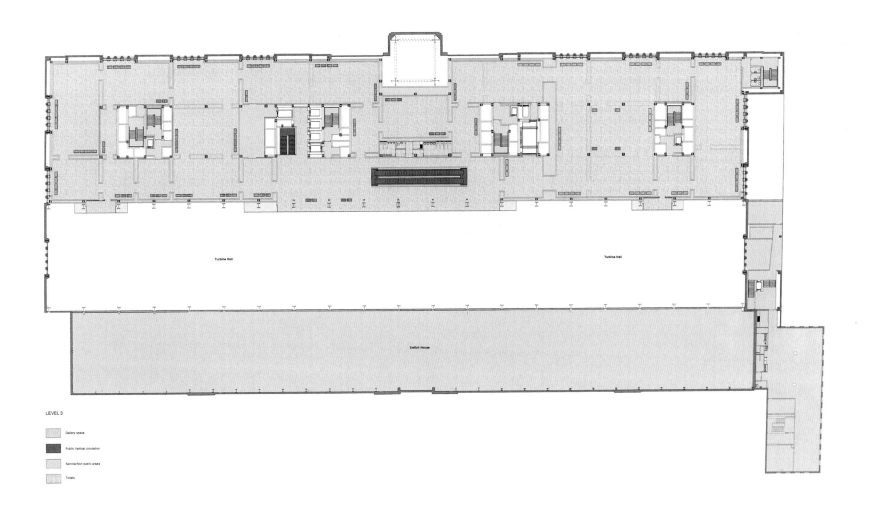

LEVEL 3

Gallery space

Public Vertical circulation

Service/non public areas

Toilets

Turbine Hall

Turbine Hall

Switch House

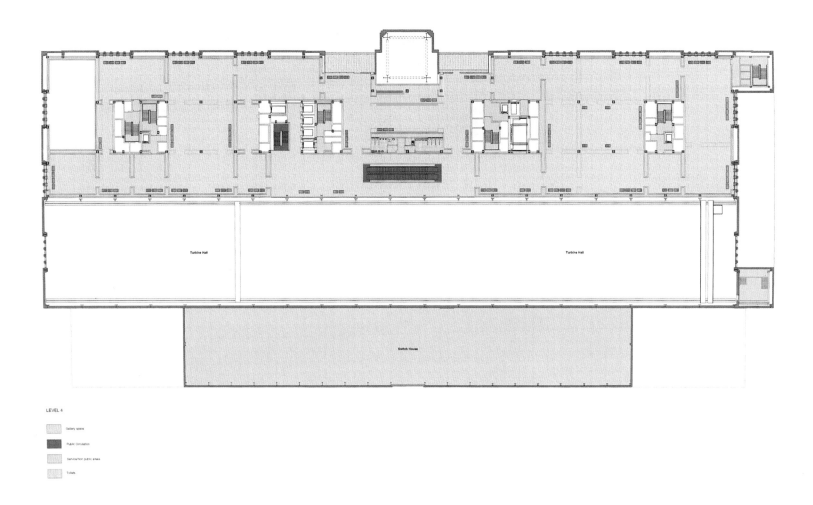

LEVEL 4

Gallery space

Public Circulation

Service/non public areas

Toilets

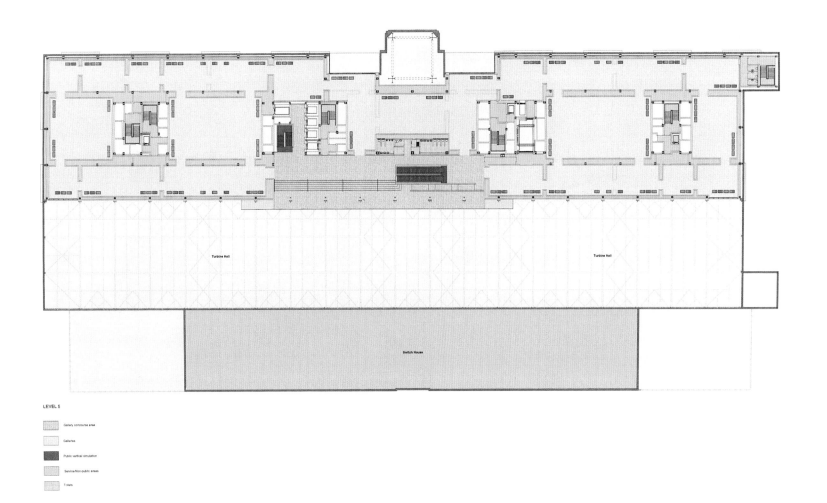

LEVEL 5

Gallery concourse area

Galleries

Public vertical circulation

Service/Non-public areas

Toilets

Turbine Hall

Turbine Hall

Switch House

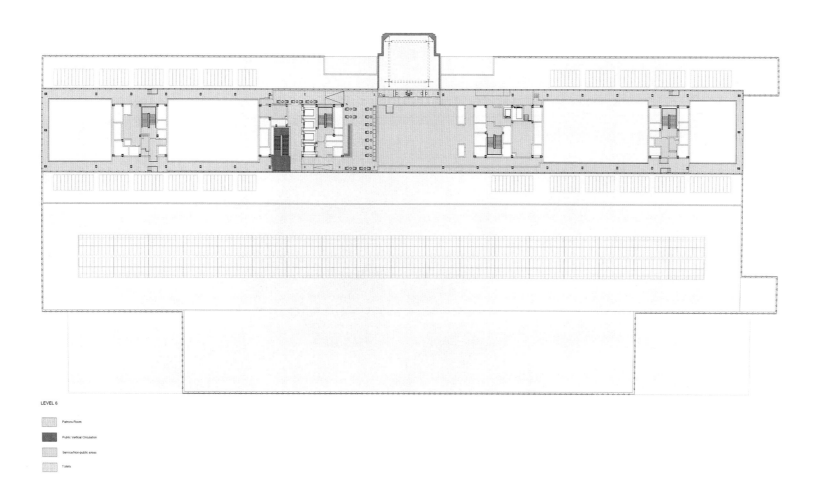

LEVEL 6

Patrons Room

Public Vertical Circulation

Service/non-public areas

Toilets

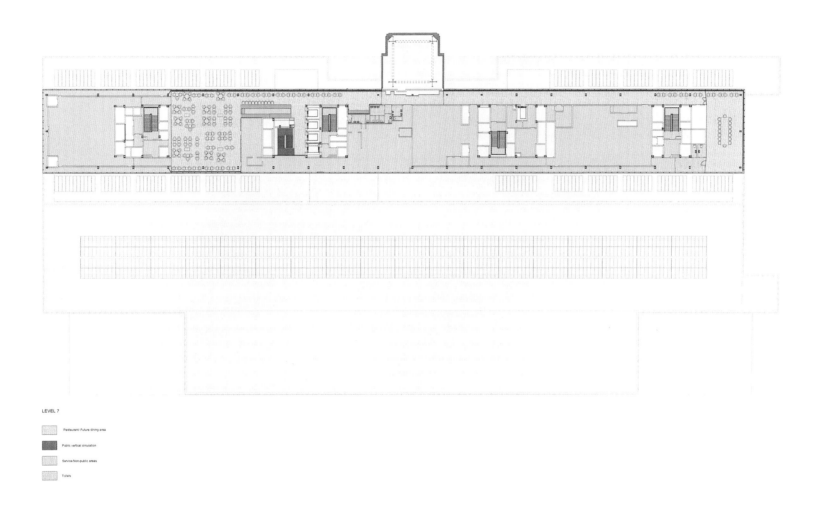

LEVEL 7

Restaurant/ Future dining area

Public vertical circulation

Service/Non-public areas

Toilets

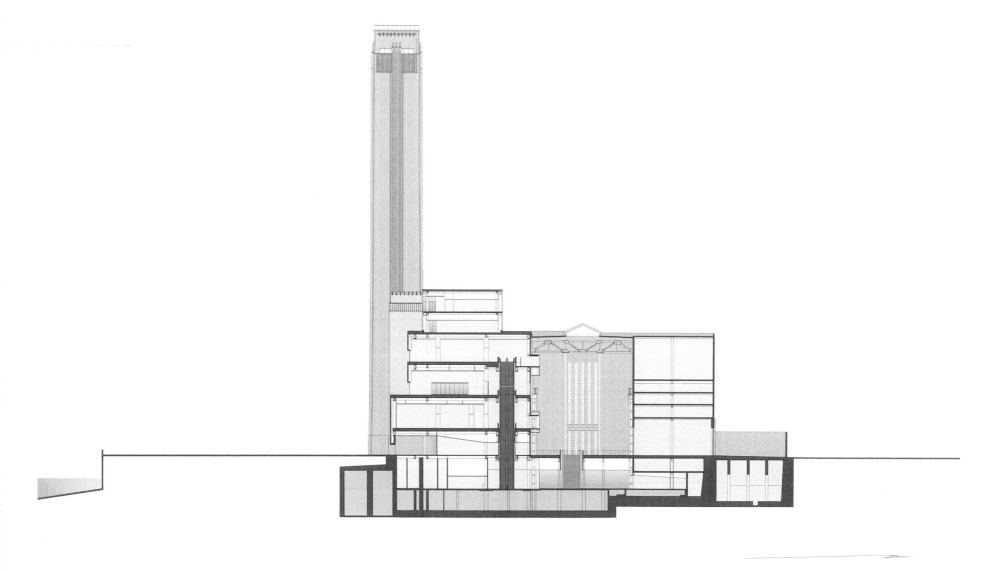

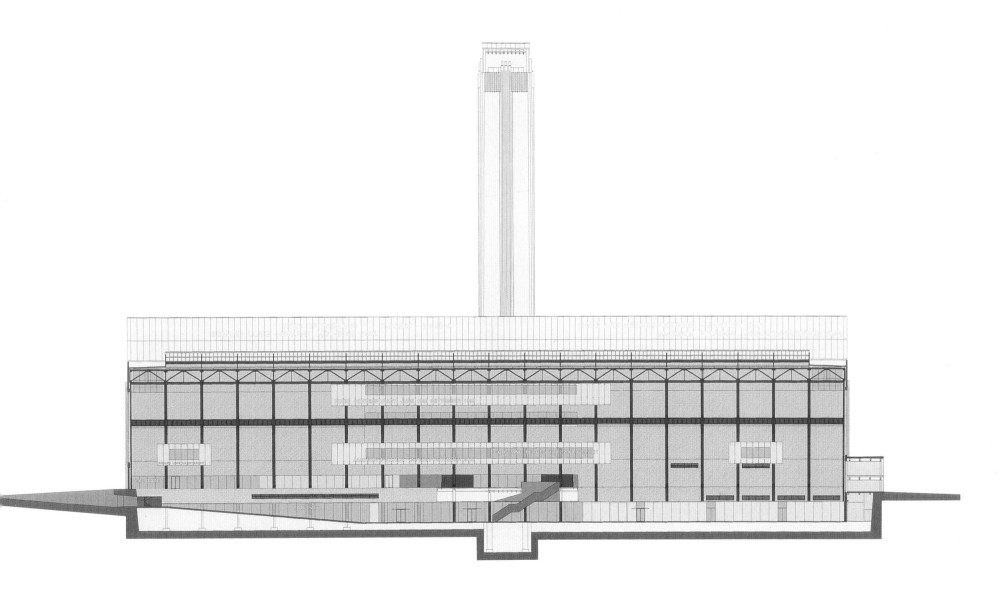

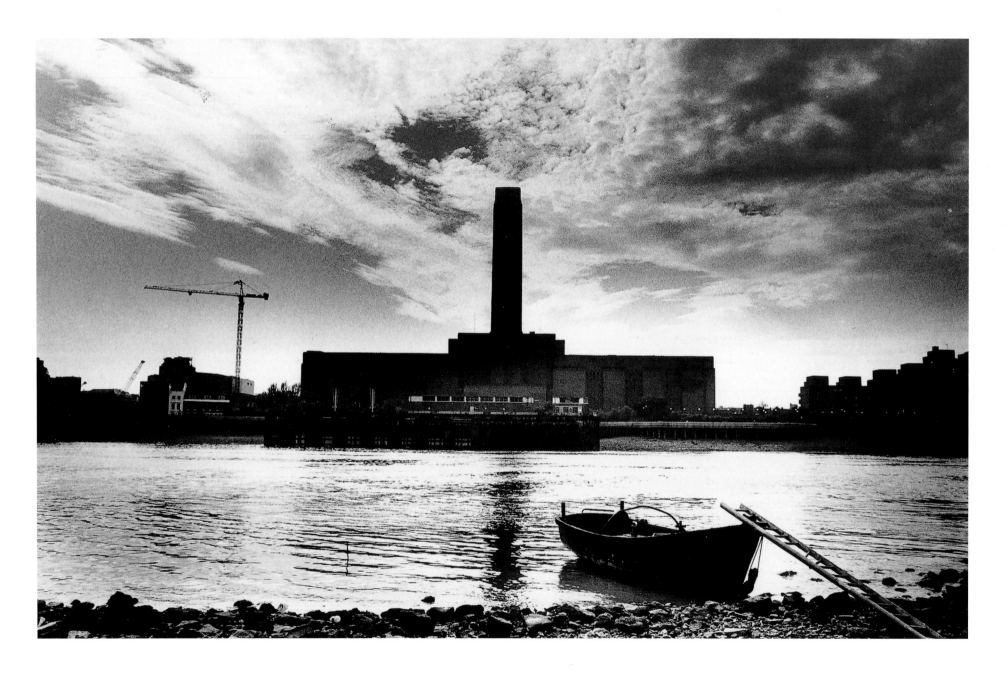

GILES GILBERT SCOTT AND BANKSIDE POWER STATION

GAVIN STAMP

Bankside Power Station should never have been built – or, rather, it should never have been built on such a prominent site in the very heart of London, on the south bank of the Thames right opposite St Paul's Cathedral. It had long been regarded as undesirable to have large power stations in the centre of cities, and in the County of London Plan, as in the several other plans for rebuilding the capital prepared during the dark years of the Second World War, banishing noxious industry was a high priority. For example, in the second report of the Royal Academy Planning Committee published in 1944 as *Road, Rail and River in London*, the river bank between London Bridge and Blackfriars was to be devoted to commercial purposes with 'well designed wharves and warehouses' but not to an electricity generating station pumping more fumes into the already polluted air.[1]

At this time, the chairman of the RA Planning Committee was Sir Giles Gilbert Scott, OM, who had been elected after the death of Sir Edwin Lutyens. No wonder, then, that the architect was a little defensive when, only three years later, he unveiled a model of his revised design for a massive new electricity generating station on Bankside. 'It has been said that the power station will dwarf St Paul's,' Scott told a press conference. 'Well, there is the so-called monster, and there, adjoining it, are the buildings as proposed in the County of London Plan for this part of the river. The station is lower than the ordinary building allowed under the London Building Act. As you can see, it will be more a question of the other buildings overshadowing the station than the station overshadowing them,' he countered, rather lamely.[2]

Sir Giles Gilbert Scott was not like his celebrated grandfather, Sir George Gilbert Scott, who had been prepared to abandon the Gothic he had espoused and design the Foreign Office in the Italian Classical style at the behest of the Prime Minister rather than give up the job. In that same year – 1947 – he had resigned as architect for the rebuilding of Coventry Cathedral after his design had been criticised by the Royal Fine Art Commission for being a compromise between tradition and modernity. At Bankside, however, Scott no doubt felt that ideal wartime plans were all

1 *Road, Rail and River in London. The Royal Academy Planning Committee's Second Report*, London 1944, p.10

2 'The Bankside Power State. Sir Giles Scott Explains' in *The Builder*, 23 May 1947, p.494

very well but, if there really had to be a new power station on the river bank opposite St Paul's, he might as well be pragmatic as he was surely the best person to improve its design and mitigate its impact. After all, an inappropriate and unsightly electricity generating station built by the City of London Electric Lighting Co. had been on the site since 1891 and it had been enlarged in 1928. Further expansion by the London Power Company had only been halted by the outbreak of war in 1939.[3]

Giles Gilbert Scott might seem an unlikely architect to have been hired to give architectural respectability to such a highly controversial industrial project. He was and is best known as the designer of the Anglican cathedral in Liverpool, that last great romantic expression of the Gothic Revival which he had won in competition at the astonishingly early age of twenty-two. Born in 1880, Scott was the son and the grandson of Gothic church architects and had been an articled pupil in the office of another, Temple Moore. Apart from the great work in Liverpool which was not to be completed until after his death, Scott's early work consisted of designing

Roman Catholic churches – at Sheringham, Ramsay and Northfleet – and, after the First World War, he had gone on to become the accomplished architect of sophisticated Anglican churches at High Wycombe, Luton and Golders Green, as well as the war memorial chapel for Charterhouse School at Godalming, and of Catholic churches at Bath, Ashford (Middlesex) and Oban.

After he was knighted in 1924, following the opening of the choir of Liverpool Cathedral, Scott's practice expanded and he showed a remarkable ability to engage with new types of commission for which his training can hardly have prepared him. First there were residential buildings at Clare College, Cambridge, and Magdalen, Oxford, and a large new educational institution in Putney, Whitelands College. Then came large new university libraries in both Cambridge and Oxford. Although able to treat traditional building materials with real sympathy and always alive to the importance of detail, he could also work comfortably with engineers on designing large steel-framed or reinforced concrete structures. Scott's

3 For the architectural history of electricity
in London, see Gavin Stamp and Glynn Boyd
Harte, *Temples of Power*, Burford 1979

Liverpool Cathedral soon after the completion of the west end in 1979

ability to handle very complex technical briefs was shown, above all, in his design for rebuilding the House of Commons after the old chamber had been destroyed by enemy action in 1941. His versatility was further demonstrated by his winning design for a new telephone kiosk for the General Post Office in a limited competition organised by the newly founded Royal Fine Art Commission in 1924. Refined for mass production as the 'K6' or Jubilee Kiosk in 1935, it soon became a familiar aspect of the British landscape, both urban and rural. Giles Gilbert Scott's talent was ubiquitous.

The new House of Commons was in a modern Gothic style; the Memorial Court at Clare in a sort of neo-Georgian or *neo-Grèc*; the chapel at Lady Margaret Hall, Oxford, vaguely Byzantine; his telephone kiosk was influenced by the work of Soane; and the controversial new Bodleian Library designed in a compromise manner at once traditional and modern, while his industrial buildings were given a modernistic treatment with an Art Deco flavour. Despite his training as a Goth, Scott was wholly undoctrinaire about style. Having demonstrated such versatility combined

with an unusual openness to new ideas, he was an ideal choice in 1933 as President of the Royal Institute of British Architects, which was about to celebrate its centenary.

It was a time when the authority of historical styles was being undermined by the impact of ideas from the Modern Movement in Europe and in this situation, Scott held to a 'middle line'. In his inaugural address, he announced that 'I hold no brief either for the extreme diehard Traditionalist or the extreme Modernist and it seems to me idle to compare styles and say that one is better than another.'[4] Impatient of dogma, although happy to use new types of construction when appropriate, Scott's approach to design was intuitive rather than intellectual. He was not hostile to modernism, recognising its 'negative quality of utter simplicity' as a healthy reaction against 'unintelligent Traditionalism'. But Scott believed that the machine aesthetic had been taken to extremes at the expense of the human element: 'I should feel happier about the future of architecture had the best ideas of Modernism been grafted upon the best traditions of

4 *Journal of the RIBA*, 11 Nov. 1933, pp.5–14

the past, in other words, if Modernism had come by evolution rather than by revolution.'[5]

With such an impressive body of work behind him and enjoying respect both inside and beyond the profession, Scott soon became in demand as a 'safe pair of hands' when large new projects ran into difficulties. He was asked by the London County Council to work with the engineers Rendel, Palmer & Tritton on the design for a new structure to replace John Rennie's old Waterloo Bridge which many argued ought be preserved. But Scott's first important intervention to defuse public controversy was over the new Battersea Power Station, further west along the Thames from Bankside.

The proposal to erect a large coal-fired generating station in Battersea naturally provoked opposition from the residents of Westminster and Chelsea on the opposite side of the Thames and was discussed in Parliament. Scott was then hired by the London Power Company as consultant architect for the exterior, but only at a late stage – in 1930 – when the general form of the structure had been designed by the Manchester firm of Halliday & Agate and construction had already begun. Scott disliked but was unable to alter the upturned table configuration of the power station, but he remodelled the four corner chimneys like classical columns in concrete, and faced the walls in beautiful brickwork which was enlivened with vertical *jazz-modern* fluting along the parapets: what John Betjeman once disparaged as 'restrained Jazz'.[6]

5 See Gavin Stamp, 'Giles Gilbert Scott. The Problem of "Modernism"' in *Architectural Design* 49, nos.10–11, special issue on *Britain in the Thirties*, 1979

6 John Betjeman, 'Antiquarian Prejudice' in *First and Last Loves*, London 1952, p.61

The result was a triumphant success. Scott had developed an external treatment which succeeded in humanising the great bulk of the monster without denying its sublime scale or industrial character. By the time the first half of the power station – Battersea 'A' – was completed in 1935, it had become a conspicuous landmark of modern architecture. In 1939, in a survey conducted by *The Architects' Journal* in which 'celebrities' were asked to list what they thought were the best modern buildings in Britain, Battersea Power Station came second overall – after Peter Jones in Sloane Square, but ahead of Charles Holden's London Transport headquarters – and it was the first choice of, amongst others, Sir Kenneth Clark, Rebecca West and Charles Laughton.[7]

Scott employed his new industrial style for similar commissions which soon followed: buildings for generating electricity and, more attractively, for generating stout at the big new Guinness Brewery at Park Royal. In a letter about designing the proposed new power station at Rye House on the River Lea, Scott explained how he took a flat fee for such jobs and how

'I confine my work entirely to matters of appearance, and as this is largely influenced by the plan and the location of the main units in relation to each other, it is essential that I come in early. Having arrived at a satisfactory grouping, I prepare elevations, and when these are approved I do scale details and full-sizes, select the materials, visit the job occasionally to see that these materials are used in the right way, and inspect sample walling, etc., but I do not superintend the erection, nor transact the business side. All this is done by the promoters' architectural staff, or another architect, who also prepare the necessary working drawings embodying, of course, my details in them.'[8] Scott evidently enjoyed such jobs and he confessed to a colleague that 'I have also found that there is not nearly as much to do as might be anticipated from the size of the buildings.'[9]

No wonder that, on the advice of the consulting engineers Mott, Hay & Anderson, the soon-to-be-nationalised London Power Company again chose Scott as consulting architect for its controversial project on Bankside. He insisted that it was possible to make a fine architectural composition

7 *The Architects' Journal*, 25 May 1939, and see Gavin Stamp, 'Battersea Power Station' in the *Thirties Society Journal* no.1, 1981, pp.3–8

8 Scott to W.N.C. Clinch of the Northmet Power Co., 7 January 1947 [British Architectural Library]

9 Scott to Howard Robertson, 17 October 1947 [British Architectural Library]

Scott's first design for Bankside
Power Station, with a chimney at
each end (published in the
Architects' Journal, 16 January
1947)

Preliminary sketches by Scott for
Bankside

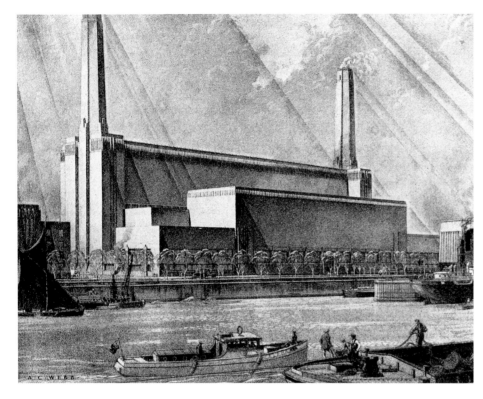

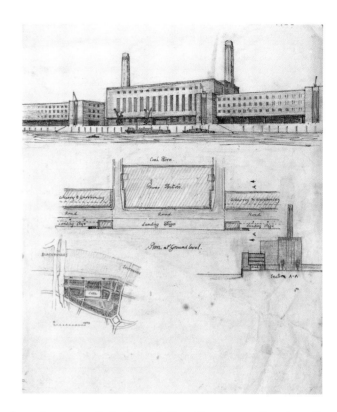

which would be a satisfactory neighbour to St Paul's. 'Why power stations should be considered as "untouchables", I cannot say,' Scott announced at the press conference. 'It is an opinion formed, I feel, by past experience. Power stations can be fine buildings, but it must be demonstrated.'[10]

This Scott certainly did demonstrate at Bankside in what was to be his supreme 'cathedral of power'. The first design, produced in January 1947, was for a symmetrical block with a tall brick chimney at either end. Following the public outcry over building a large power station on such a sensitive site, Scott was able to do what he could not do at Battersea and assume complete aesthetic control. He persuaded the engineers to gather together the flues from the boilers and combine them in one single central

smoke stack, or 'campanile', placed directly across the river from St Paul's. This elegant, tapering tower of brickwork, enhanced by slight *entasis* and by central bands of fluting on each face, rose to a height of 325 feet (lower than the top of Wren's dome) and was designed to emit 'a smokeless shimmer of vapour' from the nozzles of the four metal chimney shafts confined within.[11]

Bankside was to be the first large generating station to be fired by oil rather than coal (as at Battersea). Even so, there were worries about the damage its emissions of sulphur dioxide might do to the stonework of the Cathedral. To allay public fears about dirt and smells, the building incorporated a gas-washing plant placed at roof level behind the chimney. In

10 *The Builder*, 23 May 1947, p.495 11 *Ibid*

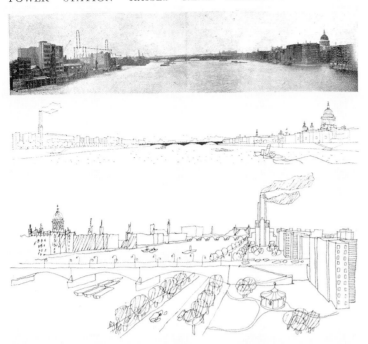

404] THE ARCHITECTS' JOURNAL for May 15, 1947

POWER STATION RAISES REAL PLANNING PRINCIPLE

The real principle which has been missed in the St. Paul's and the Power Station controversy is that, if the proposal to build a station opposite the Cathedral goes through, the whole aim of physical planning will receive an official denial and the existence of a Ministry of Town and Country Planning will become a farcical paradox. Once the idea of planning has been accepted, one of its objects should be to arrange for power stations on a comprehensive long-term basis. If these are built anywhere in the short-term, ad hoc manner of laisser-faire, planning ceases. In which case, let the Minister of Town and Country Planning face up to this ineluctable position and resign. The drawings above show how the station interrupts the Abercrombie plan. We do not plead particularly for the Abercrombie solution of the South Bank problem since it appears to destroy its traditional character. But it is at least a plan. We have reached the Manchuria Question in planning history and it remains to be seen whether the role of Neville Chamberlain is to be played by Mr. Silkin. Top, a photograph of the river showing the position of the original coal-fired station; to mitigate the visual conflict with St. Paul's a less obtrusive oil-fired station is proposed, a solution which is irrelevant to the real principle involved. Centre, a sketch showing the river with the smaller oil-fired station. Below, a sketch showing how the South Bank would lose its traditional character if the station were built.

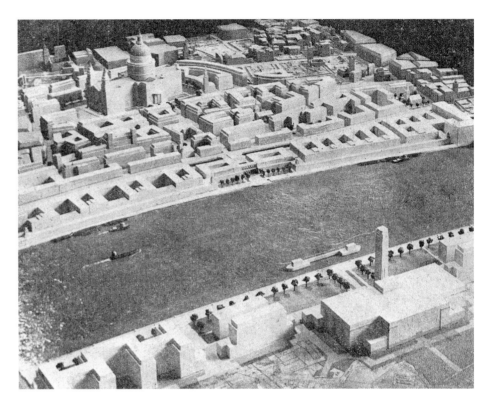

the event, this succeeded in removing 95 per cent of polluting gas from the exhaust smoke which was passed through large cast-iron washing chambers packed with cedar wood 'scrubbers' and sprayed with river water before being discharged into the atmosphere. There was an irony in this efficiency, however, for had the campanile been taller (as Scott wished) and the cleaning less efficient, the exhaust gases would have ascended vertically; as it was, despite the assistance of fans, the cooled smokeless vapour drifted across the Thames to cause mischief to the leadwork on Wren's dome.

Aesthetically, Scott's creation was a triumph: a controlled, subtly detailed composition of dramatic planes of beautiful pinky-grey brickwork laid on a subtle batter and enhanced by careful touches of abstract detailing – what he called 'decoration'. In bothering with such subtleties, he was at odds with the younger generation now committed to the austere industrial style of the Modern Movement. In notes made at this time, Scott wrote how 'we have to consider the purpose of the building. It is obvious that a factory, for instance, requires a different treatment to a cathedral or town hall as regards decoration inside and out, though this modernist movement largely disregards this and prescribes the same austerity and bleak absence of ornament for all buildings. This self-denying ordinance is the inevitable reaction from a previous period where a lifeless ornament was indiscriminately used all over buildings, but like all violent reactions it goes too far and

Alonzo C. Webb's perspective
drawing of the revised design,
1950

the pendulum will swing back to a proper balanced view of sparse ornament, beautiful in design and placed just where it is needed and nowhere else. Contrast between plain surfaces and sparse well placed ornament can produce a charming effect. Light and shade can be introduced on to plain surfaces by the introduction of ornament, and mouldings are a form of ornament used for producing lights and shadows … The relative proportions of broad and narrow lines given by mouldings is an art in itself.'[12]

The truth of this is demonstrated by the sublime brick walls and campanile at Bankside. The structure is a composition of overlapping planes, with each grand, bare mass of brickwork rising to a bold set back before the parapet is reached. These recessions are enhanced by horizontal bands of vertical fluting, while the parapets themselves are enlivened by special small brick finials, like Greek *acroteria*, which stand against the sky 86 feet above the ground. Particularly masterly is the way the large windows lighting the interior boiler and turbine houses are broken by vertical brick

12 Giles Gilbert Scott, notebook no.16
[British Architectural Library
ScGG/1/15], punctuation introduced

184

Alonzo C. Webb's perspective
drawing of Giles Gilbert Scott's final
design for Liverpool Cathedral,
1942

mullions, and the wide openings themselves treated as gaps between the outer discrete planes of brick. As at Liverpool Cathedral, there is a controlled balance between vertical and horizontal lines, with the long lines of the parapets and, facing inland, the horizontal bands of window being countered by the upward thrust of the great campanile. This chimney rose straight from the ground – as Ruskin had insisted, a century earlier, that towers always should.

Scott's brick industrial style owes something to the Expressionist work of W. M. Dudok, whose buildings at Hilversum, at once modern and traditional, were so admired by British architects between the world wars. It was also clearly influenced by modern American architecture, while his treatment of wall planes accentuated by repetitive ornament may be compared with Frank Lloyd Wright's Hollyhock House in Los Angeles. What Scott certainly shared with Wright and other architects of his generation was an interest in the sublime grandeur of the monuments of the ancient world, whose geometrical purity made them somehow resonant with the modern

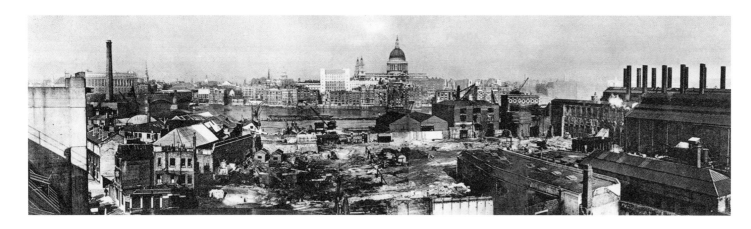

industrial age. For Wright, the ideal was Mayan architecture, while the writer Robert Byron, who so admired Lutyens's New Delhi, could find in the brick burial towers of northern Persia 'the principle of vertical mobility in design carried out with that merciless severity so fashionable in modern industrial architecture'.[13] At Bankside Power Station, so massive and monumental, these resonances could be felt, in particular, in the original powerful elevation facing the City across the Thames where Scott created a silhouette like a ziggurat, building up to his great central tower in a series of steps.

While reiterating its reservations about the choice of site, the Royal Fine Art Commission considered that Scott's revised design was 'eminently suitable' and in June 1947 it was approved by the Minister of Town and Country Planning, Lewis Silkin. The working drawings were made by Scott's former assistant, Lesslie K. Watson, who entered into partnership with H.J. Coates to handle the job.[14] Construction of the chimney and the right-hand or western half of the station was started in 1948, and the first two British Thomson Houston 60 megawatt turbines were 'commissioned' in 1952. The

last of the old power station was demolished in 1959 to make way for the eastern half, which contained another 60 megawatt turbine together with a 120 megawatt English Electric hydrogen-cooled turbo alternator. The oil-fired boilers were manufactured by Foster Wheeler. The symmetrical mass of the power station was completed soon after Scott's death in 1960, although an independent boiler house (since removed) was later designed by his son Richard and built in front of the base of the chimney.

Bankside never received the critical accolades showered on Battersea. By the time it was finished, Scott's approach to industrial design was quite out of fashion. In 1948, the Royal Fine Art Commission had offered suggestions to the recently nationalised electricity industry and insisted that 'the temptation to give the larger elements of a power station a heavy monumental character more suited to places of public assembly should be avoided'.[15] Five years later, in an article on power stations in the *Architectural Review*, Scott's brick piles were condemned by Robert Furneaux Jordan both for their cost and their inflexibility. He defined the

13 Robert Byron, *The Appreciation of Architecture*, London 1932, p.40

14 Leslie K. Watson to the author, 17 May 1979

15 Royal Fine Art Commission, *Suggestions on the Design of New Power Stations for the Guidance of Architects employed by the British Electrical Authority*, 1948

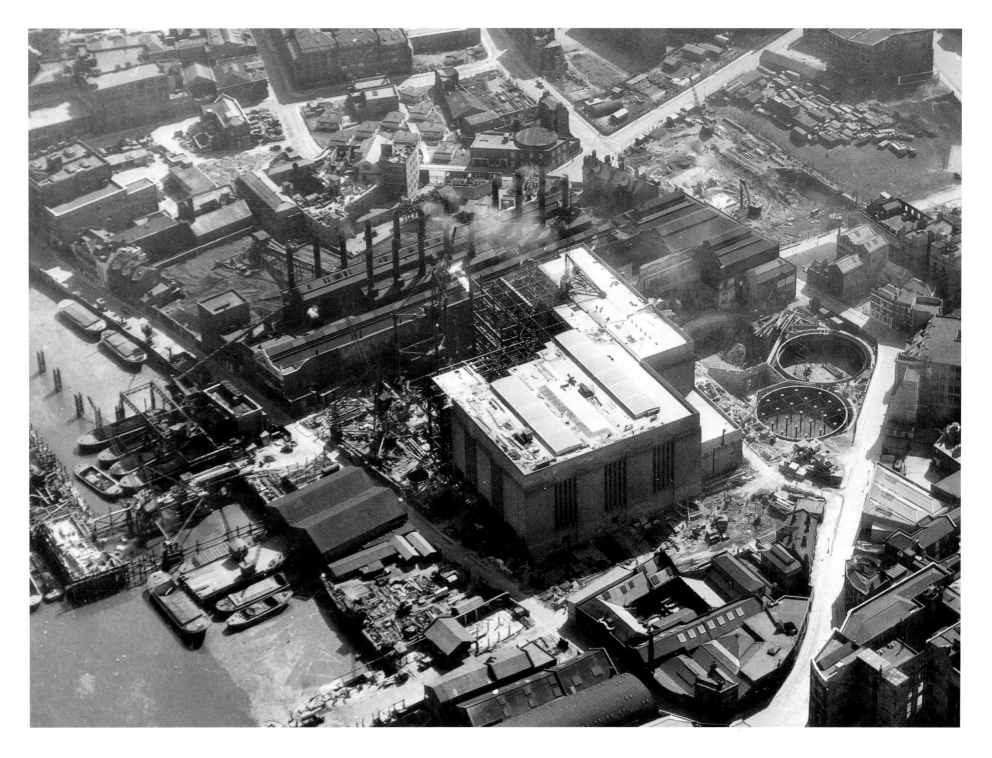

The chimney under construction Watercolour of the power station
 before the addition of the eastern
 half of the building: by A.H. Angel,
 1953

The power station at night

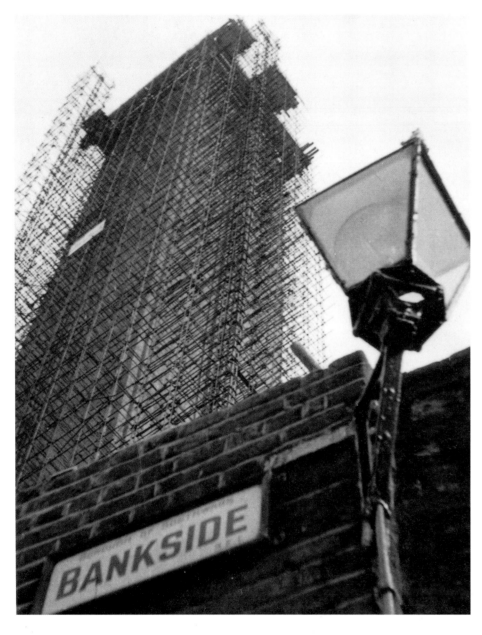

16 Robert Furneaux Jordan, 'Power
Stations' in *Architectural Review*,
April 1953, p.229

stages in the architectural development of the power station as '1. Sheds. 2. "brick cathedrals". 3. Functional or "modernistic" buildings. 4. Integration of structure and apparatus into a unity.' As far as he was concerned, 'the "brick cathedral" station (actually steel frame with brick cladding) is the largest, last and worst manifestation of the disastrous process that began at the Renaissance with the divorce of structure and "design" and culminated in the tailoring of stylish clothing for engineer's buildings.'[16]

Furneaux Jordan was a committed partisan of the Modern Movement and ideologically opposed to Scott's development of tradition, but the history of Bankside Power Station suggests he had a point. 'Silkin's Folly' had a remarkably short life which scarcely justified the massive investment in all that beautiful brickwork. At first, the power station was one of the most efficient of those supplying the national grid and in 1970 its output levels were twice exceeded, but within four years the Oil Crisis rendered Bankside hopelessly uneconomic compared with coal-fired or nuclear stations. By 1980, the Central Electricity Generating Board could propose to

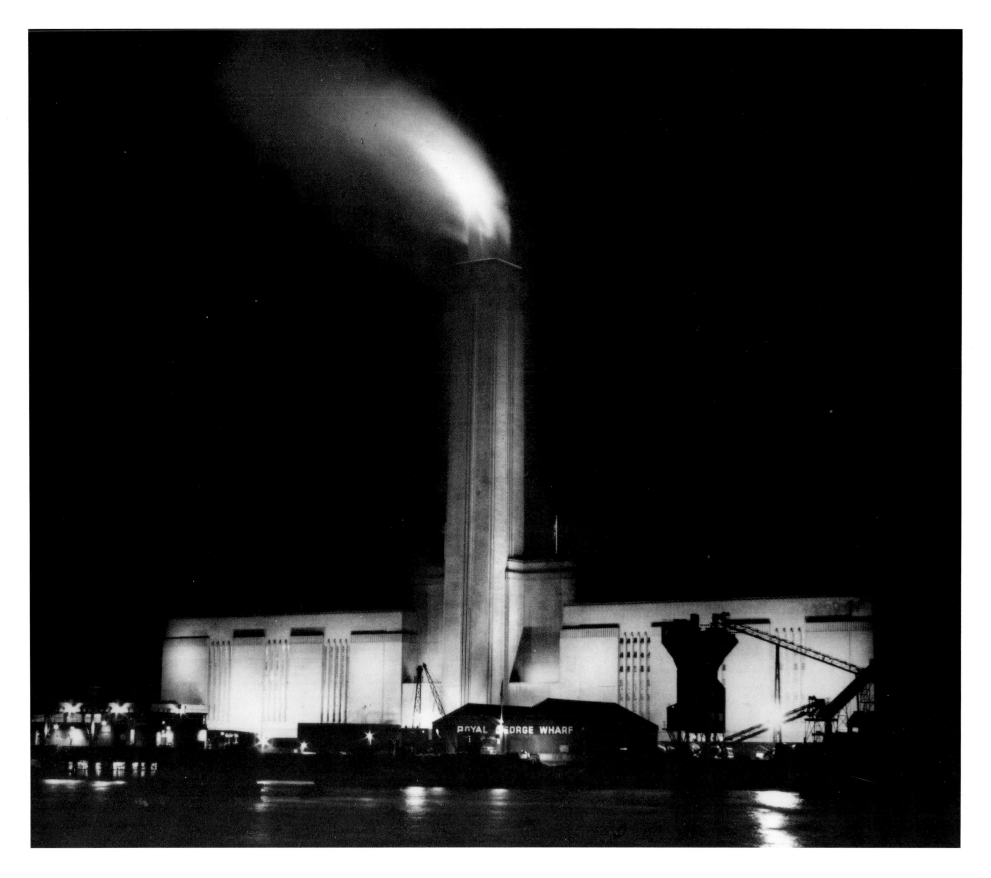

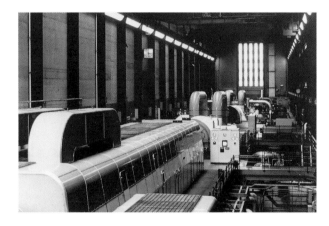

sell the site for redevelopment and, in that year, Marcus Binney of SAVE Britain's Heritage made the first imaginative proposal for the conversion of the building into a museum, arguing that 'The potential for reuse is considerable. Bankside was superbly built and is very well maintained.'[17] Bankside Power Station was shut down on 31 October 1981.

At the time there was no mechanism for protecting Scott's creation as it was too new to be considered for listing as a building of architectural or historical importance, so its future remained in doubt. In 1987, however, Albert Richardson's Bracken House became the first post-war building to be listed and the following year the Minister for the Environment announced the adoption of the '30-year rule', but his first eighteen candidates did not include Bankside. Since then, Post-War Listing has proceeded steadily, with buildings both traditional and modern in style being considered, but – dismissing repeated requests by the Thirties Society (now the Twentieth Century Society) – the government resolutely refused to list Bankside, despite the fact that it was indisputably worthy as a major work

by a leading British architect and regardless of the precedent set in 1980 when Scott's inferior and compromised design at Battersea had been listed. The reason was simple: following privatisation, the site had been given to Nuclear Electric as an asset to exploit. When the present writer made a short television film about Bankside for the BBC's *One Foot in the Past* series in 1993, Scott's finest industrial masterpiece looked doomed.

And then the Tate Gallery unexpectedly came to the rescue. In happy consequence, Bankside looks set to have a much longer life as an art gallery than it ever did serving the purpose for which it was designed. Such are the ironies of architecture and conservation, but the care and effort Scott put into the form and appearance of a mere temporary industrial building are now vindicated. It was Giles Gilbert Scott's peculiar distinction to have designed both a cathedral for worship and a cathedral of power – each with a great central tower. Now his brick cathedral has become a temple for art: it is an unexpected tribute to a great British architect who was always, above all, an artist.

17 Marcus Binney, 'Bankside Power Station. The possibility of alternative use. Report on visit with Barry Mazur on May 19th, 1980', typescript

CHRONOLOGY
ADRIAN HARDWICKE

| 1897 | 1916 | 1926 | 1937 | | 1979 | 1988 | 1993 |

TATE GALLERY

21 July Tate Gallery opened by HRH The Prince of Wales as the National Gallery of British Art. The gallery and sixty-five pictures were presented to the nation by Henry Tate

Tate Gallery officially given the additional responsibility of collecting international twentieth-century art

New galleries designed for the display of sculpture open, again supported by Duveen

8 June Opening of the modern, foreign and Sargent galleries, a gift from Joseph Duveen. This extension was originally proposed in 1916 but was delayed, as was all non-essential building work after the First World War. The first displays were of modern French painting

Llewellyn-Davies, Weeks, Forestier Walker & Bor's extension opens allowing the breadth and range of the modern collection to be seen for the first time

Tate Gallery Liverpool – designed by James Stirling, Michael Wilford & Partners – opens showing work from the twentieth-century collection

Tate Gallery St Ives, designed by Evans and Shalev Architects, opens

| 1947 | 1953 | 1959 | 1963 | 1981 | 1993 |
| 1948 | | | | | |

BANKSIDE POWER STATION

Sir Giles Gilbert Scott's architectural plans unveiled

Building of an oil-fired power station starts

First phase, including the chimney and the western half of the building, begins power generation

Construction of the remaining half of the power station begins

Official opening by Her Majesty Queen Elizabeth II

31 October Closure due to increased price of oil making other methods of generating electricity more economic

February Department of National Heritage declares that the power station does *not* merit listing, in spite of representations by English Heritage

1992

15 December Tate holds press conference to announce plans to redefine the display of the collection leading to the creation of a new Tate Gallery of British Art and a new Tate Gallery of Modern Art by the Millennium

1993

The search for suitable premises begins. Various locations considered including the area on the southern side of Vauxhall Bridge, the Hungerford Bridge car park site on the South Bank, sites in Docklands and near King's Cross and Euston stations

Spring Making of the BBC television film about the threat to Bankside Power Station, *One Foot in the Past*, in which Francis Carnwath, Deputy Director of the Tate, was interviewed

July Trustees of the Tate Gallery visit Bankside Power Station

1994

28 April Announcement that Bankside is to be the site for the new Tate Gallery of Modern Art

London Borough of Southwark offers £1.5 million towards development costs

13 July International competition to select an architect launched

26 September Thirteen architects chosen from an initial 148 applicants to go forward to the next stage of the competition

21 November Six architects chosen as competition finalists:
David Chipperfield (UK);
Herzog & de Meuron (Switzerland);
Rafael Moneo (Spain);
Office for Metropolitan Architecture – Rem Koolhaas (The Netherlands);
Renzo Piano (Italy);
Tadao Ando (Japan)

1995

24 January Herzog & de Meuron announced as winning architects

February Planning permission granted by the London Borough of Southwark for change of use of the power station to an art gallery

21 February 'Selecting an Architect' exhibition opens at the Tate Gallery

15 June Tate Gallery of Modern Art joins 'long list' of schemes being considered for funding by the Millennium Commission

June Work begins to remove the power station machinery

17 July 'Assessing the Economic Impact' report published, indicating that £30–90 million direct economic benefit could result from the development of the Tate Gallery of Modern Art and up to 2,400 jobs be created

28 July Sheppard Robson appointed as Associate Architects

30 October £50 million awarded by the Millennium Commission, using funds from the National Lottery to create one of the Commission's 'Landmark' projects. The total project cost at 2000 prices fixed at £130 million with an opening date of May 2000

1996

13 March Herzog & de Meuron unveil detailed plans which are submitted for planning consent

2 May Regeneration agency English Partnerships grants £12 million to acquire the site and cover the costs of removal of the machinery

Planning approval given by Southwark Council

June Brick manufacturers approached to create a match for the existing types of brick

Floor grilles outline detail issued to selected foundries

July Announcement that £85 million had been raised towards development costs

17 July 'Inside Bankside', an exhibition of new art inspired by Bankside Power Station, opens at the South London Gallery. Includes works by Dennis Creffield, Anthony Eyton, Deanna Petherbridge, Thomas Struth, Terry Smith and Catherine Yass

August Mock-up of rooftop glass structure under construction

31 August Removal of machinery from power station complete. Site handed over by Magnox Electric plc to Schal, Tate Gallery of Modern Art construction managers

2 September Public open days held. The last chance to see the interior before construction begins

10 December Laser projection onto the façade of the power station and the announcement of the winning design for a new pedestrian bridge. Foster and Partners, Ove Arup & Partners and Sir Anthony Caro selected

16 December Herzog & de Meuron open an on-site office

December Demolition of outbuildings along north elevation complete

1997

January Demolition of boiler house roof

February Demolition of area each side of the chimney, which now stands isolated on its own foundations

3 February Industrial Relations and Safety Code of Practice agreement signed

6 February Over £100 million raised towards funding target

April Timber floor samples laid and undergoing foot traffic tests in staff area at Millbank

June Discovery of asbestos and poor condition of existing turbine hall roof

3 June Kienast Vogt Partner appointed to work with Herzog & de Meuron as landscape architects

August Asbestos removed allowing works to recommence

Blasting and treatment of existing steelwork complete

September Turbine hall roof demolished and substructure raft begun as foundation

7 October Construction officially begins. A time capsule containing plans, photographs and videos relating to the project along with drawings by local schoolchildren and a piece of Swiss mountain crystal provided by the architects is buried in the foundations by Chris Smith, Secretary of State for Culture, Media and Sport

13 November Millennium Commission awards bridge scheme £7.1 million grant

December Structural steelwork begins to form the new seven floors in the former boiler house

1998

January Decking and floor construction starts

April Removal of original boiler house roof trusses completed, allowing the new floors to support fully the existing brick façade

May Steelwork for new two-storey glass roof structure begins

Glazing of the new turbine hall roof starts

June Drylining to Level 3 galleries begins

August Secondary steelwork for lift installation started

September Levels 6 and 7 air handling plant installation complete

Cable pulling begins

Escalator installation begins

16 September 'Topping out' achieved. Ceremony performed by Nick Raynsford, Minister for London and Construction

28 September Art arrives with the first of a series of temporary art projects. Artists' films are projected onto the façade of the building

November Escalators located in final positions

1999

January Labour levels over 500 for the first time

February Jasper Morrison appointed as furniture consultant

4 February The Arts Council of England Lottery Fund awards a £6.2 million grant allowing additional display space to be built in time for opening, raising the total project cost to £134.2 million (increased by the Trustees to £134.5 million in March 2000 in order to cover costs of further enhancements to the building)

March Auditorium fit-out begins

May Turbine hall bridge stair installed

Level 3 west galleries completed and environmental control switched on

Timber floor installation started

13 May Louise Bourgeois is announced as the first artist who has been specially commissioned to create a work for the turbine hall

July Labour levels over 600

August Permanent lighting on in most areas of the building

31 August Base build works completed. Fit-out begun

6 September Tate staff move into permanent offices

October New gallery names announced: Tate Modern and Tate Britain

23 December Many areas of the building now complete

2000

January Site officially handed over to the Tate Gallery by construction managers, Schal

Installation of art begins

11 May Tate Modern opened by Her Majesty Queen Elizabeth II

INFORMATION
ADRIAN HARDWICKE

TATE MODERN DESIGN TEAM

Client Tate Gallery Projects Ltd
Director of Buildings and Gallery
 Services: Peter Wilson
Project Director: Dawn Austwick OBE
Director: Sir Nicholas Serota

Architect Herzog & de Meuron
Partners in charge: Jacques Herzog,
Harry Gugger
Design Team: Jacques Herzog, Pierre
de Meuron, Harry Gugger, Christine
Binswanger
Michael Casey (project architect)

Thomas Baldauf, Ed Burton, Victoria
Castro, Emanuel Christ, Peter Cookson,
Adam Firth, Nik Graber, Konstantin
Karagiannis, Angelika Krestas, Patrik
Linggi, Yvonne Rudolf, Juan Salgado,
Vicky Thornton, Hernan Vierro, Kristen
Whittle, Camillo Zanardini

Irina Davidovici, Liam Dewar, Catherine
Fierens, Matthias Gnehm, José Ojeda
Martos, Filipa Mourao
Mario Meier (design: special construc-
tions)

Associate Architect Sheppard Robson
Senior Partner: Richard Young

Interior Design Herzog & de Meuron in
collaboration with Office for Design,
Jasper Morrison

Engineer Ove Arup & Partners
Directors: John Hirst, Tony Marriott

Cost Consultant Davis, Langdon &
Everest
Partners: Ian Fraser, Paul Morrell

Project Manager Stanhope plc
Andy Butler, Ron German, Stuart Lipton,
Peter Rogers

Construction Manager Schal
International Management Ltd
Project Managers: Ian Blake, Ken Doyle,
Mike O'Rorke, Dale Sager, Nick Woolcott

Landscape Architect concept design
Herzog & de Meuron with Kienast Vogt
Partner: Dieter Kienast, Günther Vogt;
detailed design Kienast Vogt Partner
with Charles Funke Associates

Fit-Out Manager Interior plc
Project Manager: Steve Howe

BANKSIDE POWER STATION

3.43 hectare (8.48 acre) site on the
south side of the River Thames opposite
St Paul's Cathedral

Northern frontage of site over 200m
(650ft) long

16,100m^2 (174,000sq ft) total floorplate,
of which 3,065m^2 (33,000sq ft) given over
to existing London Electricity
sub-station

Height of turbine hall from ground level
26m (85ft)

Chimney 99m (325ft) high, built to
be lower than St Paul's 114m (375ft)

Approximately 4.2 million bricks

Total area of basements underneath
the turbine hall, boiler house and
sub-station approximately 1.1 hectares
(2.75 acres), with average depth of
8.5m (28ft)

3 oil storage tanks with a total floorplate
of approximately 0.36 hectares
(0.9 acres)

3 × 60MW turbines

1 × 120MW turbine

4 × 420Klb/hour oil-fired boilers

1 × 860Klb/hour oil-fired boiler

Over 10,000 tons (10,000,000kg) of metal
removed, which was either reprocessed
or scrapped

TATE MODERN

Project Cost

£134.5 million

Design Information

Total internal floor area of approximately
34,500m^2 (371,350sq ft)

Display area 12,402m^2 (133,500sq ft),
comprising:

 Gallery suites for display and exhibi-
 tions totalling 7,827m^2 (84,250sq ft)

 Turbine hall 3,300m^2 (35,520sq ft),
 where works of art will also be shown

 Concourse areas that can also be used
 for display purposes on Levels 3,4 and
 5 totalling 1,275m^2 (13,730sq ft)

Auditorium to seat 240

Café on Level 7 to seat 170 plus 30 in the
bar area

Café on Level 2 to seat 240

Three shops
Level 1, 500m^2 (5,385sq ft); Level 2,
300m^2 (3,230sq ft); Level 4
exhibition shop, 150m^2 (1,615sq ft)

Education
390m^2 (4,200sq ft)

Members' Room
150m^2 (1,615sq ft)

Office
1,350m^2 (14,530sq ft)

Support services/art handling 1,500m^2
(16,145sq ft)

FLOOR BY FLOOR

Turbine Hall
Length 155m (500ft); width 23m (75ft);
height 35m (115ft)

2 × gantry cranes originally to service
the turbines, one able to lift up to 20 tons
(20,300kg), the other up to 50 tons
(50,800kg)

Level One
Shop, reception and cloakroom facilities,
education area, information,
membership, sound guide, ticketing
and orientation, plant

Level Two
Café, auditorium, shop, film/seminar
room, art management and loading bay

Level Three
Two display suites for the Collection, 28
(variable) galleries with a total area of
2,785.2m^2 (30,000sq ft), gallery heights
5.2m (17ft) apart from one gallery of 13m
(43ft), concourse of 425m^2 (4,575sq ft)

Level Four
Two display suites for temporary
exhibitions, 26 (variable) galleries with a
total area of 2,426.4m^2 (26,120sq ft), all
galleries are 4.9m (16ft) high, Espresso,
shop, terraces, concourse of 425m^2
(4,575sq ft)

Level Five
Two display suites for the Collection, 30
(variable) galleries with a total area of
2,602.5m^2 (28,015sq ft), various gallery
heights of 4.7m (15ft), 4.9m (16ft), 9.4m
(31ft), concourse of 425m^2 (4,575sq ft)

Level Six
Members' Room (with terraces), plant

Level Seven
Café and entertainment facilities

STRUCTURE AND MATERIALS

5,000 tons of new steel work

17,000m^3 (600,350 cubic ft) of concrete
poured

Level 5 gallery Silidur conductil steel
fibre concrete floor topping 2,800m^2
(30,140sq ft) placed and finished in
three pours

10,500m^2 (113,020sq ft) new timber
floor in all areas

Level 3 and 4 galleries and all concourse
areas 70 × 12mm rough-sawn,
square-edged, unfinished oak planks

62,400m^2 (671,500sq ft) of drylining

21 different types of glass used, varying
in thickness between 6 and 45mm
with light transmission values between
8% and 86%

Glazed walls of 8,200m^2 (88,265sq ft)

15,000 lights

Total length of cabling approximately
218 miles (350km)

399 cast iron floor grilles

3,700 fire sprinkler heads

Staircase with 220 stairs

1,500 internal doors

9 passenger lifts of which 4 for public
use (capacity of each 16 people), 2 goods
lifts (one for art handling, capacity
20 tons)

6 escalators

Turbine hall roof light consisting of 524
glass panes

Landscape planting consisting of:
20,000 daffodil bulbs
894 yew hedging plants
1,423 ornamental apple
1,570 ornamental quince
870 dogwood
10 magnolia
1,035 silver birch in bosques
108 specimen silver birch
plus other species including box,
hydrangea, honeysuckle, virginia
creeper, clematis, and various perennials

DONORS TO TATE MODERN

The Tate Gallery would like to thank all those who have given to the Tate Modern capital campaign.

Founding Corporate Partners
AMP
BNP Paribas
CGU plc
Clifford Chance
Energis Communications
Freshfields
GKR
Goldman Sachs

Lazard Brothers & Co., Limited
London Electricity plc, EDF Group
Pearson plc
Prudential plc
Railtrack PLC
Reuters
Rolls-Royce plc
Schroders
UBS Warburg

The Annenberg Foundation
Arthur Andersen (pro-bono)
The Arts Council of England
Lord and Lady Attenborough
The Baring Foundation
Ron Beller and Jennifer Moses
David and Janice Blackburn
Mr and Mrs Anthony Bloom
Mr and Mrs John Botts
Frances and John Bowes
Ivor Braka
Mr and Mrs James Brice
Donald L. Bryant Jr Family
Melva Bucksbaum
The Carpenters' Company
Cazenove & Co.
The Clore Foundation
Edwin C. Cohen
The John S. Cohen Foundation
Ronald and Sharon Cohen
Giles and Sonia Coode-Adams
Michel and Helene David-Weill
Gilbert de Botton
Pauline Denyer-Smith and Paul Smith
Sir Harry and Lady Djanogly

The Drapers' Company
English Heritage
English Partnerships
Ernst & Young
Esmée Fairbairn Charitable Trust
Doris and Donald Fisher
Richard B. and Jeanne Donovan Fisher
The Fishmongers' Company
The Foundation for Sport and the Arts
Friends of the Tate Gallery
Alan Gibbs
Mr and Mrs Edward Gilhuly
GJW Government Relations (pro-bono)
The Horace W. Goldsmith Foundation
The Worshipful Company of Goldsmiths
Noam and Geraldine Gottesman
The Worshipful Company of Grocers
Pehr and Christina Gyllenhammar
Mimi and Peter Haas
The Worshipful Company of Haberdashers
Hanover Acceptances Limited
The Headley Trust
The Juliet Lea Hillman Simonds Foundation

Mr and Mrs André Hoffmann
Anthony and Evelyn Jacobs
Howard and Linda Karshan
Peter and Maria Kellner
Irene and Hyman Kreitman
The Lauder Foundation – Leonard and Evelyn Lauder Fund
Leathersellers' Company Charitable Fund
Edward and Agnes Lee
Lex Service Plc
Anders and Ulla Ljungh
The Frank Lloyd Family Trusts
Mr and Mrs George Loudon
The Stuart and Ellen Lyons Charitable Trust
Ronald and Rita McAulay
McKinsey & Co. (pro-bono)
David and Pauline Mann-Vogelpoel
The Mercers' Company
The Meyer Foundation
The Millennium Commission
The Mnuchin Foundation
The Monument Trust
Mr and Mrs M.D. Moross

Guy and Marion Naggar
Peter and Eileen Norton, The Peter Norton Family Foundation
Maja Oeri and Hans Bodenmann
The Nyda and Oliver Prenn Foundation
The Quercus Trust
The Rayne Foundation
John and Jill Ritblat
Lord and Lady Rothschild
The Dr Mortimer and Theresa Sackler Foundation
The Salters' Company
Stephan Schmidheiny
Mr and Mrs Charles Schwab
David and Sophie Shalit
Peter Simon
Mr and Mrs Sven Skarendahl
Belle Shenkman Estate
Simmons & Simmons (pro-bono)
London Borough of Southwark
Mr and Mrs Nicholas Stanley
The Starr Foundation
Charlotte Stevenson
Hugh and Catherine Stevenson
John Studzinski

David and Linda Supino
The Tallow Chandlers' Company
Carter and Mary Thacher
Thomas Lilley Memorial Trust
Insinger Townsley
The 29th May 1961 Charitable Trust
David and Emma Verey
Dinah Verey
The Vintners' Company
Robert and Felicity Waley-Cohen
The Weston Family
Mr and Mrs Stephen Wilberding
Graham and Nina Williams
Michael S. Wilson
Poju and Anita Zabludowicz

and those donors who wish to remain anonymous

Tate Collection Benefactors
Douglas Cramer
Janet Wolfson de Botton

This list is correct as at 17 March 2000

INDEX

LIST OF WORKS
OF ART

Where more than one work appears in a photograph they are listed from left to right

40, Joseph Beuys, *The End of the Twentieth Century* 1983–5

41, Georg Baselitz, *Untitled* 1982–3; Richard Hamilton, *The subject* 1988–90, *The state* 1993

42 (left), Anselm Kiefer, *Ways of Worldly Wisdom – Arminius' Battle* 1978; Georg Baselitz, *Untitled* 1982–3; Richard Hamilton, *The citizen* 1981–3, *The subject* 1988–90, *The state* 1993,

43 (right), Anthony Caro, *The Window* 1966–7; Andreas Gursky, *Thebes, West* 1993; Anthony Caro, *The Soldier's Tale* 1983

48, Anthony Caro, *The Soldier's Tale* 1983, *Emma Dipper* 1977

50, Andrea Zittel, *A–Z Comfort Unit with Special Features by Dave Stewart* 1994–5; Mario Merz, *Do We Turn Round inside Houses, or Is It Houses which Turn around Us?* 1977/85

53, Germaine Richier, *Chess Board (Large Version)* 1959; Constant (Constant A. Nieuwenhuys), *After Us, Liberty* 1949; Jean Dubuffet, *The Tree of Fluids* 1950; Jean Fautrier, *Head of a Hostage* 1943–4

54, Joseph Beuys, *The End of Twentieth Century* 1983–5; Frank Auerbach, *Primrose Hill* 1967–8, *Bacchus and Ariadne* 1971

57 (left), Frank Auerbach, *To the Studios* 1979–80, *To the Studios* 1990–1

57 (right), Francis Bacon, *Triptych 1972*

83, Cornelia Parker, *Cold Dark Matter: An Exploded View* 1991

84, Bridget Riley, *Fall* 1963; Hiroshi Sugimoto, *Studio Drive-in, Culver City* 1993, *Winnetika Drive-in, Paramount* 1993; Bridget Riley, *Nataraja* 1993

85, Bridget Riley, *Cantus Firmus* 1972–3

86, Andreas Gursky, *Thebes, West* 1993; Hiroshi Sugimoto, *Tyrrhenian Sea, Scilla* 1993, *Aegean Sea, Pilion* 1990, *Ligurian Sea*, 1993

87, Hiroshi Sugimoto, *Aegean Sea, Pilion* 1990, *Ligurian Sea* 1993; Bridget Riley,

Late Morning 1967–8

88, Gabriel Orozco, *Until You Find Another Yellow Schwalbe* 1995

89, Tony Cragg, *Stack* 1975, *Britain Seen from the North* 1981

90, Richard Long, *Waterfall Line* 2000, *Red Slate Circle* 1988

91, Richard Long, *Red Slate Circle* 1988; Claude Monet, *Water-Lilies* after 1916

93, Rebecca Horn, *Ballet of the Woodpeckers* 1986

94, Bruce McLean, *Six Sculptures* 1967–8

95, Frank Auerbach, *To the Studios* 1979–80, *To the Studios* 1990–1

96, Joseph Beuys, *The End of the Twentieth Century* 1983–5; Frank Auerbach, *Primrose Hill* 1967–8, *Bacchus and Ariadne* 1971, *Oxford Street Building Site I* 1959–60

97, Joseph Beuys, *The End of the Twentieth Century* 1983–5

99, Richard Deacon, *For Those Who Have Ears #2* 1983

101, Rachel Whiteread, *Untitled (Floor)* 1994–5

102–3, Wassily Kandinsky, *Cossacks* 1910–11; Umberto Boccioni, *Unique Forms of Continuity in Space* 1913; Kasimir Malevich, *Dynamic Suprematism*, 1915 or 1916; Piet Mondrian, *Composition with Red and Blue* 1935; Ernst Barlach, *The Avenger* 1914; Laszlo Moholy-Nagy, *K VII* 1922

104, Cindy Sherman, *Untitled* 1982, *Untitled* 1982

105, Cindy Sherman, *Untitled* 1982, *Untitled* 1982; Sarah Lucas, *Chicken Knickers* 1997; Nan Goldin, *Jimmy Paulette and Tabboo! undressing, NYC* 1991, *Nan one month after being battered* 1984, *Misty and Jimmy Paulette in a taxi, NYC* 1991, *Greer and Robert on the bed, NYC* 1982

107, Francis Bacon, *Triptych 1972*

108, Giacometti, *Standing Woman* 1948–9; Germaine Richier, *Chess Board (Large Version)* 1959; Constant (Constant A. Nieuwenhuys) *After Us, Liberty* 1949; Jean Fautrier, *Head of a Hostage* 1943–4; Jean Dubuffet, *The*

Tree of Fluids 1950

109, Jean Fautrier, *Large Tragic Head* 1942; Henry Moore, *Reclining Figure* 1951; Jackson Pollock, *Number 14* 1951

110, Germaine Richier, *Chess Board (Large Version)* 1959; Constant (Constant A. Nieuwenhuys), *After Us, Liberty* 1949

111, Franz West, *Viennoiserie* 1998; Absalon, *Cell No. 1* 1992; Mario Merz, *Do We Turn Round inside Houses, or Is It Houses which Turn around Us?* 1977/85

113, Gilbert and George, *England* 1980, *Cunt Scum* 1977